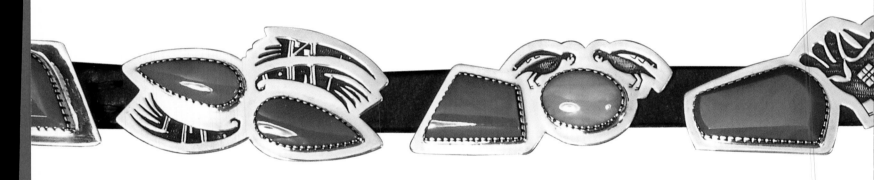

SHARED IMAGES

The Innovative Jewelry of

YAZZIE JOHNSON & GAIL BIRD

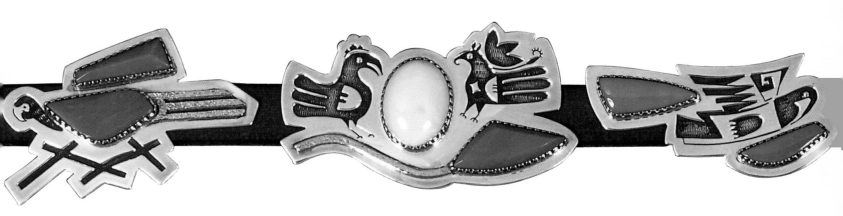

DIANA F. PARDUE

Photography by Craig Smith

HEARD MUSEUM PHOENIX

MUSEUM OF NEW MEXICO PRESS SANTA FE

Project editor: Mary Wachs
Manuscript editor: Dana Asbury
Design and production: Deborah Flynn Post
Composition: Set in Requiem and Optima
Manufactured in Singapore
10 9 8 7 6 5 4 3 2 1

Library of Congress Cataloging-in-Publication Data
Pardue, Diana F.
 Shared images : the innovative jewelry of Yazzie Johnson and Gail Bird / by
Diana Pardue ; photography by Craig Smith.
 p. cm.
 Includes bibliographical references.
 ISBN-13: 978-0-89013-496-2 (clothbound : alk. paper)
 1. Johnson, Yazzie, 1946- 2. Bird, Gail, 1949- 3. Navajo artists—Biography.
4. Laguna artists—Biography. 5. Indians of North America—Jewelry—Southwest,
New. 6. Belts (clothing)—Southwest, New. I. Title.
E99.N3J585 2006
739.27092'39726—dc22
[B]
 2006025947

Page 6: A Zia deer and four stars (see page 139).

Museum of New Mexico Press
Post Office Box 2087
Santa Fe, New Mexico 87504
www.mnmpress.org

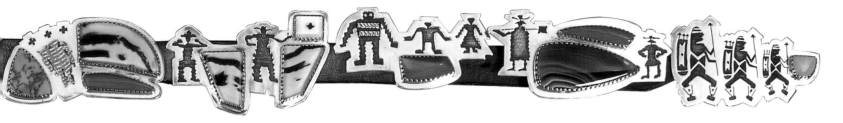

Contents

FOREWORD ❖ 7

ACKNOWLEDGMENTS ❖ 9

CHAPTER ONE
Developing an Individualistic Style ❖ 15

CHAPTER TWO
Creative Explorations ❖ 55

CHAPTER THREE
Refining Direction ❖ 111

APPENDIX
Thematic Belts in Chronological Order ❖ 155

NOTES ❖ 185

BIBLIOGRAPHY ❖ 187

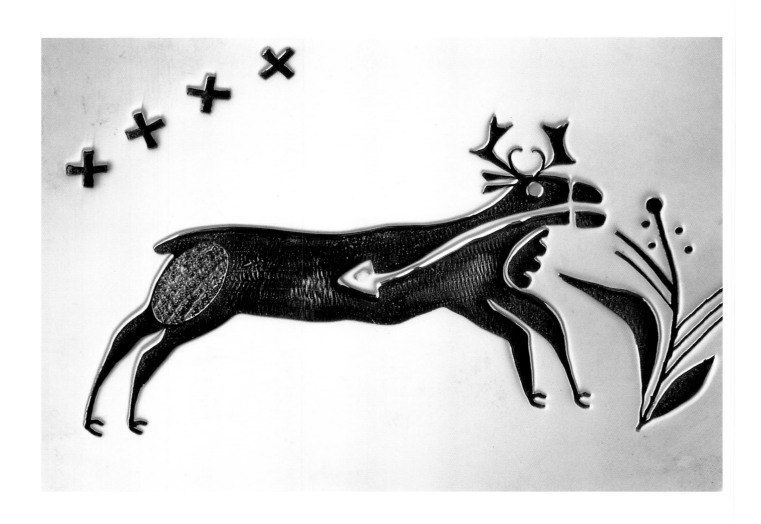

Foreword

I N THE MID-1970S my Indian art business in Chicago was blossoming from a tiny shop into a full-fledged art gallery. I began to mount exhibitions of well-designed contemporary Indian art; this required a continual search for artists creating original works. I sought artists whose design concepts reached beyond the traditional boundaries of what was then thought of as "Indian art." In the fall of 1977, a visitor came by my gallery. He asked if I had met a couple of young artists named Gail Bird and Yazzie Johnson. "They are newcomers," he remarked, "and they're doing some innovative jewelry." He gave me their phone number and I determined to look them up on my next trip to Santa Fe.

Later, I called and they graciously agreed to see me. I drove up to their home in northern New Mexico. Gail was ill but Yazzie met with me. He talked about their design concepts and his personal interest in sculptural forms, and I was impressed with the jewelry I saw. Their designs, using a variety of stones set in silver and brass, were clearly in tune with modern tastes. By using a far greater variety of stone types than turquoise and coral alone, they were able to create simple, elegant geometric combinations to very strong effect.

I was pleased to purchase several items. We found we shared similar ideas about the design and presentation of jewelry and agreed to an exhibition and sale of their jewelry in Chicago in October 1978. This was the first of many Gail and

Yazzie openings at the Indian Tree, my Chicago gallery, thus launching a long and close friendship and twenty-eight years of successful business together. I have seen their ideas continue to evolve into remarkably sophisticated jewelry as they have been recognized by countless awards, including Best of Show at Indian Market. I also found that when I needed help, Gail and Yazzie were among the first to be there.

Gail and Yazzie have a special symbiosis that strengthens their remarkable talents. Gail is gregarious—outgoing, bright, thoughtful, alert to good design and original ideas. She frequently lectures on American Indian jewelry and always goes out of her way to recognize and promote promising artists. I know few artists so willing to endorse others. When they begin a new project it is usually Gail who sketches the initial concept; then their teamwork begins. Yazzie is quiet and contemplative, with a wonderful, sometimes ironic sense of humor. He has developed great skill in transforming the chosen metal into forms that please him. He sets the wide combination of stones or pearls they have agreed on, then adds witty touches to the petroglyph-like motifs he often fashions on the inside surface of his metalwork.

The jewelry they produce is distinct from the work of other American Indian jewelers. Their pieces are frequently dramatic and always wearable. By seeking out stones of unusual color and surface pattern or pearls of various shapes and hues, then juxtaposing them in original compositions, they have created a unique style. After years of visiting prehistoric pictograph and petroglyph sites, Gail and Yazzie realized that these ancient peoples had developed a distinctive set of designs, from which they have drawn much inspiration. Over their career of more than three decades, Gail and Yazzie have developed a body of work that is both distinctly their own and continuously evolving.

Martha Hopkins Struever
February 2006

Acknowledgments

T HE HEARD MUSEUM is pleased to present the innovative jewelry of Yazzie Johnson and Gail Bird. This catalogue of Yazzie and Gail's jewelry provides a range of their work, from Yazzie's first brass ring in 1969 to their recent collaborations using 18k gold and myriad stones. One emphasis of this publication and exhibit is to include, with Yazzie and Gail's input, their forty-six thematic belts.

A few months before Yazzie and Gail completed their first thematic belt in 1979, the Heard Museum played a key role in presenting a retrospective exhibit and accompanying catalogue of Charles Loloma's jewelry. Then, as now, the museum sought to bring to the attention of its visitors exemplary contemporary works while continuing to exhibit important historic materials. The Heard has continued its focus on contemporary art; in 1997 it presented the works of leading jewelers in the exhibit "The Cutting Edge: Contemporary Southwestern Jewelry and Metalwork." Curated by Diana Pardue, the exhibit acknowledged the creative efforts of thirty-seven contemporary jewelers, Yazzie and Gail among them, and paid tribute to innovators Charles Loloma, Kenneth Begay, and Preston Monongye.

For more than a decade, the Heard has benefited from the knowledge and expertise of Yazzie and Gail. In 1994, they reviewed jewelry in the Fred Harvey Company Collection and gave information about the collection that was used in

the development of an exhibit about the company's collection of American Indian art. In 2001–02, they served as guest curators for the exhibit "Be Dazzled! Masterworks of Jewelry and Beadwork from the Heard Museum Collection," for which they reviewed and made a selection of jewelry.

For this catalogue and exhibit, Gail and Yazzie worked closely with the Heard's curator of collections, Diana Pardue, giving insight into their creative process and providing access to their extensive drawings that document their work. During the course of planning for this project, they have made several visits to the Heard Museum to review, comment upon, and in many instances polish the more than forty thematic belts that were borrowed from the owners for photography, as well as numerous buckles, necklaces, pairs of earrings, and brooches. Their participation in the planning of this exhibit and catalogue has been invaluable.

We would like to recognize a number of individuals for their support of this exhibit and catalogue. They include: Jason Aberbach, Dan and Martha Albrecht, Dale and Doug Anderson, JoAnn and Robert Balzer, Linda and Jonathan Batkin, Marcia and Bill Berman, Barrie Birge, Caroline Boeckman, Elizabeth Boeckman, Mary Cavanaugh, Judy and Ray Dewey, Valerie and Charles Diker, Marcia Docter, Pat and Martin Fine, Penny and John Freund, Diane Gabriel, Helen Gabriel, Susan and Howard Goldsmith, Lynn and George Goldstein, Robert Haozous, Jean and Joseph Harlan, Joan W. Harris, Nancy L. Harris, Lanny Hecker and Mavis Shure, Terry Hershey, Hazel and William Hough, Katherine Boeckman Howd, William and Tunia Hyland, Shirley Jennings, Anne Kern, C. Wesley and Shirley D. Lingenfelter, Joanne Lyon, James and Jeanne Manning, Bill Massee, Lamar Meadows, Charlotte and Thomas Mittler, Nancy and Hiroshi Murata, Gail Neeson and Stefan Edlis, Robin Neustein, Suzy and David Pines, Sharen Popkin, Tony Reyna, Jack Reynolds, Rona C. Rosenbaum, Gary, Brenda, and Harrison Ruttenberg, Ramona Sakiestewa, Sid and Ruth Schultz, Susan Schwartz, Jean and Laurel Seth, Jane Dunn Sibley, Deborah Slaney, Linda and Irwin Smith, Judith Zee Steinberg, Martha H. Struever, Richard H. Sweetman, Eric Tack, Ellen Taubman, Lee and Tommy Thompson, Michelle M. Serra and Brad Tompkins, Eileen Wells, and

Joyce and Erving Wolf. Also, we wish to thank the Albuquerque International Sunport and 1% for the Public Arts Program, the Millicent Rogers Museum in Taos, and the Wheelwright Museum of the American Indian in Santa Fe. We are greatly indebted to these individuals and institutions who so willingly loaned their jewelry for photography for the catalogue and to the exhibit. The Heard's photographer Craig Smith took painstaking efforts with each photograph.

This exhibition and catalogue would not have happened at the Heard Museum without the hard work and passion that Diana Pardue, the exhibition's curator, brought to the project. One of the acknowledged authorities on Southwest Native jewelry, Diana sets a standard of excellence for which all of us here are grateful.

The Heard Museum's registrar, Sharon Moore, deserves special recognition for arranging the careful packing and shipping of borrowed materials for photography and the exhibit. Also, the creative director, Lisa MacCollum, worked with her colleagues Kevin Coochwytewa, Phil Douglass, Anna Glenn, Melissa Martinez, and Manny Wheeler to plan the exhibit installation.

The Heard's goal is to make the jewelry of these two very talented artists available to connoisseurs of American Indian art, to those who appreciate jewelry, and to new admirers of the art form. The catalogue offers only a glimpse of work from their more than thirty-year career. We look forward to all that they will create as their careers continue.

Frank H. Goodyear, Jr.
Director, Heard Museum

SHARED IMAGES

Yazzie Johnson & Gail Bird

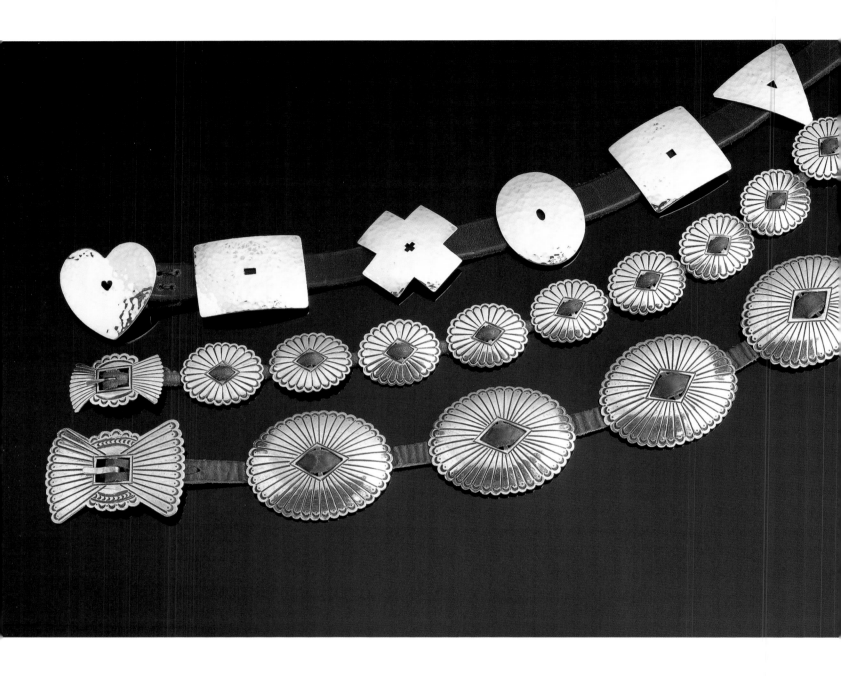

Developing an Individualistic Style

Y AZZIE JOHNSON AND GAIL BIRD are two of the most well-known, innovative, and creative American Indian artists working today. They have known each other since they were children and have collaborated in designing and fabricating jewelry since 1972. To many, they are best known for the thematic belts they make each year for the Southwestern Association for Indian Arts Market in Santa Fe, but they also design elegant earrings, bracelets, rings, and necklaces which are shown in galleries and museums across the country. They are part of a generation of American Indian artists from the Southwest who have acknowledged and honored the traditions of their respective areas while push-ing the creative boundaries and addressing contemporary concerns. Their work is characterized by an extensive knowledge of materials and by their technical skill and keen design sense. Johnson and Bird's extraordinary collaboration began years before the first belt was made.

Early southwestern jewelers used turquoise in its rich and diverse forms as well as river stones, native garnets, wood, local black jet, and valued trade materials such as shell and coral. Johnson and Bird became aware of the rich legacy and the materials used by early jewelers through their study of early Southwest jewelry and its history recorded by John Adair in his book *Navajo and Pueblo Silversmiths*. This inspired them to use a variety of materials, relying on the knowledge that "you could use anything, as the early silversmiths had. This is the impetus and catalyst

1. From Top: Child's belt, silver, 1996, buckle 1.5 x 2.5 inches. Private Collection. Child's concho belt, silver, c. 1981, 1-inch-diameter concho. Ray and Judy Dewey Collection. Concho belt, silver, 1985, buckle 1.5 x 2.25 inches, concho 1.74 x 2.25 inches. Kate Massee Tremper Collection. Yazzie Johnson made his first concho belt in 1976 and continued to make silver conchos through 1990. The conchos are characterized by precise, crisp lines.

Yazzie Johnson and Gail Bird in San Francisco, California, 1969.

for what we could do." Throughout their careers, they have distinguished their work by the use of stones with unusual markings.

When talking about their work, Johnson and Bird emphasize the importance of materials. They may keep a stone for several years before deciding to incorporate it into a design. Often, the metalwork, though important, follows the lines of a stone or is created to reflect the texture or pattern of a stone. The beauty of their work rests not only in the diversity of the stones they use but also in the range of techniques. The metalwork may share a subtle message or theme that is expressed through embellishments of designs on the reverse of clasps or pendants. According to Bird, "We see our jewelry as being very traditional in nature. But we carry the traditions further. The stones we use are of a wider variety than those usually associated with Indian jewelry. The symbols and narratives on our pieces are expansions of traditional symbols and stories."[1]

Yazzie Johnson (b. 1946 in Winslow, Arizona) and Gail Bird (b. 1949 in Oakland, California) met in 1960 when Johnson was fourteen years old and Bird was twelve. Johnson's parents, Matthew and Marilyn, worked at the Bureau of Indian Affairs Inter-Mountain Indian School in Brigham City, Utah, as did Bird's mother, Andrea. Johnson's mother and father are from Sanosotee, New Mexico, and Leupp, Arizona. Bird's mother was from Laguna Pueblo and her father from Santo Domingo Pueblo, both in New Mexico. Her father, Tony, worked for the Southern Pacific Railroad, and when Bird and her brothers were children, the family traveled by train from California to New Mexico to visit other relatives.

Johnson and Bird's peers were the more than twenty other children of the employees of Inter-Mountain School. Among the teachers at the school were Apache sculptor and painter Allan Houser and jeweler Dooley Shorty. The children played on the expansive grounds that surrounded the employee homes. Bird jokes that when she and Johnson first met, he mistook her for a boy until her braids fell out of the cap she was wearing. Johnson's observation of silversmith Dooley Shorty would have a lasting impact on him, as he recalled in a 1981 interview,

"I was influenced by just seeing the things made by Dooley Shorty. I lived right across from him at Inter-Mountain School. My mother was teaching there. That was long before I thought of doing silver, but even then I knew I was going to do something with my hands, paint, sculpt. I hadn't thought of jewelry. When I was growing up, I thought I was going to be a painter or a sculptor. That was my main interest."[2]

After graduation from high school in 1965, Johnson attended Utah State University in Logan. In 1966 he enlisted in the U.S. Army. Initially, he was stationed in Germany and in 1968 in Viet Nam. In 1963, Bird moved to Oakland for better educational opportunities and lived with her father, whose work with the railroad required him to live in California. She graduated from high school in 1966 and attended the University of California at Berkeley for two semesters, where she took general courses. After a brief visit with her brothers and her mother, who was now working in Santa Fe at the Institute of American Indian Arts, Bird returned to Berkeley and worked at an imports store as a stock assistant and bookkeeper and eventually became an unofficial assistant manager.

Bird and Johnson corresponded throughout his overseas assignment. In 1968, after he was honorably discharged from the army, Johnson joined her in California, where he worked for General Motors. One of their childhood friends, Robert Haozous, was also in California studying at the California College of Arts and Crafts.[3] In 1969, Haozous told Johnson about a two-week metalsmithing course; Johnson took the class and made his first piece of jewelry, a brass ring with stamped designs (figure 2).

In December 1969, the couple decided to move to New Mexico. Johnson did construction work with another childhood friend and son of Allan and Anna Houser, Philip Haozous. When winter approached, Johnson and Bird worked at Bob Ward's Gallery on San Francisco Street on the plaza in Santa Fe, as did Gail's brother Charlie Bird. Ward encouraged the sales staff to learn about American Indian art and had numerous books about the topic in the gallery. During the winter months, with few gallery visitors, Bird and Johnson had ample time to study

American Indian art. In 1971, Johnson went to work for another dealer and Bird worked for a friend she had met while at Bob Ward's, Kate Massee Tremper. Tremper opened the first cheese shop in Santa Fe, and Bird began baking bread for the

2. Brass ring with stamped designs, 1969. The stamped designs on the ring have a randomness of application and a freedom of design evident in later works. Private Collection.

shop and making pastries for a sandwich shop owned by Tremper's husband. Bird would get up each morning at five o'clock to finish her baking, and then Johnson drove the baked goods to the shop. Johnson made some things for Tremper's restaurants, including a brass door panel with a design of a rabbit in a garden and a truck driving goods to the restaurant for Massee's, a business Tremper owned in the early 1980s (figure 3).

In 1972, Johnson and Bird were contacted by an American Indian recruiting program at the University of Colorado in Boulder, and they made plans to attend the university beginning in the fall. Although they both had scholarships, they needed money for the move from New Mexico to Colorado. Jewelry-making became a means to an end. Harold Littlebird, another of Gail Bird's brothers, had a booth at the Santa Fe Indian Market. Since the Indian Market rules were not as stringent as they would later become and "family" included Bird and Johnson, Littlebird offered to share his booth. Rather than make several small items, Johnson began an ambitious undertaking of making a silver concho belt. It sold for $200, and the trip to Colorado was funded.

At UC Boulder, Johnson took painting, sculpture, and other art classes, and Bird studied literature and liberal arts. In the summer of 1973, Johnson worked for the Native American Education Program as a work-study teaching assistant in a geology course. His formal studies of geology provided basic knowledge of the properties of stones, knowledge that would prove useful when customers asked questions about the variety of stones Johnson and Bird later used in their work.

After one year of college, Johnson thought he might earn more money by making and selling jewelry than he would as a work-study employee. In the summer of 1974, the couple approached a bank in Santa Fe and requested a $200 loan.

They planned to buy materials and tools so Johnson could make jewelry to show at the market, sponsored by the Southwestern Association of Indian Affairs (later called the Southwestern Association for Indian Arts, or SWAIA). The bank agreed to the loan and jewelry-making began.

This was also the second summer that the Eight Northern Pueblos, the affiliated Pueblo Indian villages from Tesuque to Taos, held what would become an annual sales event. In Colorado, Johnson made several brass bracelets that he sent to Gail's older brother, Charlie, to see if he could sell them at the Eight Northern Pueblos show. Although onlookers were interested in the $6 bracelets, there were no buyers. Johnson continued, however, to make jewelry in preparation for the Santa Fe Indian Market scheduled for August.

As the Indian Market approached, the couple realized that they needed to fund their trip from Colorado to New Mexico. They remembered meeting and talking with the owner of the Arrow Gallery in Aspen, a Mr. McMillan. They traveled to Aspen hoping to sell some jewelry, but realized that they would have to limit their sales to have inventory for Indian Market. They also realized that the $3 wholesale price they would get for a $6 bracelet would not earn them the amount of money needed for their trip. They decided to double the retail price of the bracelets to $12. They showed McMillan all of their jewelry but told

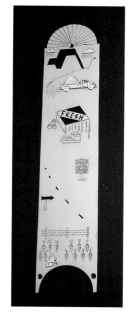

3. Panel for a door, brass and silver, early 1980s, 14.5 x 3 inches. Kate Massee Tremper Collection. This panel was made for a restaurant door at Massee's, a catering business owned and managed by Kate Massee Tremper in Santa Fe in the early 1980s. As on the reverse of their buckles or in their thematic belts, Johnson and Bird tell a story in this panel with images of carrots growing, a bunny in a field of carrots, and a truck driving to market.

him that they could only sell him a small amount at that time. McMillan agreed to purchase their limit, about $48 worth of jewelry, and indicated his interest in purchasing a belt similar to the one he was shown, whenever it was available. Johnson entered a brass belt with cabochons of red jaspers in Indian Market and received a second-place award. Bird and Johnson shared a booth with Charlie Bird and their jewelry sold well. With their proceeds, the couple repaid their bank loan. The following year, they borrowed $500 from the same bank, purchased more materials,

Johnson at his workbench in his studio, 1981.
Photograph by John Adair. John Adair Collection
at the Wheelwright Museum of the American
Indian.

sold more jewelry at Indian Market, and again repaid their bank loan. In the fall of 1975 Johnson and Bird felt that they had taken the classes they wanted at the University of Colorado. Bird wished to return to Berkeley, and Johnson was interested in art classes offered at the California College of Arts and Crafts. It had been almost ten years since Bird had attended Berkeley, so she had to reapply for admission and Johnson had to apply to CCAC. Bird was accepted at Berkeley and Johnson at the California College of Arts and Crafts for spring term 1976. They arrived in New Mexico on December 23, 1975, with the understanding that they would visit briefly and then travel to California so that Johnson could begin class on January 2. Both Johnson and Bird had severe colds, and according to Bird, "We just looked at each other on January 1 and knew that it was not going to happen" (conversations and interviews with Gail Bird and Yazzie Johnson June 2004–July 2006 herein undocumented). They decided to delay college attendance in California until the following fall. Events would defer that move.

Apart from the two-week course Johnson took in California in 1969, and an advanced jewelry course at Utah State, where he learned wax casting and forming, he learned most jewelry-making techniques by studying jewelry and photographs and reading descriptions in John Adair's book *The Navajo and Pueblo Silversmiths* (1944) and by experimenting. According to Johnson, "We met John Adair in 1977. He was planning a sequel to his classic work and had begun a series of visits to the Southwest, meeting and interviewing prospective subjects. John visited our home and studio many times over a several-year period, photographing and talking to us. I told John that I had learned about and tried techniques, specifically tufa casting, after reading his book and used it as a valued source of information." Adair, who had continued his interest in jewelry, had talked with Johnson and Bird at Indian Market in Santa Fe and was interviewing and photographing several jewelers. Over the next few years, he visited Johnson and Bird several times.

Johnson began working with brass and copper, as had the early metalsmiths, because those metals had properties similar to silver, but were less expensive. In addition to Johnson and Bird's interest in southwestern history, and the early jewelers of the region, they also had a fascination with stones. The couple took advan-

tage of living in an area with a diverse topography and a rich cultural heritage by exploring the land formations and indigenous rocks of New Mexico and Arizona.

In the Four Corners area of the Southwest, petroglyphs offer a pictorial history of ancestral Pueblo and early Navajo culture on tall cliff walls and huge boulders. As both a visual record of former lives and an early art form, these carved or painted images provide a glimpse of life in the distant past. Johnson and Bird photographed petroglyphs at the sites they visited, and Johnson made sketches in small

4. Fabricated brass bracelets, 1972–76, .25 to 1 inch wide. The bracelet on the right was purchased at Eight Northern Pueblos market; the center bracelet was the earliest style made. The wire bracelet and the wide band bracelet are not signed. The other bracelet has a Y hallmark. Private Collection.

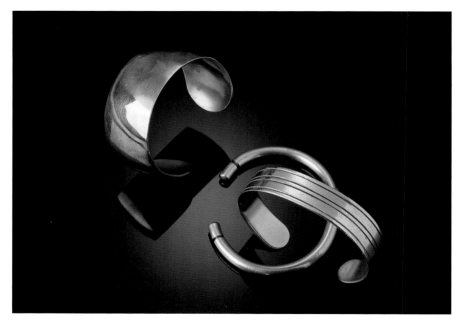

notebooks. They also studied the rich tradition of shell and stone jewelry that is centuries old and American Indian metalwork, which has a 150-year history in the Southwest.

Using hammers, an anvil, and a few other tools, Johnson developed his jewelry-making skills and also made his own tools by studying old books. He made and continues to make his own stamps. His first bracelet was a flat 14-gauge brass piece

with four grooves filed for the design. Johnson purchased a stamp with a "Y" to use as a hallmark and began marking his work around 1973. Another style of brass bracelet Johnson made from 1972 to 1976 was of wire with two grooves filed at each end. From 1972 to the late 1970s, he also made undecorated wide domed brass cuffs. Johnson worked with brass from 1972 until the mid-1980s (figure 4).

Adair's book provided information about making tools for metalworking. Johnson purchased steel to make tools from a shop in northern New Mexico, but he found most of his tools at flea markets and yard sales. In the late 1970s, Johnson bought a selection of jeweler's tools, including approximately two dozen hammers, a rolling mill, and forming stakes, from the studio of the late Boris Gilbertson, a Santa Fe artist and friend of Allan Houser. Houser's son, Robert Haozous, called Johnson after seeing the number of jeweler's tools from Gilbertson's vast collection. It was an early and fortuitous purchase. Johnson used the rolling mill for many years until he could afford a newer model, then passed the old one on to a younger jeweler. He still uses the hammer and stakes.

From the beginning, Johnson and Bird collaborated by planning together and choosing the materials for the jewelry that Johnson was making. They began to use red jasper because it was a natural stone native to the area; it had density and richness and was inexpensive. Johnson began to use red brass in addition to yellow brass and silver because the couple liked the way it looked with red jasper and other stones. Bird and Johnson sought stones for their color and natural beauty. In the 1970s, they purchased stones at rock shops and looked for markings or inclusions in the stones. They chose calibrated jaspers and bloodstones because of the colors. According to Bird, "What we liked about brass was that you could combine it with turquoise or red jasper. It has always been the way the colors work together that means more to us than using precious materials."

Bird and Johnson were not the only Native jewelers using brass at this time. They were familiar with Santo Domingo jeweler Tony Aguilar, who decided to work in brass after seeing the gold-colored brass jewelry worn in Tunisia and Morocco when he served in the army during World War II. Another jeweler from

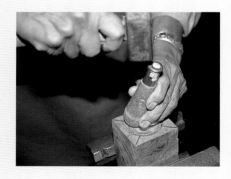

CONCHOS

Johnson ground and polished the rounded end of a railroad bolt to form a stake. He used it to pound and shape various-sized round and oval depressions in a block or stump of wood. This block, with its depressions, serves as the form for conchos. Johnson cuts a flat oval or round concho out of metal and places it over the corresponding depression. He places the curved end of the metal railroad bolt or curved hardwood dowel over the metal, and hammers and pounds the flat end to make the concho conform to the curved depression in the wood.

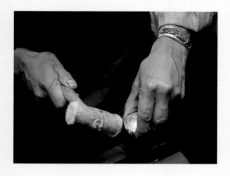

New Mexico working in brass in the early 1970s was Felix Chama from Cochiti Pueblo. Those jewelers, however, combined brass with turquoise, unlike Johnson and Bird, who distinguished their brass jewelry through the use of unusual stones.

In 1977 Johnson and Bird agreed to take part in an arts fair held in Kansas City at the Nelson-Atkins Museum in conjunction with the exhibit "Sacred Circles." Along with Bird's brother, Harold Littlebird, they participated in the arts fair to see the exhibit. Because the show was on a weekend and the museum was closed on Mondays, the artists had limited time, if any, to see the exhibit. According to Bird, the fair organizers "hadn't thought that artists would want to see it. We convinced them and they opened the gallery early and invited all of the artists to attend. We had to rush through, but it was worth it." Opportunities like this to see examples of American Indian art were of great value to Johnson and Bird, who had been studying primarily through books. This was the first time Johnson and Bird had seen American Indian art displayed as fine art rather than as cultural groupings in natural history or anthropology exhibits. Just seeing great American Indian art was important to Johnson and Bird, but seeing it displayed in a fine arts museum made an indelible impression.

The collaboration between Johnson and Bird was casual at first. According to Bird, "For a couple of years we just used Yazzie's name, because he did all the fabrication, although we discussed objectives, selected materials, and made design decisions together." In 1977, while she was recovering from a medical procedure, Yazzie gave Gail a sketchpad and asked for her help in designing jewelry for a show at the Potcarrier in Burlingame, California, scheduled for December. "I was sick in bed for quite a while and couldn't do anything," Bird recalls, "and a show was coming up. Yazzie walked in one day with a sketchbook and a big box of stones, saying, 'since you're just watching television and as long as I have to make coffee, the least you could do . . .' and that started my design work." [4]

Bird, who has always thought of herself as someone who cannot draw, began to make rough sketches of jewelry designs on large sheets of drawing paper. She described this process to John Adair in a 1981 interview, "So I just started drawing

things. The designs worked out really well. We had a good first show here. And from that time on I started to help more and more with the design work. And for a long time I didn't want to do any of the actual silver work because I felt we should maintain two separate things." [5] Their collaboration intensified as Bird began to work more with Johnson on the design and execution of jewelry. She said, "Our big interest in jewelry has always been [in the] traditional. We [also] wanted to do

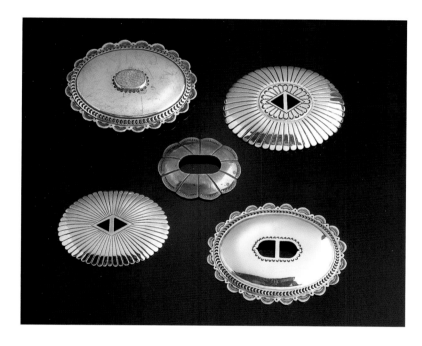

5. Conchos of silver, brass, and copper, buckle of turquoise and silver, early to late 1970s, 2 x 2.5 inches to 3 x 3.625 inches. Hallmarks are Y except the copper concho, which is unsigned. The copper concho was the prototype for the first silver concho belt Johnson made. Joanne Lyon Collection and Private Collection.

something that was not just like everyone else's. We were using unusual stones and that influenced how we would work with the materials. That simplified it and then when I started to help Yazzie, just the interaction of our ideas was changing the whole thing. But we always tell people our work is basically traditional. The techniques are what count." [6]

During this period, Martha Struever (then Cusick) came to visit the couple at their home to discuss selling their jewelry in Chicago. One of the first dealers to

handle their jewelry, she liked their work in brass as well as in silver. Her background was in fashion retail. She was living in the small town of Munster, Indiana, when she saw jewelry by Hopi artist Charles Loloma in a 1972 issue of *Arizona Highways,* a publication that Struever credits as having "a tremendous influence on collectors, dealers and scholars throughout the U.S. in the 1970s." She met Charles Loloma in 1975 when she was beginning to sell Native American jewelry. She has

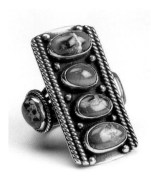

6. Cerrillos turquoise and brass ring, 1978. Johnson hand-twisted the wire and appliquéd it to the ring for decoration. Private Collection.

described Loloma as an entrepreneur who encouraged her to open a gallery in Chicago, which he saw as a good market for his jewelry. Struever opened the Indian Tree Gallery in 1976.[7]

When she met with Johnson in the fall of 1977, Struever was taken by the fact that Johnson and Bird's jewelry was unlike any she had seen before. She purchased $700–$800 of their jewelry on the day of the meeting. Years later, Bird would tell her that it had been their largest single sale to date. Upon her return to Chicago, Struever's belief in the appeal of Bird and Johnson's jewelry was confirmed; it sold quickly because of the designs and interesting use of stones. She also sold brass and silver bracelets with clean, chiseled lines.[8] Struever offered Bird and Johnson their first gallery show, which opened in October 1978 in Chicago. She exhibited primarily rings in silver and 14k gold and other small items as well as the pottery of Bird's brother, Harold Littlebird. They had not yet made their first necklace. Johnson and Bird had annual shows at the Indian Tree until it closed in 1983 and continue to sell jewelry to Struever as well as work with her on different projects that pertain to jewelry in the Southwest. They participated in the educational seminars she prepared for Crow Canyon Archaeological Center, and she handles their work privately.

Around 1978 Bird and Johnson met Ray and Judy Dewey at Santa Fe Indian Market. That meeting led not only to a business relationship but also a close friendship. Judy immediately recognized the unusual characteristics of their

work and recalls being attracted to it because of the brass and the variety of stones. She stated, "Their jewelry has always been unique and had a wonderful quality about it. The stones would remind them of something and they would relate it to the piece."[9]

In their early work, if Johnson and Bird included stones in conchos and buckles, they were small and in proportion to the size of the metalwork. By the late 1970s, they began to use picture jaspers because the stones reminded them of the New Mexico landscape. They found good-quality jaspers and agates that were cut larger and began to place them in buckles. With the inclusion of larger stones and Bird's more active involvement in the design, their jewelry dramatically changed in style. They found the stones to be so exciting that they wanted to emphasize their characteristics. The larger picture jaspers became the focus of the buckles, and in an effort to simplify the overall design, they placed metalwork designs on the reverse side of the buckles, a technique they refer to as "underlay." (Picture jasper is a general term given to stones from Washington, Oregon, and Idaho that have pictorial patterns reminiscent of landscape settings. Deschutes, Biggs, Rocky Butte, Owyhee, Owyhee Junction, Wild Horse, and morrisonite are examples of picture jaspers. The terms "picture jasper" and "jasper" are used interchangeably throughout the text when referencing these stones.) Johnson continued to make the more traditional buckles, belts, and conchos as well, but increasingly Bird and Johnson shifted away from the traditional forms and toward buckles that featured the stones (figure 7).

Johnson and Bird used similar design concepts in the earrings that they made at the time. The first earrings, often simple drops with a silver loop that passed through the ear, had turquoise, coral, or red jasper set in silver sometimes with hand-hammered silver pieces that dangled below. As with the buckles, the earrings became larger with the incorporation of picture jaspers and other stones, and the amount of visible silver on the earrings was noticeably reduced. Even in the early earrings, Bird and Johnson had not felt bound to have pairs of equal-sized stones. Several pairs made in the late 1970s were of different widths or lengths

PULLED WIRE

Johnson pulls 16-gauge silver or gold wire through a drawplate to make it thinner and stronger for use as earring loops or to twist and appliqué as a surface decoration, as in figure 6. The drawplate allows Johnson to buy one gauge (or thickness) of wire and pull it to make different gauges for various needs. Johnson begins by filing the wire to a point and positions it in the drawplate. He uses his feet as leverage and pulls the wire several times through successively smaller-diameter holes to achieve the desired size. Southwestern American Indian jewelers have used this process for more than a century. However, the use of the rolling chair adds a twentieth-century touch.

(figure 8). At times, Johnson extended the silver to give the appearance of the same size. Judy and Ray Dewey took note of and appreciated the design concepts in the unmatched earring pairs. According to Judy Dewey, "At a glance, they looked the same but they were not exactly the same." [10] In later work, Bird and Johnson would design earring pairs with noticeable differences in lengths and stones.

Yazzie Johnson and Gail Bird completed their first thematic belt in 1979, after they were invited to be in the initial exhibit, "One Space, Three Visions," at the newly constructed Albuquerque Museum. They were asked to make a concho belt based on their single stone picture jasper buckles. According to Bird, "We told the curator finding ten jaspers identical in size and picture was impossible, and the prospect was boring, but we would make something." They chose to use a variety of stones, primarily picture jaspers, and the overlay technique on the back of the buckle to set the theme for the imagery on the face of the conchos. They executed designs in overlay, stamp work, and appliqué. Titled "Before the Hunt," it was the first of more than forty-six thematic belts that the couple would create through 2005. This was the first time that any American Indian jeweler combined diverse stones and metals in nonmatching concho combinations (figure 9).

The second belt, completed in August 1979, continued the theme of the first so they titled it "After the Hunt." "The first two belts were hunting belts," said Bird. "We first started to use jaspers and tried to use imagery that went with those stones. A natural association seemed to be with animals in their habitats. Picture jaspers for us looked like the landscapes in New Mexico. We wanted to use imagery that reflected the landscapes. The first belt has a Mimbres figure on the reverse of the buckle with a bow in one hand and things coming out of his mouth because he is praying before the hunt. It is about what he sees and what sees him. Animals are aware of him in their environment. This is very simple imagery. The second belt shows the figure after the hunt with the deer over his shoulder on the back of the buckle. The belt is about his journey and shows what the hunter saw and his inter-relationship with the landscape. The walking of the animals becomes a measure of time. Some, like hawks, are flying both in daytime and nighttime (figure 10)."

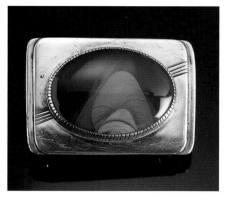 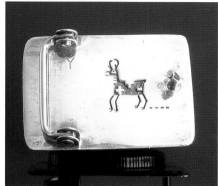

7. Bruneau jasper and silver buckle, 1982, 1.5 x 2 inches. In this early buckle, the silver and jasper share the design field equally. In later buckles, the silver surface is reduced and the stone is emphasized. The buckle reverse is an antelope with a textile design within the body surrounded by stars in silver overlay. HMC Collection.

8. Clockwise from top: Rocky Butte jasper, brass, and silver earrings, no hallmark. Lace agate and silver earrings, Y hallmark. Brazilian agate and silver drop earrings. Serpentine and brass earrings, Y hallmark, all from the late 1970s. Private Collection and Martha H. Struever Collection.

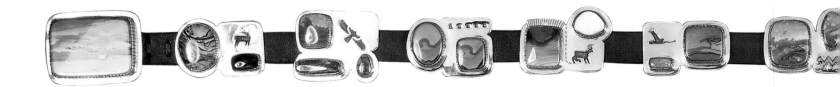

When they first started making the belts, they used silver and yellow brass and incorporated small touches of 14k gold in bezels. They set some stones in silver bezels, others in brass, and small stones in 14k gold to bring out the colors of the stones. In the early belts, Johnson sawed lines on the bezels and varied the spacing of them. These extra details took a lot of time to complete but added another dimension to the overall look of the belts. In 1979, they began to use 14k gold for bezels to accomplish the same effect of brass with select stones. When they made the first thematic belt, Bird and Johnson were looking at pictures of petroglyphs in books. They also started to sketch and photograph petroglyphs on the hills near the Chama River as well as in the Three Rivers area near Alamogordo. Many of the images on the reverse sides of the buckles and some on the individual conchos in the early belts are from petroglyphs. Johnson keeps small notebooks in which he sketches petroglyphs and pottery designs as well as jewelry ideas.

The first two belts share a theme as well as other features that characterized the belts for several years. The last conchos of the early belts have the same wedge shape and include two stones and designs of groups of five or six sandhill cranes. Johnson and Bird chose this image because the cranes fly over their house twice a year during seasonal migrations. The design or shape of the last concho began to gradually evolve. In the 1982 "Pottery Maker Belt" (figure 29) they used a bird design from Hopi pottery rather than sandhill cranes on the last concho, and the following belt, the "Basket Belt" (figure 30), had a design of basketry plaiting rather than birds. For the next belt, the 1984 "Mimbres Black and White Belt" (figure 32), Johnson and Bird included an image of a duck. They continued to make the last concho a wedge shape through 1985 (figure 33). They began to stylize the last concho in the "Constellation Belt" (figure 37) in December 1985 so that it still resembled the shape of the last concho of the early belts. They changed the number of stones on the last concho from two to one in the 1985 "Birthday Belt" (figure 36), which also had smaller conchos because it was customized for the size

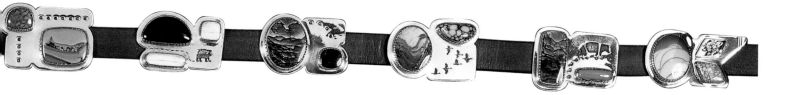

9. "Before the Hunt," January 1979

of the wearer. Another feature the belts share is the inclusion of at least one animal design. All backs of the buckles are decorated in overlay, or as the artists describe it, underlay, because it is on the underside. This design on the reverse of the buckle reveals the theme of the belt. Each belt also refers to the theme of the prior belt in some way.

"After the Hunt" was the first belt shown at Indian Market in Santa Fe in 1979. It was submitted for judging but removed by the officials because it did not fit any defined jewelry categories. Bird and Johnson were encouraged by SWAIA board member and judge Anita Da to talk to the judging committee about expanding the categories not just because of their own situation but also because other jewelers were creating new and exciting nontraditional items that did not fit into existing categories. They met with SWAIA officials Don Owen and Marianne Kapoun, and two new divisions were added. Owen asked Bird to help with the proper placement of the next year's Indian Market entries, and she agreed. To address the problem of inconsistent practices, Bird was asked to organize the volunteer receivers the following year, at which time she trained them about the differences in divisions and categories in each classification, as well as how to handle art and talk to artists submitting entries. This marked the beginning of Gail Bird's more than twenty years of volunteer work with SWAIA.

Bird had been sewing since she was ten years old, and made velvet shirts and ribbon shirts that she sold at the Eight Northern Pueblos Show. Johnson made the silver buttons for the shirts. Bird began to make fabric sleeves or cases, initially of velveteen with ribbon trim and later silk with ikat patterns, to hold each thematic belt. Every year she selected a different fabric to make the belt sleeves and pouches for the smaller items they sold at Indian Market. Bird also made a few silver bead necklaces in the late 1970s after Johnson showed her some of the techniques. "I think it was in 1980," Bird recalls. "We had planned so many things for Indian Market; we had the silver and we had all of the materials ready, and we were plan-

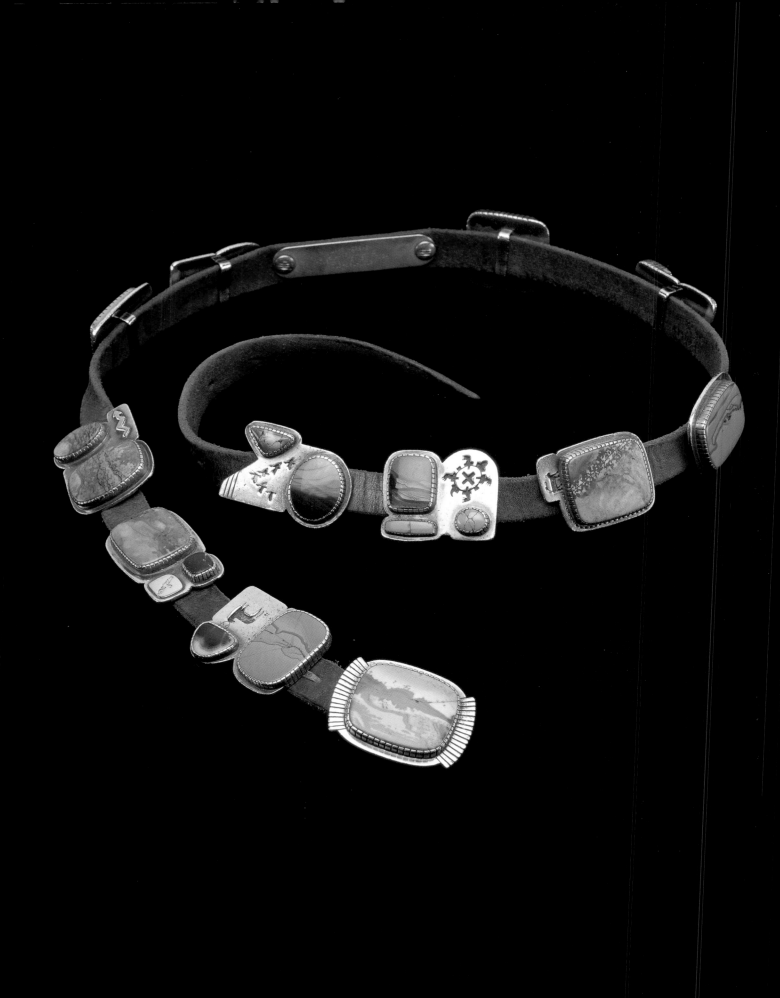

DEVELOPING AN INDIVIDUALISTIC STYLE

ning on making beads for Indian Market. I had gone ahead and done all of the pre-liminary work, the cutting out of the silver, the doming and drilling. All that remained to be done was the soldering. At that point Yazzie just didn't have any time. He said, 'You've got to do it.' So he showed me how to solder. I made the beads and polished them. It took me two weeks to do what he could do in three days. But they came out really nice. Then he talked me into entering them. I didn't want to because I felt that was really presumptuous, here it was my first beads. But he entered them for me under my name. And we were really surprised. I got a sec-ond [prize] for them."[11]

Johnson and Bird completed their third thematic belt in February 1980 as a commission for New York art dealer Joachim Jean Aberbach. In developing a theme for the commissioned work, they thought the belt should be about the cre-ation of art, since Aberbach's career was directly connected to the promotion of art. They produced the "Petroglyph Maker Belt," in which the reverse of the buckle is underlaid with a stylized male Mimbres figure drawing petroglyphs on a wall (figure 11). Johnson used a nail to punch in the design to replicate the pecked style of petroglyphs. He also carved one of the coral pieces used in the belt, referring to sculpture that Aberbach represented.

The year 1980 was significant for Johnson and Bird in many regards. They established working relationships with two galleries and three individuals that would last for many years. They also applied for a SWAIA fellowship under a pro-gram recently developed by the SWAIA board president Ramona Sakiestewa and board member Art Wolf, who was then director of the Millicent Rogers Museum in Taos. In addition to two slides of the "Petroglyph Maker Belt," Johnson and Bird submitted slides of a garnet and fossil bone necklace with eohippus teeth clasps, a stamped silver bracelet with three Indian Mountain turquoise set in gold bezels, and fronts and backs of four pendants. A single pendant was made for John Adair, according to Johnson, "John asked me to set a Japanese river stone for his wife Casey. I set it in a double-sided pendant, and later used the image in the applica-tion for the SWAIA fellowship."

10. "After the Hunt," August 1979. This was the first belt shown at Indian Market in Santa Fe. It uses the same Mimbres-style male figure on the reverse of the buckle and follows the theme of the first belt. On the reverse of the buckle, the hunter carries a deer over his shoulders. The belt was entered for judging at Indian Market, but was not judged because it did not fit in any category. It has jaspers and agates, silver, brass, and gold. Photograph by George Hixson. Private Collection

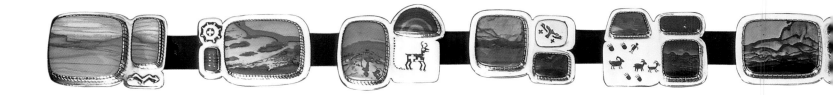

This was the first year the fellowships were offered, and the SWAIA officials were still deciding if they would award $1,000 to five artists or $2,500 to two. They decided to give five fellowships. Johnson and Bird are the only fellowship recipients who won the Best of Show Award at Indian Market the year after they received the fellowship. The other recipients of these first SWAIA fellowships were Norbert Peshlakai, also for jewelry, Karita Coffey for ceramics, and Harry Fonseca and David Bradley for painting. Bird and Johnson shared the $1,000 award as collaborative artists and used the money to buy supplies and tools.

At Indian Market in August 1979, Joanne Lyon of Aspen approached them about buying their thematic belt. Preferring not to sell to a gallery, they waited to sell to an individual. Lyon, whose business partner in the Aspen gallery was Lee Cohen of Gallery 10 in Scottsdale, was interested in having their jewelry in her gallery. Lyon knew their work from seeing it in Santa Fe, and she had met Johnson and Bird in the mid-1970s when they attended the University of Colorado. They crossed paths at Robert Musser's shop in Boulder where he sold Native American artwork. Lyon had a specialized knowledge of jewelry because of her father's jewelry businesses in Denver and Pueblo, Colorado, and in Albuquerque. "I grew up in the jewelry business," Lyon said, "and Gail and Yazzie were doing fine jewelry with extraordinary attention to detail and workmanship."[12]

In the fall of 1979, while on a trip to Colorado, Bird and Johnson decided to visit Aspen to look at Lyon's gallery. They found Joanne and her husband Lee Lyon to be exceptionally gracious and knowledgeable and agreed to have their jewelry in the gallery. Their first show in December 1980 began a long business relationship and friendship.

Although it began as a gallery of Native American art, the focus changed when Lyon bought her partner Lee Cohen's share of the business. It became an

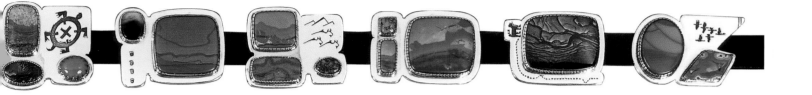

eclectic mixture of Native American art, including work by Santa Clara potter Jody Folwell and Luiseno painter Fritz Scholder, but also of nineteenth- and twentieth-century American paintings, contemporary art including Andy Warhol, and glass art including Dale Chihuly. Bird and Johnson's jewelry was well received from the beginning, and the Aspen location provided an international clientele.[13]

In 1980 the relationship between Johnson and Bird and Ray and Judy Dewey of Santa Fe grew stronger. When the two couples met, the artists were selling jewelry to two small shops in Santa Fe, and they were loyal to those establishments. But the shops were not interested in the choice of materials or the new direction in Johnson and Bird's work, which led to a cordial dissolution of both business associations. This gave the Deweys the opportunity to show Johnson and Bird's work.

The Dewey-Kofron Gallery was on East Palace Avenue and later on East San Francisco Street. In July 1980, Johnson and Bird's first show opened at the gallery, although they had sold individual items prior to that. It was called "Shared Images" to reflect, according to Judy Dewey, the "coming together of their ideas." Judy stated, "Yazzie had done work early on and Gail became a major factor in the design. They are seamless together." Ray Dewey recalls, "They had such high integrity from the beginning, never compromising in their goal to do beautiful work all of the time. The more we learned about their work, the more we realized how much depth they had. There was more to their work than first met the eye. People are drawn to beautiful jewelry and then sometimes when they meet the artist, they can be disillusioned. But with Gail and Yazzie, there is depth to their work and to them."[14]

The announcement for this show featured a silver, 14k gold, and Rocky Butte jasper buckle (bottom image, figure 12). Ray Dewey referred to it as a "breakthrough" piece. As with the earrings that incorporated different shapes of stones,

11. "Petroglyph Maker Belt," February 1980

Johnson placed stones of different sizes in the two-piece buckle. At first glance, the stones appear to be the same size, but upon closer examination, one is notice- ably smaller. The forged 14k gold design appliquéd to silver below the smaller stone in the buckle provides balance, while making the overall design more visually intriguing.

The use of materials and designs distinguished Johnson and Bird's jewelry from the work of others. Judy Dewey stated, "They had great stones and they kept some for a long time. No one else was using stones that way. They were unique in the materials that they used and they had a high level of creativity."[15] As in the buckle on the announcement, Johnson and Bird often used Rocky Butte jasper

OVERLAY

Johnson and Bird's buckles have several parts: the stone, the bezel to hold the stone, and for the reverse side, a design in silver overlay. To make silver overlay, the artists use two sheets of varying thicknesses of metal. Johnson cuts a design out of a heav- ier sheet of silver. On the lighter sheet, he often textures the corresponding negative space with rocker engraving instead of the more usual stamp work. Then the two pieces are soldered together. The negative space is often oxidized to darken it and to accentu- ate the depth of the design.

Johnson and Bird refer to the overlay technique as underlay when it is used on the reverse of stones in buckles or clasps. In the late 1970s and early 1980s, Johnson used overlay as an accent on the front of some items. Now they use it only on their thematic belts.

The ideas for the overlay designs come from wide sources of inspiration, including details from Impressionist paintings, Asian tapestries and metal- work, American quilts, and everyday objects like the rusted keyhole Johnson saw in a taxicab in New York that looked like a bird to him. Most notable are the images adapted from petro- glyphs, prehistoric and historic Indian arts, and nature. Many of the images come from photographs or books, but countless others are images that Johnson

sketches in small notebooks, which he always carries. After choosing a design from among hundreds of sketches, Johnson draws it to the actual size it will be on the buckle, clasp, earrings, pen- dant, or other jewelry. He then makes a drawing on tracing paper. He attaches the tracing paper to the silver plate with rubber cement, then pierces and saws out the design. When he first began to make overlay, he drew directly on the silver in ink, but changed the process because the ink smeared.

comanche gap - galisteo

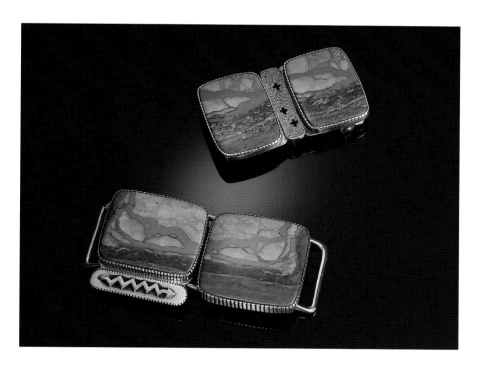

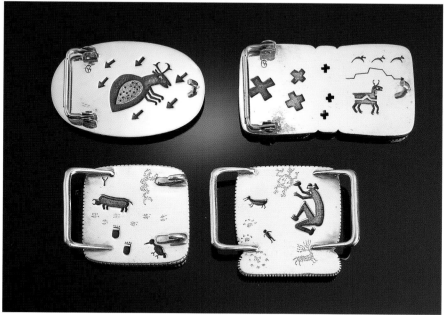

12. Top: Buckle of Rocky Butte jasper and tufa-cast silver with stars accomplished by pierce work, 1980s, 1.5 x 2.825 inches. The design on the reverse in silver overlay is of a skyline of mesas and an antelope dreaming of three small antelope. JoAnn and Robert Balzer Collection. Bottom: Rocky Butte jasper and silver double buckle, 1980, 1.625 x 4 inches. This buckle contains several design aspects characteristic of Johnson and Bird's work. The stones are visually intriguing, as is the overlay design on the reverse. Perhaps more important, the stones are of different sizes; the artists achieve balance by the addition of an appliquéd design. This buckle was on the cover of the invitation to the opening of the "Shared Images" show at the Dewey-Kofron Gallery in Santa Fe held on Sunday, July 27, 1980. Ray and Judy Dewey Collection.

from Oregon because they liked the range of colors—yellows, greens, blues, and reds—and the way the stones reflected the land and sky. Bird observes, "Many stones have green for the earth and blues and yellows for the sky swirling and simulating the movement of air."

Johnson and Bird also created their first necklace with satellites, or small bezel-set stones that are inserted in the bead strands, for this show at Dewey-Kofron Gallery. It was a trade bead necklace based on a South American *milagro* prototype. They cleaned old white heart beads—red glass beads with white interiors—and added stones of value, echoing the look of the prototype. The original *milagros,* special tokens or amulets often in the form of arms, legs, hearts, and other body parts, represented prayers for health and fortune. Johnson and Bird used the white heart beads because they were the most common beads traded to Native people throughout the world. Many cultures used them as the base of a necklace and added special tokens, amulets, or *milagros.* Johnson and Bird wanted to emulate the look rather than the symbolic intent. Johnson soldered silver tubes to the backs of the satellites in order to string them on the necklace (figure 13).

For the 1980 Santa Fe Indian Market, Johnson and Bird created their fourth belt, the "Birdwatcher Belt." For the second time, they entered a thematic belt for judging. This time the belt received several awards including first prize, Best of Division for Non-Traditional Jewelry, and the Otero Creative Excellence Award. Like earlier belts, the "Birdwatcher Belt" depicted a figure on the reverse of the buckle, included an appliquéd arrow on the buckle front, and showed a hawk spreading stars on one of the conchos. The belt also incorporated new design concepts. It was the first time that a silver overlay animal and the stone merged to make one design in one of the conchos of the belt. On the eleventh concho, a Mimbres-style bird stands on an egg that is formed of variscite (figure 14). The "Birdwatcher Belt" was also the first instance where tiny appliqués of 14k gold drops were used as accents. After this belt, Johnson began to make tiny additions to individual belt buckles. Bird has said of this process, "For each belt there was a point when we were developing new designs or using new materials. Something

13. *Milagro*-style necklace of glass beads, rutilated quartz, coral, Owyhee Junction jasper, white moonstone, carnelian, variscite, azurite, and silver, 1980, 26 inches long. This was the first trade-bead necklace Johnson and Bird made, and it was based on a South American *milagro* prototype. The clasps are silver. The satellites have tubes of silver soldered to the backs in order to string them on the necklace. The Y hallmark is visible on the reverse of the clasp. Wheelwright Museum of the American Indian Collection.

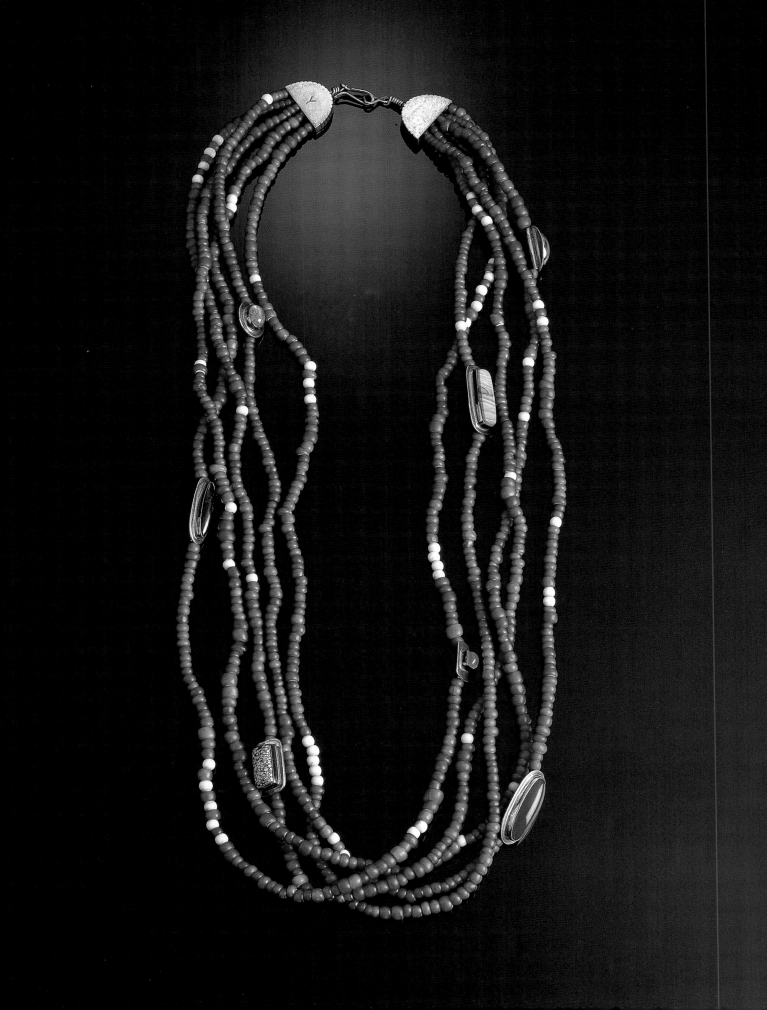

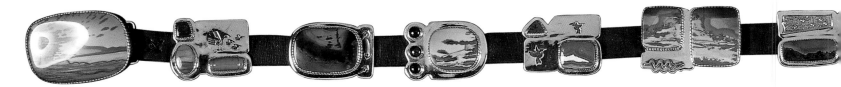

like a dot of gold was indicative of where we were going next. We had floated textile stars in the body of an animal before, but we had never used gold accents."

In early winter of 1981 Johnson and Bird traveled through the Southwest. They went to places along the San Juan River and Butler Wash in Utah, where they found layers of petroglyphs. They also looked at petroglyphs in northern New Mexico, northern Arizona, and southern Utah. This journey inspired the 1981 belt "Petroglyph Migration," the seventh thematic belt made by Johnson and Bird and their third entry at the Indian Market in Santa Fe. It won four prizes including a first-place ribbon, Best of Division for Non-Traditional Jewelry, Best of Classification in Jewelry, and Best of Show. They entered two other belts, both traditional silver concho belts, both of which also won awards. Saturday morning of Indian Market, Bird's brother, Charlie, picked up the belts for them at La Fonda Hotel, where they had been submitted for entry. He approached their booth with belts and ribbons to tell them of the awards. A collector followed Charlie Bird to the booth and bought all three belts.

In August 1981, the Official Indian Market Program ran a story about the fellowship winners. At that point, Johnson and Bird had made six belts in four years. They were living away from Santa Fe in northern New Mexico, and their home and garden were of great importance to them. Johnson is quoted in the program: "Separating ourselves from Santa Fe gives us the chance to be very selective with what we make and where and how we sell it. We're not interested in mass-producing saleable jewelry, and that, too, is hard to explain to people."[16] In October 1981, *The Indian Trader*, a Gallup monthly newspaper, reprinted an article about the recipients of the SWAIA fellowships. Bird was quoted as saying, "We use copper, brass, jaspers, and agates—materials that were used by the early Southwest jewelers. Our work is different. When we started in 1976 we decided not to do the fad-

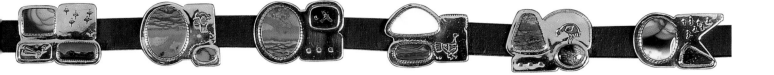

14. "Birdwatcher Belt," July 1980

dish turquoise and silver. We are combining traditional materials with our own personal style." Johnson stated, "For the first couple of years we had a hard time. At Indian Market and the Eight Northern Pueblos Show we could sell the work ourselves. But [outside the shows] traditional traders wouldn't carry it."[17]

Johnson and Bird began to develop other necklace styles in 1981. For the first time they used pearls, combining them initially with coral. They preferred freshwater Biwa pearls from Japan and made other necklace combinations with stone or glass beads. They were now buying stones from cutters rather than from gem shops and had established working relationships with cutters throughout the country. In addition to picture jaspers and pearls, their repertoire included garnets, moonstones, and amethyst. They had begun to use 14k gold to accentuate the stones in a manner similar to the way they had used brass.[18]

In 1982, the Native American Community Center in Soho wanted to feature the SWAIA fellowship winners, Johnson and Bird, Peshlakai, Coffey, Fonseca, and Bradley. Bird recalls, "The director Peter Jemison wanted to have exhibits that Native Americans living in an urban environment could connect to and appreciate." Of the fellowship winners, Johnson and Bird were the only ones who traveled to New York to attend the opening. They toured the city and its sights, and visited the Heye Foundation in Harlem (now the National Museum of the American Indian in the financial district in New York and at the Smithsonian in Washington, D. C.), the Metropolitan Museum of Art, the Guggenheim, and other museums. For the first time, apart from photographs in books, they saw major collections of artworks created by American Indians from the Northwest Coast at the American Museum of Natural History and the Heye Foundation. They also visited Washington for the first time, and went to various venues of the Smithsonian Institution. Impressions from this trip inspired the belt completed for the

"Shared Images II" show at the Dewey-Kofron Gallery in July 1982. In this "Traveling/New Directions/New Ideas Belt" (figure 28) the artists used Northwest Coast designs for the first time by depicting a loon on the seventh concho. They also incorporated on the first concho a design of a bird inspired by an African rattle they saw at the Metropolitan Museum of Art. On the second concho, they created a parrot design based on an Acoma jar they had seen in another museum. On the fifth concho, they designed a bird based on a shape Johnson had seen in the rusted keyhole of a moneybox in a New York taxi. This was the first time Bird and Johnson used designs that were not purely southwestern in origin, as reflected in the title of the belt.

For the 1982 Santa Fe Indian Market, Johnson and Bird created the "Pottery Maker Belt" (figure 29). According to Bird, "This was the tenth in the series and we decided since we had used so many pottery symbols, to do one based on pottery designs from all Pueblos. This was our way of saying thank you to great pottery makers who had created the designs and passed them on for centuries. This was important to people like us who had drawn on that legacy." All of the larger stones are Rocky Butte picture jaspers with patterns that look like yellow skies and rust-colored land formations. Johnson made saw marks on many of the conchos to further accentuate them. The San Ildefonso water serpent design on the third concho is similar to that on the "Traveling/New Directions" belt, and the small bird with the raised foot on the fourth concho is a variation on the other's second concho. "Pottery Maker Belt" won a first-place ribbon and Best of Division for Non-Traditional Jewelry. For the first time people waiting to purchase at Johnson and Bird's booth decided to begin a list according to order of arrival to help Johnson and Bird facilitate sales. A pottery collector began the list.

The events of the early 1980s marked a transition for Johnson and Bird's career. They had a clear vision of their jewelry, of how it fit with that of southwestern jewelers before them, and of the new directions they wanted to pursue. "Winning the fellowship for us was about growth and acceptance," Bird noted. "Winning the Best of Show was a complete surprise."

Interior of Johnson and Bird's home in New Mexico, 2004.

Bird's studio, 2004.

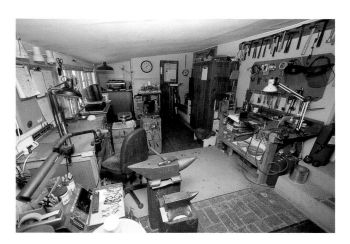

Johnson's studio, 2004.

15. From top: Brass and rainforest jasper buckle, c. 1975, 2.75 x 3.5 inches, Y hallmark. Richard H. Sweetman Collection. Brass and coral buckle, December 1976, 3-inch diameter, Y hallmark. Tony Reyna Indian Shop Collection. Brass and red jasper buckle, c. 1978, 2.25 x 3 inches. Martha H. Struever Collection. These represent some of Yazzie Johnson's earliest buckles.

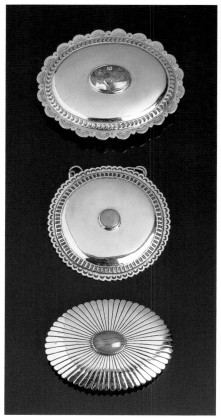

16. Brass hoop earrings, late 1970s, Y hallmark. Private Collection.

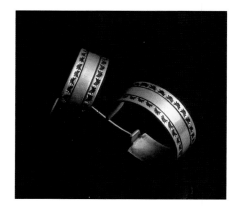

17. From left: Poppy jasper and brass ring, 1978. Mastodon ivory and silver ring, 1979. Serpentine and brass ring, 1978. All three rings have the early Y hallmark. Private Collection.

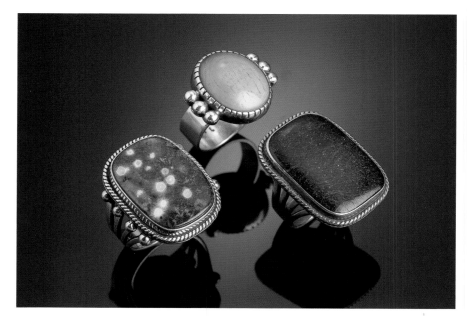

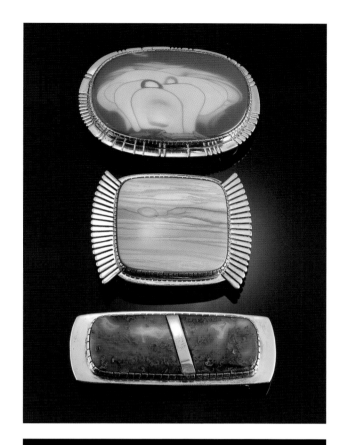

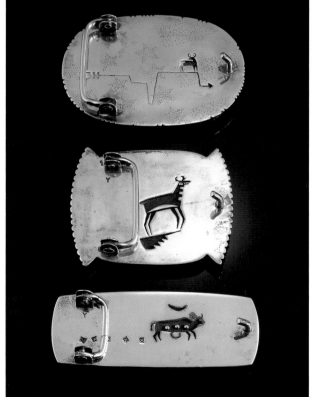

18. From top: Bruneau jasper, brass, and silver buckle, 2 x 2.75 inches. Owyhee Junction picture jasper, brass, and silver buckle, 2 x 2.25 inches. Texas plume agate and silver buckle, 1.125 x 3 inches. All buckles have a small Y hallmark and were made in the late 1970s/early 1980s. Charles Diker Collection. Reverse: Design of a deer standing on an arrow that forms a mesa top. The background is a design of awl-punched stars and stripes of the U.S. flag. Design of a Mimbres-style antelope with a 14k gold drop for an eye. Design of a buffalo from a Plains shield with tracks behind him and a waning moon overhead.

19. Clockwise from top left: Owyhee Junction jasper, silver, and gold buckle, 2 x 3 inches. Biggs jasper, silver, and gold buckle, 2.475 x 3 inches. Amethyst sage agate, silver, and gold buckle, 2.25 x 2.875 inches. Owyhee Junction jasper, Tyrone turquoise, silver, tufa-cast gold appliqué buckle, 2.25 x 2.25 inches, Y hallmark. JoAnn and Robert Balzer Collection. Buckles are late 1970s through 1990s. Reverse, clockwise from top left: Silver overlay of stars and a bighorn sheep with gold appliqué in the large star. The design is from a California basket. Silver overlay of a Mimbres-style elk and a fish. Silver overlay of a bird with gold appliqué and hand and star designs. The inspiration for this design is from a petroglyph near Albuquerque. Although the petroglyph includes a hand and star, Johnson added more of these elements to the pattern he created for the buckle. Silver overlay of a monkey on a plant from Timor surrounded by stars.

Opposite: 20. Five-strand 1920s Italian coral and Chinese white fossil bead necklace with coral clasp and satellites of fire agate, Laguna agate, coral, Bruneau jasper, Bisbee turquoise, Mexican opal, Chilean azurite, moonstone, silver, and 14k gold, 1981–82, 22 inches long. The backs of the clasps are underlaid with the logo of Martha Struever's Indian Tree Gallery in Chicago. Martha H. Struever Collection.

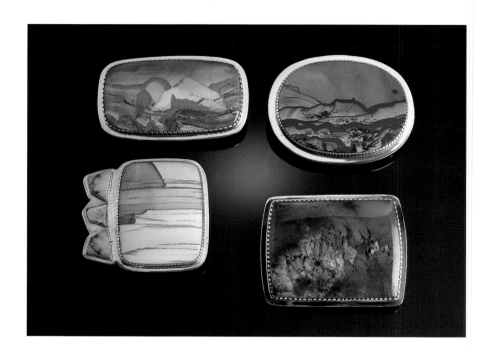

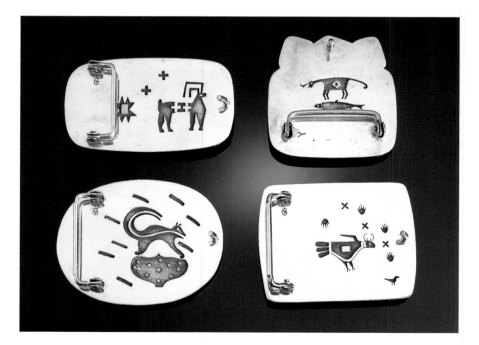

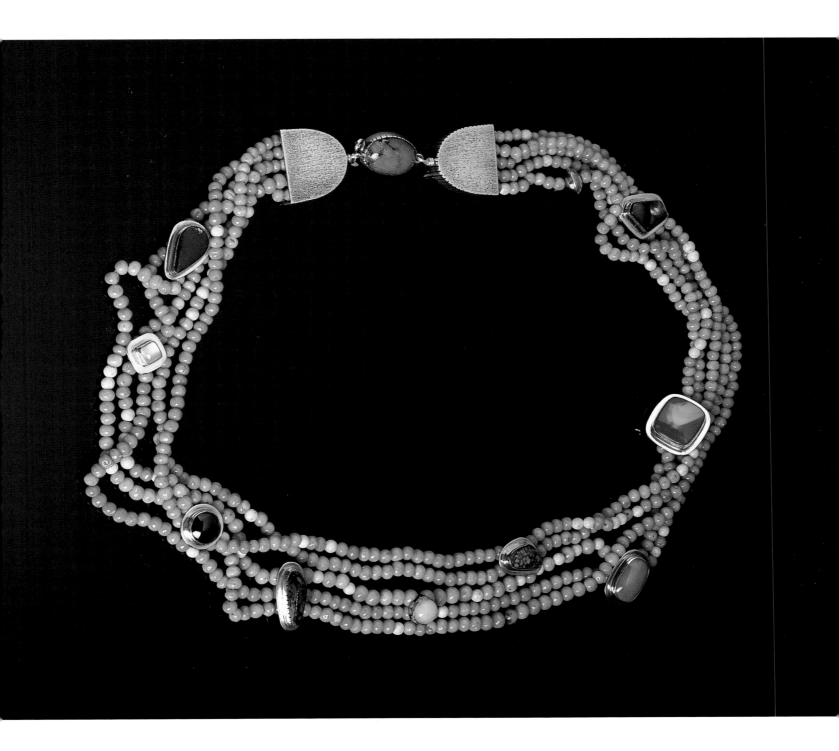

21. Clockwise from top: Laguna agate and silver pendant, 1979, 2.5 x 1.25 inches, Y hallmark. Coyomito agate and silver pin, 1983, 1 x 2.25 inches, Y hallmark. Red Mountain turquoise and silver pin, late 1970s, .75 x 1.5 inches, engraved "Yazzie Johnson Santa Fe." Variscite and silver pin, late 1970s, .75 x 2.5 inches, Y hallmark. Private Collection. The choice of stones and the shapes distinguish the Laguna agate and Coyomito agate pins from the work of other jewelers. Also unusual are the random stamp marks on the Coyomito agate pin. The shape and design of the variscite pin is similar to traditional Navajo silverwork, but the choice of stone is not typical. The turquoise pin features the natural shape of the stone, which is accented by drops of silver. Private Collections.

22. From left: Brazilian agate and silver ring, 1981, Y hallmark. Persian turquoise and silver cluster ring, 1980, Y hallmark. Martha H. Struever and private collection. These two rings look traditional, but the choice of the Brazilian agate distinguishes the work.

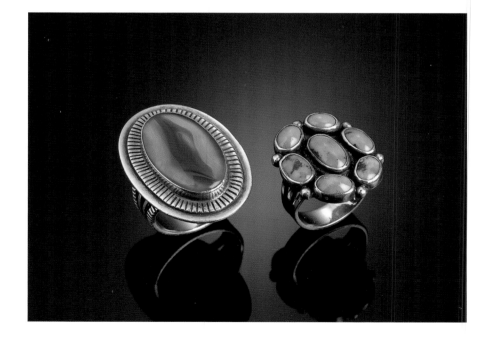

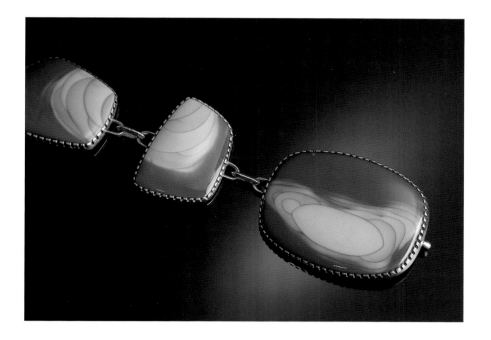

23. "Bruneau Clouds and Sandhill Cranes Belt," Bruneau jasper and silver, 1983, buckle 1.75 x 2.25 inches. This is the only metal-link belt Johnson and Bird have made. It has sixteen jaspers set in silver, five of which have sandhill cranes in silver overlay on the reverse. Purchased at Santa Fe Indian Market. Private Collection.

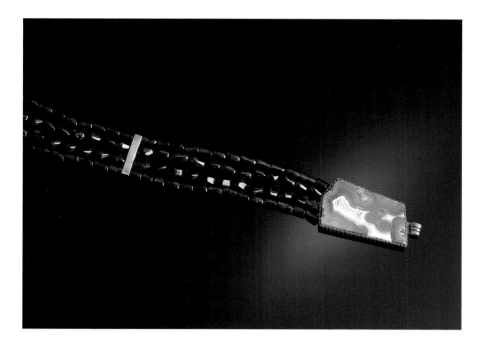

24. Garnet belt, Dryhead agate buckle with shaped garnet beads from India and silver bezel-set belt ends which include peach moonstone, Dryhead agate, garnet, and Holley Blue agate, 1984–86. The buckle reverse is a hawk spreading its wings and spreading stars, 1 x 2 inches. This was inspired by the style of the historic Plains German silver belts and was one of six garnet belts made by Johnson and Bird. Purchased by the Wheelwright Museum Friends in honor of curator Steve Rogers, Wheelwright Museum of the American Indian Collection.

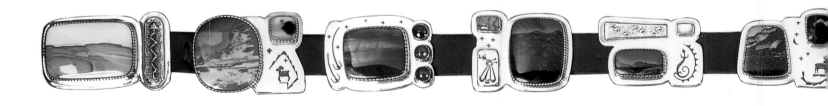

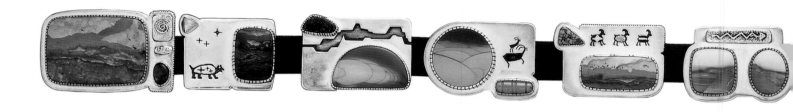

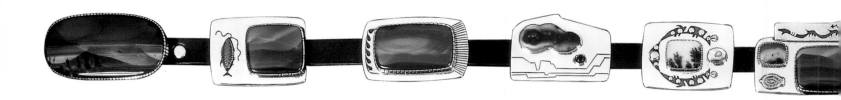

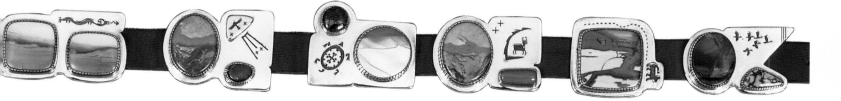

25. "Hawk Spreading Stars and Moon Over the Desert Belt," December 1980

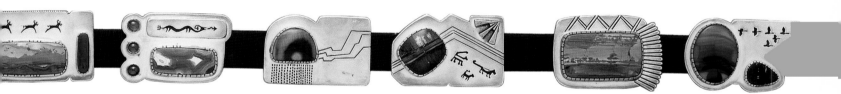

26. "Petroglyph Migration," August 1981

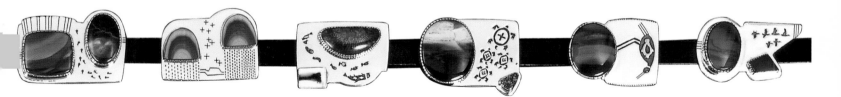

27. "Water Belt," October 1981

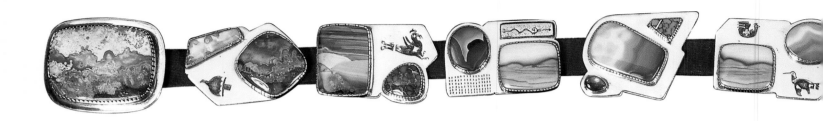

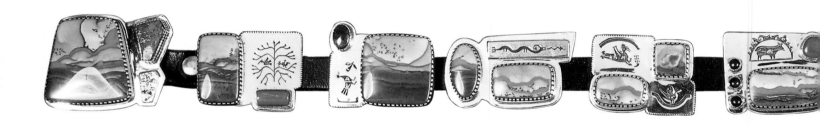

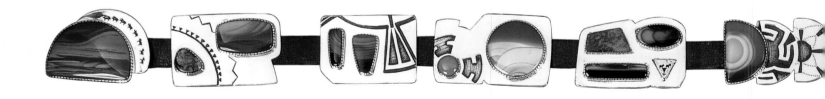

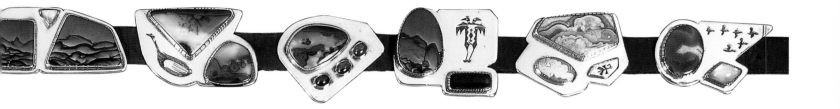

28. "Traveling/New Directions/New Ideas Belt," July 1982

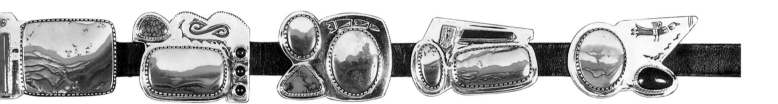

29. "Pottery Maker Belt," August 1982

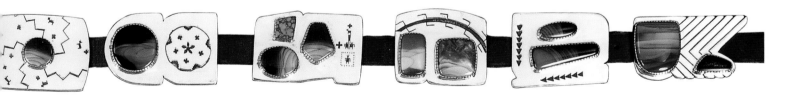

30. "Basket Belt," August 1983

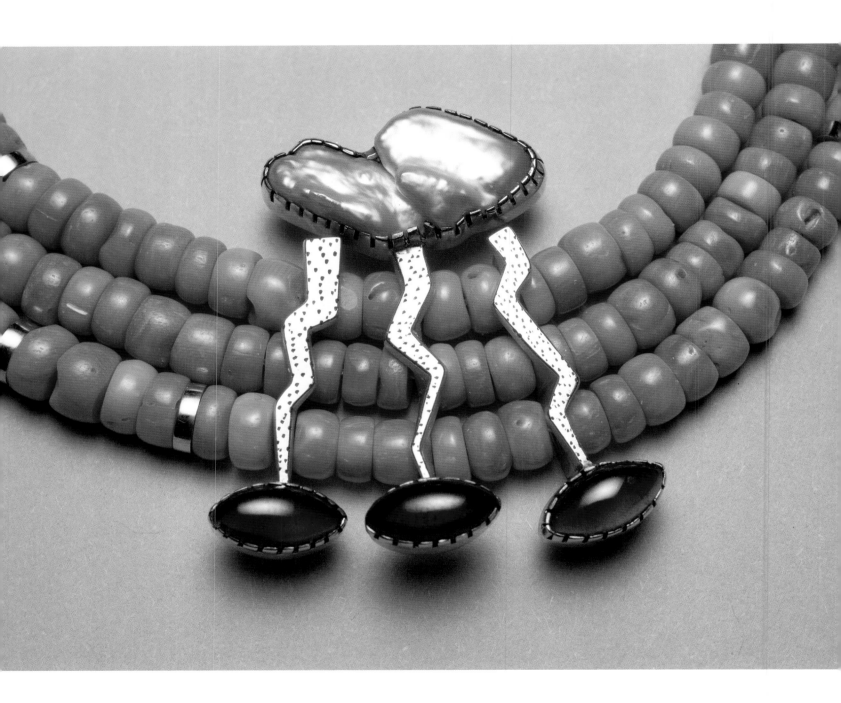

Creative Explorations

Y AZZIE JOHNSON AND GAIL BIRD distinguish their work from that of
other southwestern jewelers through the use of unusual stones, materi-
als, and designs. One of their predecessors, the Hopi entrepreneur
Charles Loloma, was a groundbreaker in the use of atypical materials such as lapis
lazuli, malachite, and fossilized ivory at a time when most Native American jewel-
ers used turquoise and silver. Along with Navajo jewelers who worked at the
White Hogan in Scottsdale, Arizona, including Kenneth Begay and Allan Kee,
Loloma also incorporated ironwood into his silver jewelry and service ware.

As with many art forms, innovation in southwestern jewelry often is met
with hesitation or resistance from its admirers. Like Johnson and Bird in 1979,
both Loloma and Begay initially had jewelry entries rejected at Indian art competi-
tions because they did not fit into traditional categories. Eventually, though, col-
lectors came to appreciate and seek out their work. When Loloma, Pala Mission
jeweler Larry Golsh, and others began to use gold in the 1970s, American Indian
jewelry was no longer solely made in silver. Loloma's work was inspirational for his
peers and for the younger generation of jewelers, Johnson and Bird among them.

Loloma began making jewelry in the 1950s, so by the early 1980s, when
Johnson and Bird were really defining their own style, Loloma was the master of

Detail (figure 35) of a three-strand coral necklace with 14k gold lightning design, 1987. Dale and Doug Anderson and Barrie Birge Collection.

the previous generation. His style was as clearly defined and distinctive as Johnson and Bird's would become during this decade. A generation older than Johnson and Bird, Loloma had a significant influence on their jewelry design, just as Johnson and Bird would for artists younger than they. Loloma featured complex stone inlay in primary colors—blue lapis lazuli, red coral, green malachite, purple sugilite—whereas Johnson and Bird emphasized the complexity of the patterns in

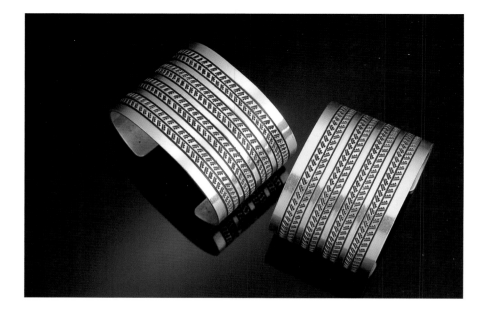

31. Stamped silver bracelets, 1992, 1.5 inches wide. Private Collection.

stones such as Biggs, Deschutes, Rocky Butte, and Bruneau jaspers and the compatibility of color combinations of varying stones. As Bird designed more complex belts, Johnson's metalsmithing skills also became more intricate. Johnson and Bird credit Loloma with inspiring the underlay designs on the reverse of the buckles they designed and created. Between 1962 and 1964, Loloma added stones to the interior of a ring he was making for a colleague and developed the "inner gems" concept that he would continue to refine.[1] Johnson and Bird adapted the concept, initially using silver overlay rather than stones on the reverse of buckles

and later on the reverse of necklace clasps and satellites and at times even on the reverse sides of earrings.

Innovations in the thematic belts resulted in changes in other types of jewelry as well. In the first belts, the metal served as a platform for the designs. Rectangular plates of silver were the background for a stone. At times, the stone covered the entire surface of the silver, but more often it was accompanied by a design; sometimes one design united two stones. The designs were somewhat static, although the stones Johnson and Bird selected for the buckles and for many of the conchos on the thematic belts were very dramatic and often resembled small landscapes.

The buckle of the thematic belts often featured a single, large stone, sometimes accented with a smaller stone or gold appliqué. Initially the stones Johnson and Bird selected for the buckles on the thematic belts were rectangular or slightly oval with rounded corners. In more recent years, they have chosen triangular stones for buckles, and with the 1991 "Human Figures Belt" they incorporated two triangular companion stones (figure 46). The color and the pattern of each buckle stone distinguish a belt and sets the tone for the theme. For example, the Wild Horse picture jasper in the buckle of the 1995 "Route 66/Tourism Belt" (figure 55) resembles a small desert landscape complete with vegetation. The Parrel plume agate in the buckle of the 1999 "Protein Belt" (figure 93) looks like the horizon at sunset.

Over time the shape of the belts has also changed. The early belts made from 1979 to 1982 had comparatively small designs stamped, appliquéd, or created from silver overlay of animals or elements of nature. Some, like the design on the first concho of the "Pottery Maker Belt" (figure 29), are incredibly light and delicate. The undecorated silver, the stones, and the design are all in balance on the rectangular conchos in these early belts, with each element of equal importance.

Some changes in the design elements of the thematic belts have been subtle, almost going unnoticed. Others are more apparent and represent a major departure from prior designs. After Johnson and Bird positioned the design and stone

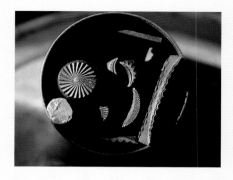

STAMPING

Stamping is the process of forcing an impression in metal using a punch or stamp bearing a single design. The imprint is formed by a single hammer blow to the flat end of the punch. A single stamp can be used in repetition to create an overall or more complex design. Johnson uses older stamps that he buys or fabricates new stamps when the need arises.

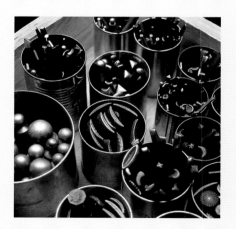

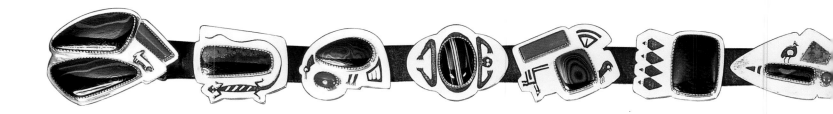

to touch in the 1980 "Birdwatcher Belt" (figure 14), they introduced another innovation when they used a stone as the body of an animal in the "Water Belt." Bird designed the belt to have a piece of coral form the body of the fish, and Johnson carved the coral to look like fish scales (figure 27). Both of these designs are diminutive and subtle, but in 1984 these concepts merge, resulting in an obvious design shift and a stylistically different belt format.

The dramatic shift in style occurred in the 1984 "Mimbres Black and White Belt." This belt was planned for but not completed in time for Indian Market that year. Because of its complexity and the larger size of the conchos, it took the artists longer than anticipated, so they decided to save it for the show "Arts of New Mexico," an invitational exhibit which opened at the Santuario de Guadalupe in Santa Fe and later traveled to the Museum of Modern Art of Latin America in Washington, D.C. The stones have replaced silver for the bodies of the animals, and the animals appear to have movement; they are less static than on earlier belts. Inspired by the painted style of Mimbres pottery, in which animals were depicted in a particular stance as they encircle the concave bases of some bowls, Johnson and Bird have placed the animals on the conchos in a similar fashion.

The balance of the concho composition also began to change with the "Mimbres Black and White Belt." The diminutive animals of the first belt, "Before the Hunt," have been replaced by larger ones that seem to engulf the stones and

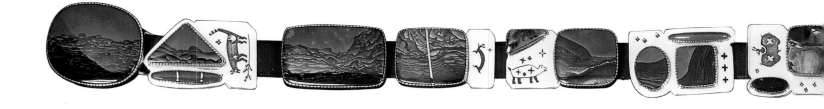

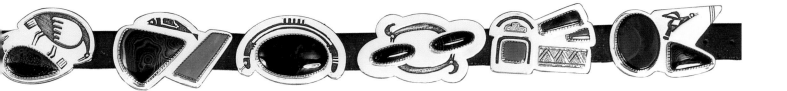

fully incorporate them into the design of the Mimbres belt. When they merged the designs with the stones, Johnson and Bird changed not only the size and shape of the animals but also the shape of the conchos, making them curvilinear, rather than rectangular, to reflect the animals. The larger size of the animals also makes them more dominant than the stones (figure 32).

The changes Johnson and Bird introduced in the "Mimbres Black and White" belt did not show up immediately in subsequent belts. "Night Animals and Stars," made in 1985, features bezel-set stones, such as Deschutes and Biggs jaspers, often as the only element of the concho (figure 33). When silver is visible, it is minimized, and stamped designs are diminutive, as in earlier works. "Wildflowers and Butterflies Belt" (1986) addresses topics that are favorites of the artists who enjoy their garden and the butterflies it attracts. The butterfly belt is whimsical in the way the artists use stones of the same type but different shapes to form abstract butterfly wings on five of the conchos and the way they position stones to form the shape of a butterfly on the buckle (figure 38). During this time, Johnson and Bird were making innovations in other types of jewelry as well. In 1981, they created a necklace that combined drilled freshwater pearls and coral. The concept developed from a glass bead necklace made in 1980. The first pearl necklaces were shorter than the early glass bead necklaces. By 1979 Johnson and Bird were adding stones to the necklace clasps, and by 1981 they were designing them to be worn to

33. "Night Animals and Stars Belt,"
August 1985

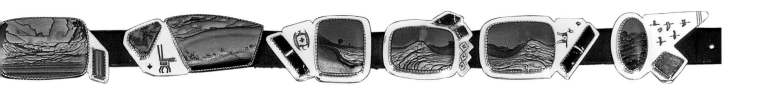

34. Ten-strand necklace of nineteenth-century coral with fossil shell clasp, 14k gold, 1994, 23 inches long. The clasp has a pin and is designed to be removed and worn separately or with the necklace. HMC Collection.

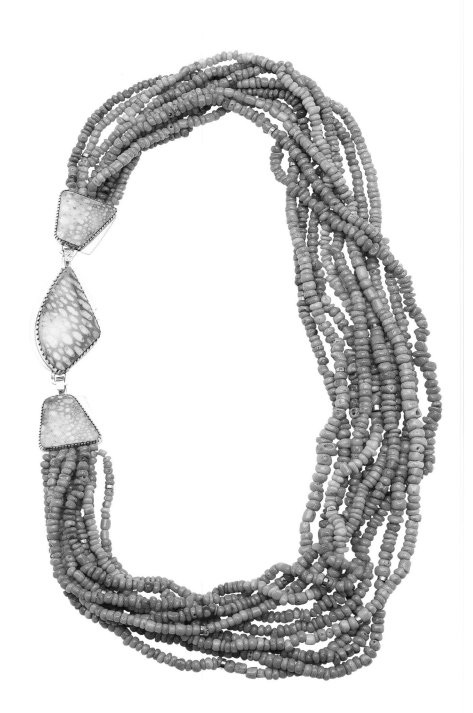

hang on the side and to be visible rather than hidden at the back of the neck. Some necklaces were also designed with removable pins (figure 34).

The artists developed a style of earring that featured the cabochons, or calibrated and cut stones such as moonstones and garnets, they had used as small accents in belts. They expanded the repertoire to include other stones such as Holley Blue agates and occasionally pearls, surrounding them in silver bezels and designing silver around the stones. The silver served as a platform or accent for the stones (figure 58).

For a jeweler, the fit or comfort of the jewelry for the wearer can be as important as the way it looks. In the early 1980s, to determine sizes and shapes of earrings, Bird would select stones for earrings, design the setting, and draw it to scale. She then cut out the drawings, which she had colored with pencils. She would attach these to her ears to check the design and size, a process that enabled her to visualize the finished jewelry. With experience this process became unnecessary, although Bird continues to draw earrings to scale and color them (page 62).

Johnson and Bird continued to be approached by galleries wanting to represent their work. In 1984, Gallery 10, a Scottsdale-based Native American arts gallery, had a show for Johnson and Bird in its New York branch. The gallery primarily featured the works of contemporary southwestern potters, but it also represented one other jeweler, Charles Loloma. The New York venue introduced Johnson and Bird's jewelry to a new clientele. Gallery 10 closed the New York space after one year and shifted the focus exclusively to the Scottsdale location. Around that time, unrelated to the New York closing, Johnson and Bird ended their working relationship with Gallery 10.

The couple was now planning the jewelry for each show and considering how the overall case display would look. They spread out pages of drawings, matching stones to drawings, and discussed color range, types of jewelry—the number of bracelets versus the number of brooches, for example—and price range. As they had several items in initial stages of design, they selected what they would make for each show based on how the individual items looked together as a group. They used this planning process to ensure that a range of jewelry types,

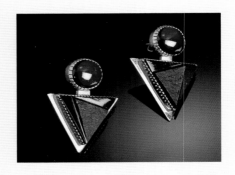

DESIGNING EARRINGS

Bird begins earring designs by combining stones that complement each other in color or shape. Initially it is the color or unusual shape that appeals to her as she works to make a balanced pair. She then draws and hand-colors the finished designs. The final combinations are placed on small labels and held in trays according to color and materials. She saves the drawings and trays of stones until she and Johnson select those that are to be made.

Right: Bird's sketches of jewelry that include, in the center of the page, the earrings shown above.

materials, and prices would be represented. They made lists of items they would include for each show. Sometimes the lists were organized by jewelry type, indicating the colors of stones in colored-pencil drawings; at other times the lists had drawings of specific items they planned to include.

Rarely have the couple agreed to make belts upon request. They accepted some commissions, such as the one for New York art dealer Joachim Jean Aberbach, during the first few years they made belts. Others have been for people with whom they had long-standing relationships. One example is a belt made in 1985 at Ray Dewey's request for his wife Judy's birthday. Johnson and Bird chose the stones with Judy Dewey's skin and hair color in mind, selecting Montana agates, moss agates, Botswana agates, and blue-grey chalcedony. They made the overall belt and the individual conchos in a small scale because of the owner's size. Other commissioned belts include the "Parrots and Coral Trade Belt" in 1991, the "Col-

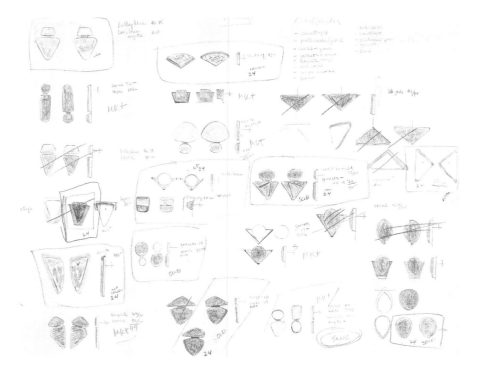

lector's Belt" in 1995, the "Four Seasons Belt" in 1996, the "Tourist Spoons Belt" for the Wheelwright Museum in 2003, and the "All Things Hopi Belt" in 2005. Along with the "Collector's Belt" and the "All Things Hopi Belt," the "Birthday Belt" is one of the more personal belts with designs that reflect specific aspects of the owner's life.

With a dozen or more thematic belts completed by 1985, Johnson and Bird were gaining recognition for their creative works. Their "Petroglyph Migration Belt," which won Best of Show in 1981, was legendary; visitors to Indian Market referred to it for years. In recognition of their innovation, the Taylor Museum in Colorado Springs invited the couple to exhibit their work in 1985. The museum had initiated a series of exhibits with contemporary themes in an effort to cultivate collectors and add current works to the permanent collection. The second exhibit in the series featured textiles by Hopi artist Ramona Sakiestewa and Johnson and Bird's jewelry. It opened in September 1985 and continued for six weeks. Most of the thematic belts were included in the show. When asked how the contemporary artists were chosen, the former curator of the Taylor Museum, Jonathan Batkin, stated, "If you think about who was doing outrageous jewelry at the time, they were the logical choice."[2]

Johnson and Bird continued to make thematic belts annually for Indian Market, and in some years they made a second belt. Although they generally did not make more than two a year, in the years 1980 and 1985 they made three. The themes of the belts were often prompted by recent events in the artists' lives. They created the "Wildflowers and Butterflies Belt" for the 1986 Indian Market after incredible spring rains, which followed years of drought, resulted in extraordinary flowers that year. Johnson and Bird bought books to identify the wildflowers they saw and made the belt to record them (figure 38).

According to Bird, "Many of the butterflies in the belt were adapted from Hopi pottery designs; many of the flowers and vegetal images are adapted from Santo Domingo pottery and were researched in Kenneth Chapman's book on Santo Domingo pottery. Collectors and scholars view the highly abstract interpretation of natural forms in Hopi pottery as high artistic achievement. Often the

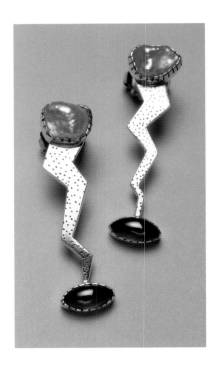

black-and-white images boldly painted on large forms by Santo Domingo potters
seem simplistic or clumsy by comparison. Hopi potters add and build; Santo
Domingo painters simplify complexity. Both create highly abstract images. We
chose to use both in this piece along with realistic depictions. The choice of
accompanying metal or stone color reflects the respective pottery's design origin."

Sometimes, Johnson and Bird applied a belt theme to other creative works.
The "Wildflowers and Butterflies Belt" shows "the result of rain on the landscape,"
whereas the "Lightning Belt," made for the 1987 Indian Market, shows "the drama
of lightning and rain," according to Bird (figure 39). The Blue Mountain jasper in
the buckle looks like a dark, rainy sky over a mesa top. The reverse of the buckle
has jagged lightning bolts. They used the lightning design motif in a necklace cre-
ated for a 1987 benefit auction for the American Craft Museum, now the Museum
of Art and Design in New York (figure 35). The lightning bolts are separate ele-
ments that connect the strands of the necklace. Aspen gallery owner Joanne Lyon
donated the necklace to the auction, and Johnson and Bird traveled to New York
to attend the event. While there, they were reunited with the former director of
Gallery 10, Dexter Cirillo, who had selected and invited the individual American
Indian artists to participate, Johnson and Bird among them. Meanwhile, Cirillo
was arranging private sales for southwestern artists, which eventually led to annual
private showings of Johnson and Bird's jewelry at the Westbury Hotel, at Madison
Avenue and 69th Street in Manhattan, from 1990 through 1995. Guests attended
by invitation only. The first year the sale lasted three days, with an opening recep-
tion the first day and sales on the second and third days by appointment only. Sales
were so brisk that the event was reduced to two days the following year.

Cirillo noticed a shift to more complex necklaces during the years of these pri-
vate shows. Johnson and Bird made several necklaces for the sales, as well as smaller
items such as earrings and pins. "They have been successful over the years because
their jewelry crosses over to fine jewelry," says Cirillo. "I feel that they are very
important and am struck by how unique they have remained. . . .Gail and Yazzie
have captured a niche in American Indian jewelry that has remained their own."[3]

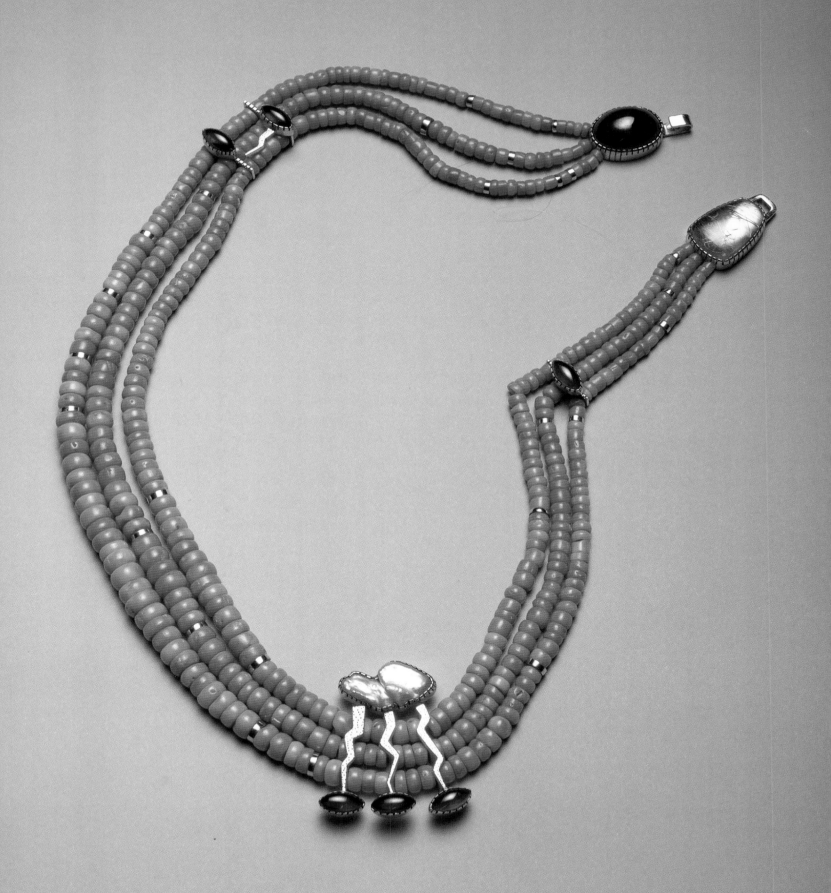

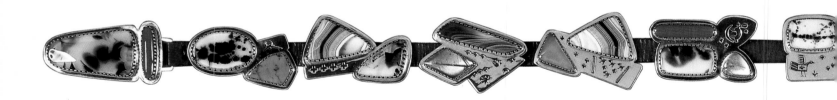

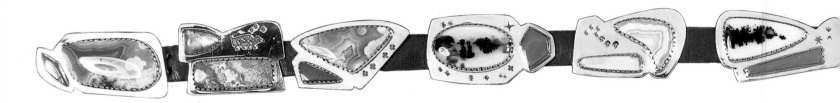

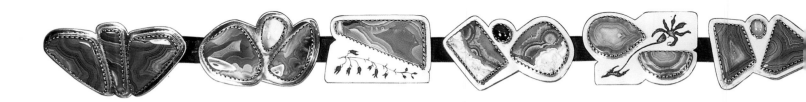

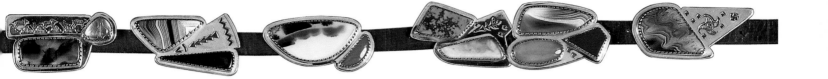

36. "Birthday Belt," April 1985

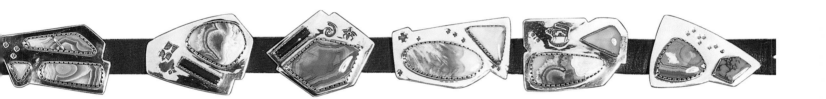

37. "Constellation Belt," December 1985

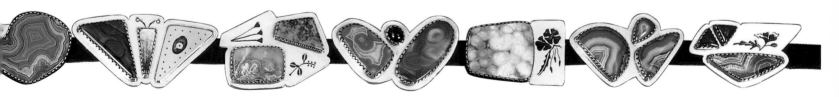

38. "Wildflowers and Butterflies Belt," August 1986

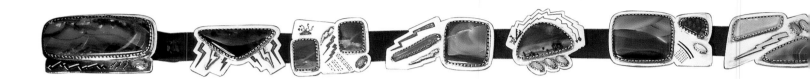

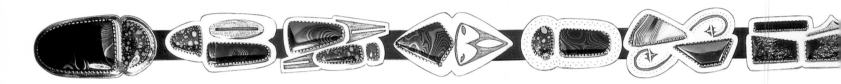

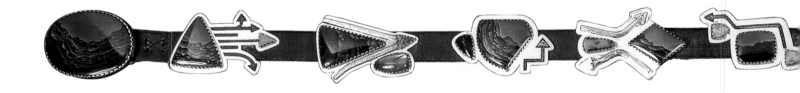

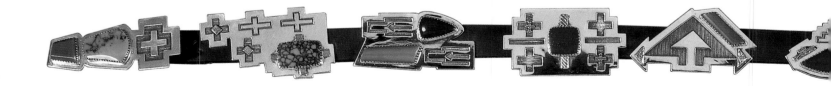

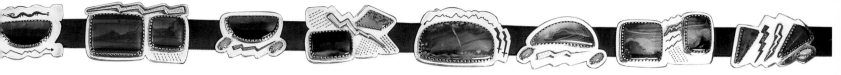

39. "Lightning Belt," August 1987

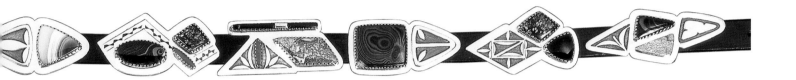

40. "Santo Domingo Pottery Belt," December 1987

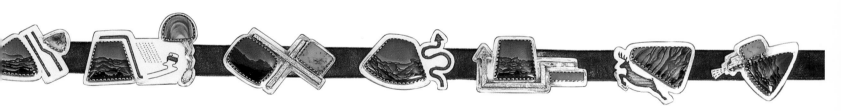

41. "Road Signs Belt," June 1988

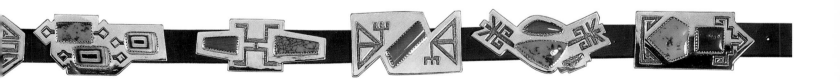

42. "Navajo Geometric Textiles Belt," August 1990

43. "Kate Peck Kent Pueblo Textile Belt,"

August 1988

As their necklaces became more complicated, their belts also made a thematic shift. In June 1988, Johnson and Bird made a belt with no connection to southwestern collectors or to nature, but instead incorporated their other interests. Johnson and Bird served on the volunteer fire department in their community for sixteen years. Besides fighting fires, according to Johnson, "We would be called to wrecks because of the fire potential. We were conscious of the areas that were more hazardous to drivers." "Yazzie came home one day and wanted to take me to see something," Bird recalls. "It turned out to be a dangerous curve sign that was being placed in a difficult area of the road." They noticed the series of directional arrows dotting the road, and Johnson commented on the design and what a great belt it would make. They spent the next few months photographing the signs, usually from the open passenger window. Ironically, in the fall, Johnson went to renew his driver's license and found a manual with all of the road signs pictured. They chose to use Deschutes and Biggs picture jaspers because of the intricately detailed landscapes contained in the stones. They made the "Road Signs Belt" in 1988 with stones placed at angles to represent curves and changes in elevation. It was shown at their Dewey Gallery exhibit in July and a fall sales exhibit at the Southwest Museum in Pasadena, California. According to Bird, "When the belt did not sell at the two shows, this led us to think about the use of playful themes versus serious Indian themes." The belt remained unsold until that winter, when Martha Struever showed it at her gallery in Chicago. A collector with a passion for cars recognized the iconography and bought it (figure 41).

For the 1988 Indian Market, Johnson and Bird made the "Kate Peck Kent Pueblo Textile Belt" as a tribute to scholar, teacher, and author Kent, who died in 1987 (figure 43). Johnson and Bird used imagery from her book *Pueblo Indian Textiles*. The artists had met Kent when she and Bird served on the SWAIA board together and had gotten to know her better when she accompanied Ramona Sakiestewa to the Taylor Museum show in 1985. The artists admired Kent because she made a point to include Pueblo and Navajo women in seminars and because she

Plans for the "Navajo Pictorial Textiles Belt," 1990 (belt not pictured). The design is based on pre-1900 Navajo pictorial weavings.

46. "Human Figures Belt," August 1991

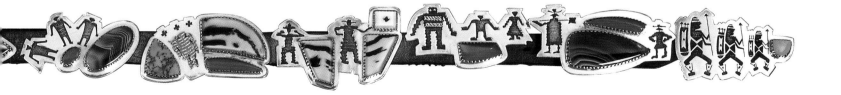

14k gold. The way the color of the metal complements the color of the stone has always been an important feature for Johnson and Bird. When they first began, they used brass for bezels because it was more affordable. When they first used gold, they used it in smaller quantities for the smaller stones.

Other aspects of Johnson and Bird's jewelry were changing as well. They admired the work of lapidary artists and had used Chinese jade carvings in their work in the 1980s. A dealer who sold them stones brought their attention to the

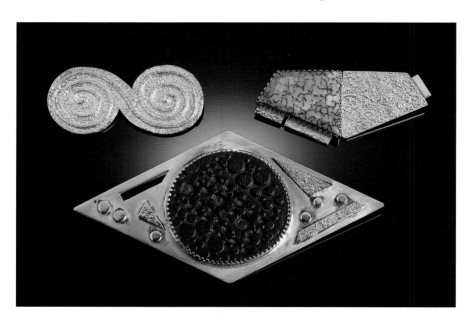

47. Clockwise from top: Tufa-cast 18k gold pin, mid-1990s, 1 x 2 inches. Tufa-cast pin of dinosaur bone and 14k gold, mid-1980s, 1 x 2.25 inches. Pin of a Steve Walters onyx carving, silver and 14k gold drops, and appliqués of tufa-cast 18k gold, 1994, 2 x 4 inches. The dinosaur bone on this pin was the first stone Johnson cut after he purchased equipment to do this. Before this he would reshape stones and cut them with a hand grinder. Private Collection.

work of American carver Steve Walters, who included agates in his carving reper-toire. His abstract carved stones appealed to Johnson and Bird. They incorporated them into their jewelry for the first time in 1991, when they created a pin that held one of Walters's carvings. Another dealer in stones introduced them to the work of German lapidary artist Dieter Lorenz. According to Bird, "His carved stones con-tain surface depth that parallel our interests in stone patterning." They have incor-porated carvings by Walters and Lorenz into several jewelry items, which were later sold through one of their galleries (figures 48–51, 119).

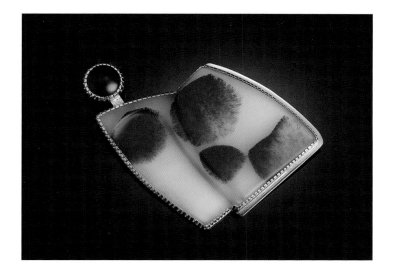

48. Dieter Lorenz carved dendritic agate, black onyx, and 18k gold pin, 1998, 3.5 x 2.5 inches. This pin and one other were featured on the announcement for a show that opened at LewAllen Gallery in Santa Fe on August 21, 2000. Private Collection.

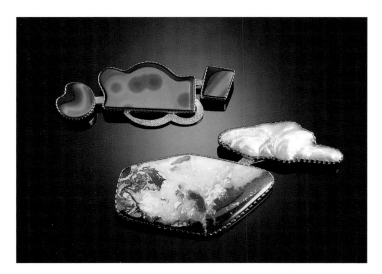

49. Top: Dieter Lorenz carved cameo stone and 18k gold pin, 2001, 1 x 2.5 inches. Rona C. Rosenbaum Collection. Bottom: Yowah opal, freshwater pearl, and 18k gold "Landscape and Cloud" pin, 1996, 2 x 3.25 inches. Private Collection.

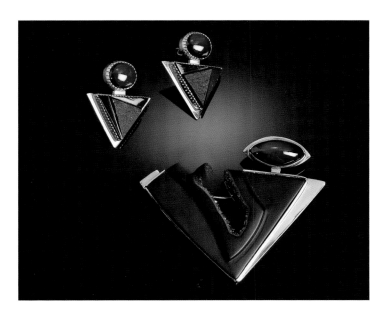

50. Pin of a Dieter Lorenz onyx carving and 18k gold, 1990, 2.25 x 2.75 inches. Earrings of onyx, garnets, and 18k gold, 1990. Ramona Sakiestewa Collection.

Johnson and Bird developed bolder designs in earrings in the 1990s. Although subtle differences in size within a pair of earrings were evident by 1980, in the early 1990s size and shape differences became more noticeable. Working with a carved cameo stone by Dieter Lorenz, Johnson and Bird created a second earring of the same pattern and size, but in tufa-cast gold. That same year, they

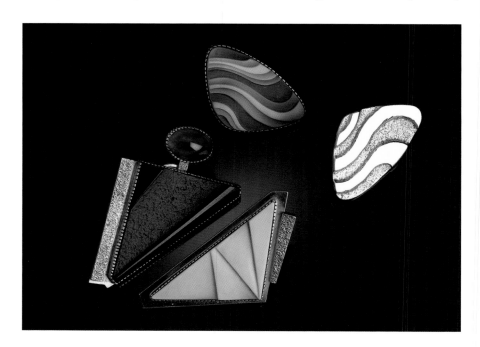

51. From top: Dieter Lorenz carved cameo stone (banded agate) and 18k gold tufa-cast earrings, 1994. Steve Walters carved onyx and amethyst earring and Dieter Lorenz carved cameo stone and 18k gold earring, 1994. Johnson and Bird incorporate the work of noted gemstone carvers in their jewelry with regularity. The bottom pair combines the carvings of two different artists, and the colors and materials used are different as well. Private Collection and Martha H. Struever Collection.

made a pair of earrings using a carved stone for each earring, one by Steve Walters and the other by Lorenz. Although the shape of each earring was similar, they were not identical, and the colors were not the same (figure 51).

In 1991 the "Human Figures Belt" represented a new stylistic departure (figure 46). Previously, Johnson and Bird had placed human forms only on the reverse of the buckles in silver overlay. For this belt they adapted figures from bas-ketry designs and used both silver overlay and appliqué techniques. The browns and golds of the Botswana and Brazilian agates in the belt offered inspiration for the belt that would follow, the "Canines and Felines Belt" (figure 52). According

Bird's sketches of the hatband sold to the
National Museum of American History,
Smithsonian, 1992.

to Bird, "When laying out the stones of the 'Human Figures Belt,' I thought of the soft palette of the Botswana agates. I may begin with fifty to sixty stones and select a much smaller number for a belt. I had all of these stones left that did not go into the 'Human Figures Belt.' They were so good that I wanted to use them in the next belt. There is always a connection between belts and for me this was a natural transition."

In 1992 the artists were asked to make something, preferably a belt, for the "American Encounters" exhibit at the Smithsonian's National Museum of American History. It was to be purchased for the collection. For the price offered, the artists felt that they could not afford to make a belt, so they made a hatband, a miniature version of one of their belts (above). They approached the design much like they would a thematic belt. They drew individual components, reviewed and eliminated some, and then drew them all in sequence. The hatband (above) is currently on exhibit at the Smithsonian.

Beginning in the late 1970s, the artists used images of cats and dogs from both petroglyphs and Mimbres pottery designs on the reverse of buckles, necklace clasps, and pendants. "We had two dogs and three cats," Bird explains. "Watching our own dogs jump fences and our cats climb trees gave us the idea to use them as the central theme for the belt we made for the 1992 Indian Market, "Canines and

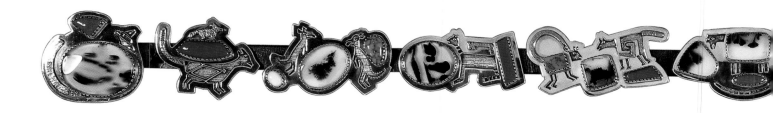

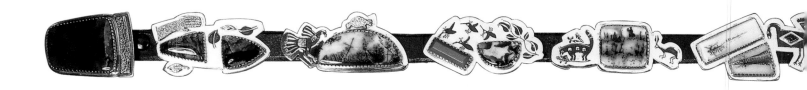

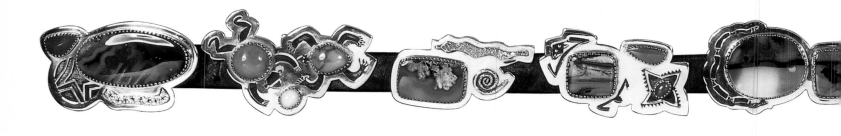

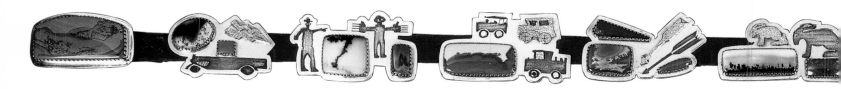

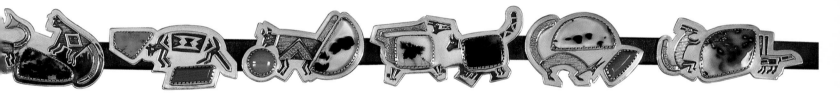

52. "Canines and Felines Belt," August 1992

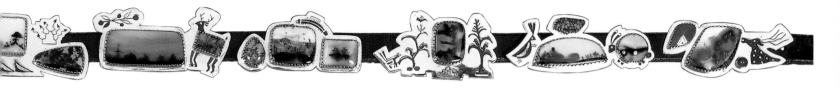

53. "Pueblo Garden Belt," August 1993

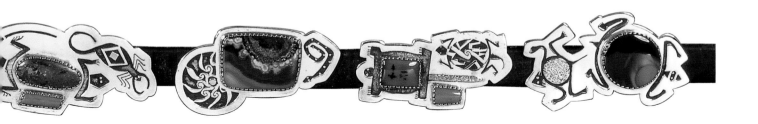

54. "Drought and Desert Belt," August 1994

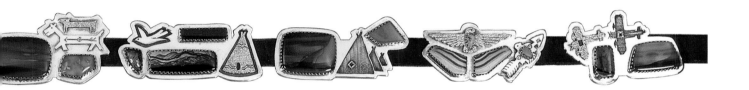

55. "Route 66/Tourism Belt," August 1995

TUFA CASTING

A compacted volcanic ash called tuff or tufa is used in tufa casting. Johnson cuts a block of tufa with a handsaw to the desired shape and size, and then saws it in half. The two halves are pressed and rubbed together to make two matched compatible surfaces. An opening or sprue is carved into the top of both blocks. A design is carved into one block, using a sharp metal tool, such as a knife, an awl, or a nail. Shallow straight lines are carved upward away from the design. These lines allow air, gases, and excess metal to escape. The matching block serves as the back.

In these photographs, Johnson carves the shape of the design and a sprue at one end. Next, he starts at the center and draws a spiral for an earring. Then he carves the design and uses a flat tool to deepen the spiral. He brushes away any dust or debris with a clean paintbrush. Next, he carves shallow straight lines away from the design. He blackens the inner surfaces with carbon. This coating helps the metal flow into the carved depression and keeps the metal from sticking to the mold. The two

Felines." After Bird had chosen the cat images, Johnson exaggerated the shape and length of the tails. Several cats have long tails, made in tufa-cast 14k gold, that go over the heads of the other animals. Some of the tails encircle and meet above the animals. Other tails look like they are interacting with the animal looking at them. Since animal tails in Mimbres pottery can be very elaborate, Johnson varied them on the belt, giving some a high polish on the tips, stamping others, and adding saw lines to others. The animals appear active and full of movement and dominate the design field. All figures have punched 14k gold drops for eyes, which gives them a lifelike quality.

In 1994, Johnson and Bird began using 18k gold in the belts rather than 14k. They also used more gold on the thematic belts. In early belts, gold was used as an accent—a drop of gold for an animal's eye, a section cut out of a tufa-cast sheet that was appliquéd to the body of a silver overlay animal. Beginning with the "Wild Horse Belt" (figure 44), they appliquéd and juxtaposed an animal of tufa-cast gold with silver overlay animals.

In 1995, Johnson and Bird joined the Horwitch LewAllen Gallery in Santa Fe after Dewey Gallery stopped showing modern work. In *Pasatiempo*, the weekly arts supplement to *The New Mexican*, Arlene LewAllen stated that selling modern jewelry alongside contemporary art was challenging. "However, Gail and Yazzie's jewelry, in my estimation, are almost like sculptured pieces. . . .So, I made an exception. I never want anyone else's jewelry. I'm not in the jewelry business. But I think that their jewelry comes up to such a mark of fine art that I made the exception, and I did pursue them. I wanted to have their work."

"This gallery has what I consider the best in many different media. I'm not interested in having a lot of examples, but I try to pick the best example of ceramics, glass and jewelry."[4]

Also in 1995 the Heard Museum bought one of Johnson and Bird's thematic belts, the first museum to do so. The director at that time, Martin Sullivan, arrived at Indian Market early but not early enough; he was fifth in line. He intended to buy the belt, and since the other buyers chose different items, he was able to do so.

Johnson and Bird had an idea for a belt based on Route 66 and tourism around 1993 and had put it aside. They were consultants to, as well as participants in, the exhibit "Inventing the Southwest: The Fred Harvey Company and Native American Art," which opened at the Heard Museum in early 1995. They reviewed approximately 700 examples of jewelry at the Heard Museum from the Harvey Company Collection and made comments about the items, from which a smaller selection was made for the exhibit. After the review, Johnson and Bird completed the "Route 66/Tourism Belt" for the 1995 Indian Market (figure 55). It was an ideal addition to the contemporary section of "Inventing the Southwest," which

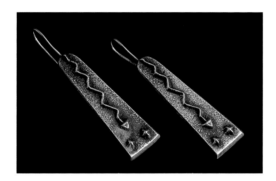

Silver tufa-cast earrings with
Y hallmark cast on the reverse,
late 1970s. Private Collection.

blocks are bound together with wire or clamps and placed upright in a bed or container of dry sand or stones. The metal is heated in a crucible to an oil-like consistency and sprinkled with borax. The borax helps to raise the temperature and cleanses the metal of impurities. The crucible and tufa are heated simultaneously before the pour. The application of continuous heat to both the metal and the mold combined with a smooth single pour ensures the smooth gravitational flow of the metal. The mold is set aside and allowed to cool completely and then taken apart. The cast item is removed; the excess metal and sprue are clipped. Problems occur when the mold is not hot enough and the metal does not flow, or if there are not enough air vents. Once the metal has cooled, the two sections of tuff are separated and the roughly textured metal form is removed. Johnson may choose to leave the surface texture or polish all or part of it to a smooth finish.

featured artwork by descendants of artists who worked for and sold art to the Fred Harvey Company as well as work that addressed the theme of tourism in the Southwest. The belt traveled with the exhibit to the Albuquerque Museum, the Nelson-Atkins Museum in Kansas City, the Autry Museum in Los Angeles, the Carnegie-Mellon Museum in Pittsburgh, and the Denver Art Museum.

As with the other belts sold at Indian Market, Johnson and Bird kept "The Route 66/Tourism Belt" for visitors to see during the two days of the event. When they sent the belt to the Heard Museum, Bird provided the following information in a letter.

"This is one of the most playful of all the belts we've ever done—generally for Market we try to do an 'Indian' theme belt for the 'serious' collector (we

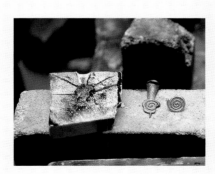

learned this in 1988 with the 'Road Signs Belt')—but the past few have had themes about cats and dogs, human figures, gardening, desert and drought—each has marked a more personal use and interpretation of design.

We thought about doing this particular theme several years ago, but it never quite came together. This year in Santa Fe, as elsewhere, there have been many discussions, public forums, etc. on the impact of tourism and the commercialization of culture, with loud denunciations from those who think they've discovered or uncovered something new.

This belt is about change and about impact, about growth, survival and memory. It's especially about appreciation for all those things and people who saw and recorded and saved their impressions.

The majority of the designs are from Navajo pictorial weaving, others are from billboards, roadside signs, neon lights, roadside structures."

The "Route 66/Tourism Belt" was markedly different stylistically from previous belts. The complexity of its design reached a new level. The conchos on this belt are wider, providing a larger overall design field. The appliquéd designs are more intricate and more numerous, and the artists used more gold overall in this belt. As in previous belts, the stones are an integral part of the composition. This complexity is also evident in the later "Four Seasons Belt" and the "Antlers Belt" (figures 89, 91).

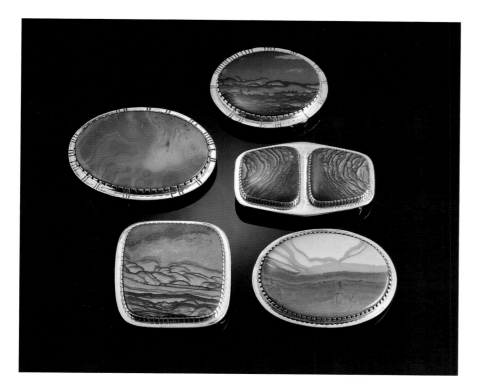

56. Clockwise from top: Deschutes jasper and silver buckle, 1.75 x 2.25 inches. Biggs jasper and silver buckle, 1.5 x 2.675 inches. Rocky Butte jasper and silver buckle, 2 x 2.5 inches. Biggs jasper and silver buckle, 2.125 x 2.125 inches. Laguna agate and silver buckle, 2 x 2.75 inches. All buckles have the large Y hallmark and were made in the late 1970s/early 1980s. Charles Diker Collection. Reverse: designs in silver overlay, clockwise from top: A bear under a single star. A soaring hawk spreading stars with stamp work. A Mimbres-style ram with arrows. Four mountain goats or sheep. The one on the bottom has an appliquéd gold star in the center of its body. Sikyatki design amphibian and two dragonflies in silver overlay.

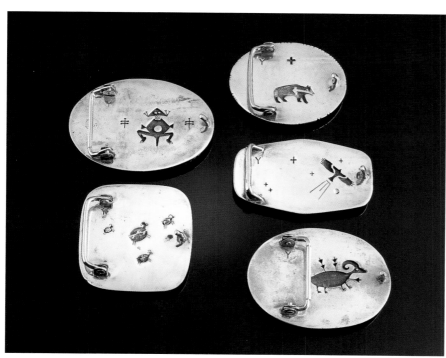

57. Clockwise from top: Tribolite and 18k gold cufflinks, 2004. Dendritic agate and 18k gold cufflinks, 1992. Meteorite and 18k gold cufflinks, 1997. The stud sets are not shown. Private Collection.

58. Clockwise from top: Moonstone and silver earrings. Chilean azurite and 14k gold earrings. Holley Blue agate and 14k gold earrings, early 1980s–1984. HMC Collection.

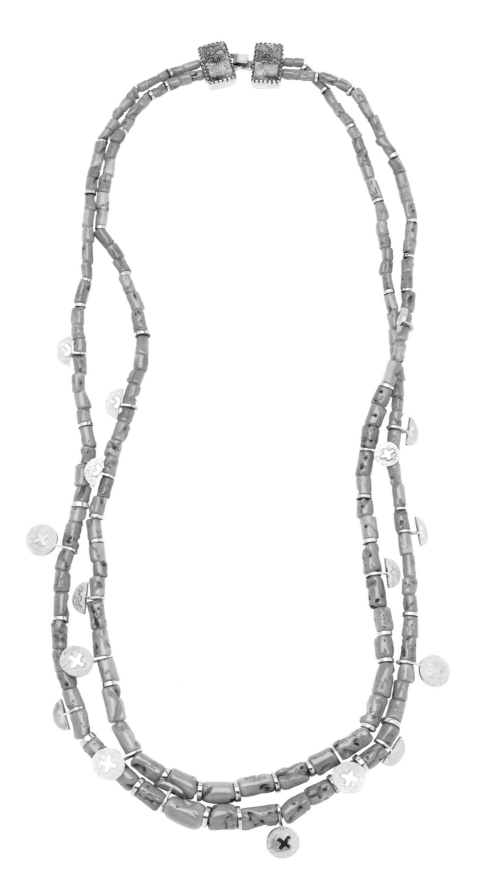

59. Two-strand coral necklace with 18k gold satellites and lace agate clasps, 1997, 29 inches long. The concept for this necklace was developed when the Santa Fe Indian Market rules changed to limit coral to 50 percent of the composition. Johnson and Bird filled natural holes in the coral with 18k gold and added gold satellites to meet the restrictions. The necklace sold at Indian Market. Dr. and Mrs. E. Daniel Albrecht Collection.

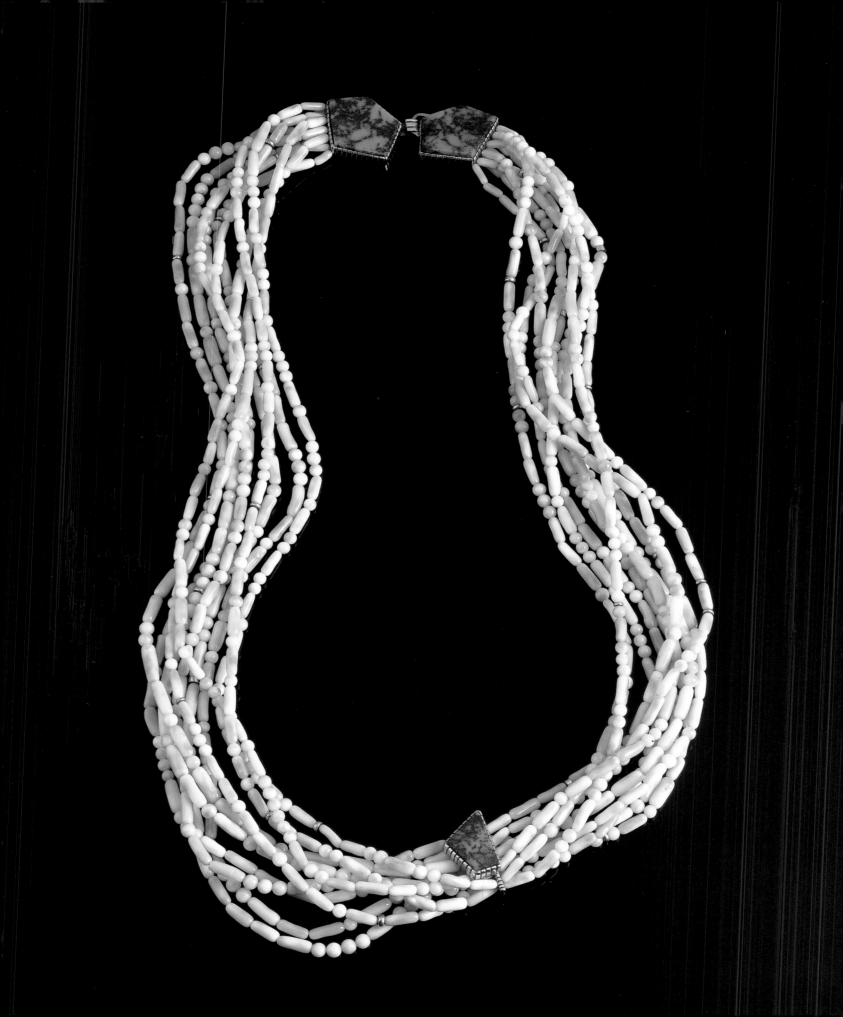

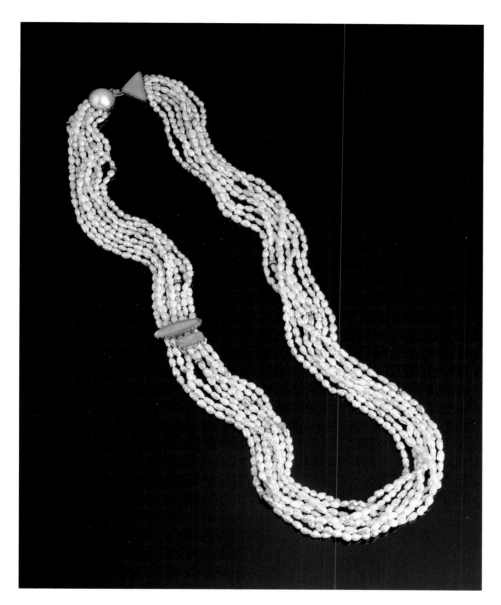

Opposite: 60. Ten-strand pink coral necklace with Tyrone turquoise clasps and satellite, 14k gold, early 1980s, 28 inches long, Y hallmark. Jane Dunn Sibley Collection.

61. Eight-strand Biwa pearl necklace with mabe pearl and blue chalcedony clasps and satellites of Mintabe opal, blue chalcedony, and 14k gold, 1985, 33 inches long. This is one of the first pearl necklaces made by Johnson and Bird. Generally, they do not use materials provided by other people, but this was an exception. Martha Struever provided the pearls and opals, and it was the first time Johnson and Bird used opals. Martha H. Struever Collection.

62. Three-strand white coral necklace with three pink coral satellites, clasps of imperial jasper, 14k gold, 1987, 25 inches long. HMC Collection.

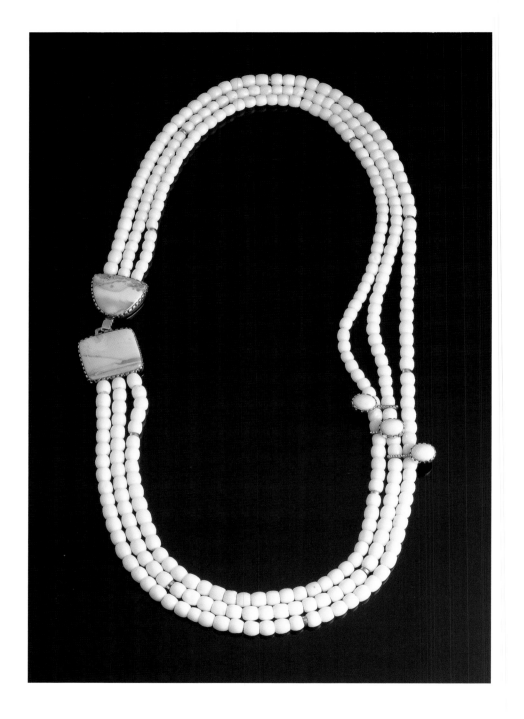

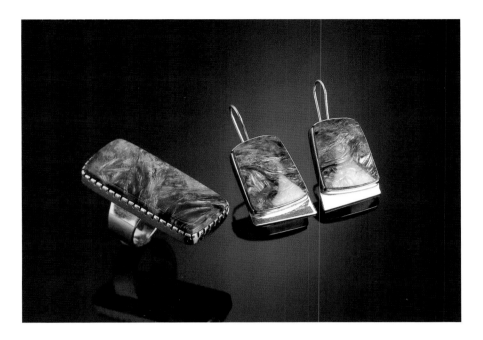

63. Charoite and 14k gold ring and earrings, 1985. Charoite, first used by Hopi artist Charles Loloma, met Bird and Johnson's criteria for selection because of its unusual and pleasing color. Martha H. Struever Collection.

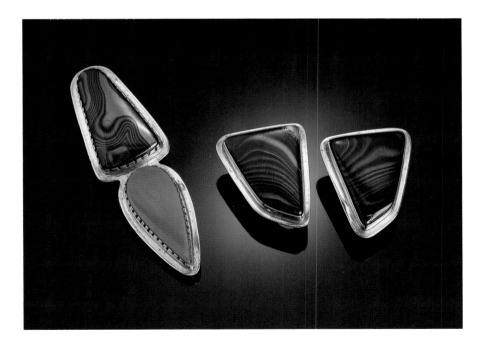

64. Psilomelane, coral, silver, and 14k gold pin, 1987, 7.5 x 2.5 inches. Psilomelane and silver earrings, early 1980s, 1.25 x 1 inches. Martha H. Struever Collection.

65. Clockwise from top: Dendritic Brazilian agate, silver, and 18k gold buckle, late 1990s, 3 x 2.25 inches, Brazilian agate and silver buckle, 1998, 3.25 x 2 inches, Parrel plume agate, silver, and 18k gold buckle, late 1990s, 2.5 x 2 inches. Private Collection. Reverse, clockwise from top: A petroglyph design. Bird and lightning design. Three bats. Designs are in silver overlay.

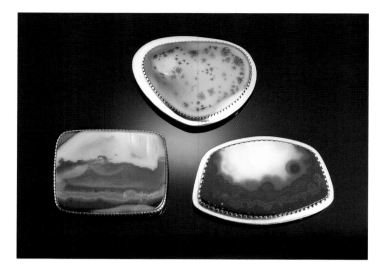

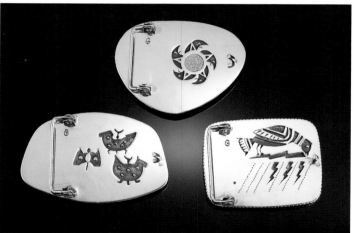

66. From top: Fan Series pin of snowflake obsidian and 14k gold, 1989, 1.25 x 2.25 inches. Pin of lapis lazuli, Tyrone turquoise, azurite, silver, and 14k gold, 1988, 1.5 x 2.25 inches. Pin of Blue Gem turquoise, silver, and 14k gold, 1993, .875 x 3.375 inches. Private Collection.

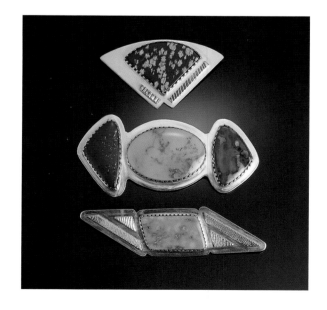

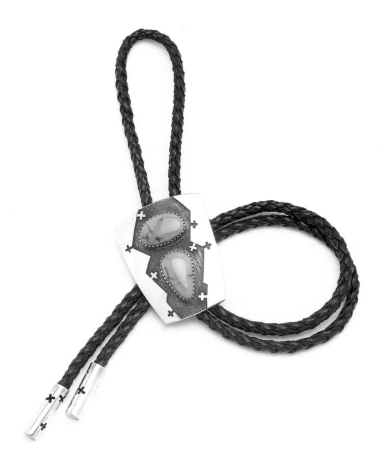

67. Morenci turquoise and silver overlay bolo tie and buckle with appliquéd 18k gold tufa-cast textile stars, 1991, 2.5 x 2 inches and 2.25 x 3 inches. The stars are adapted from Navajo textiles and are a design motif that Johnson and Bird use frequently. Private Collection.

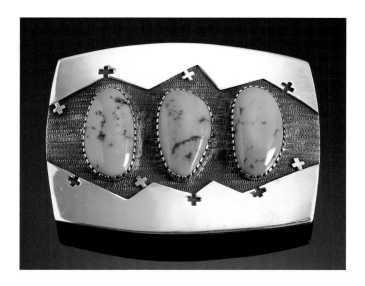

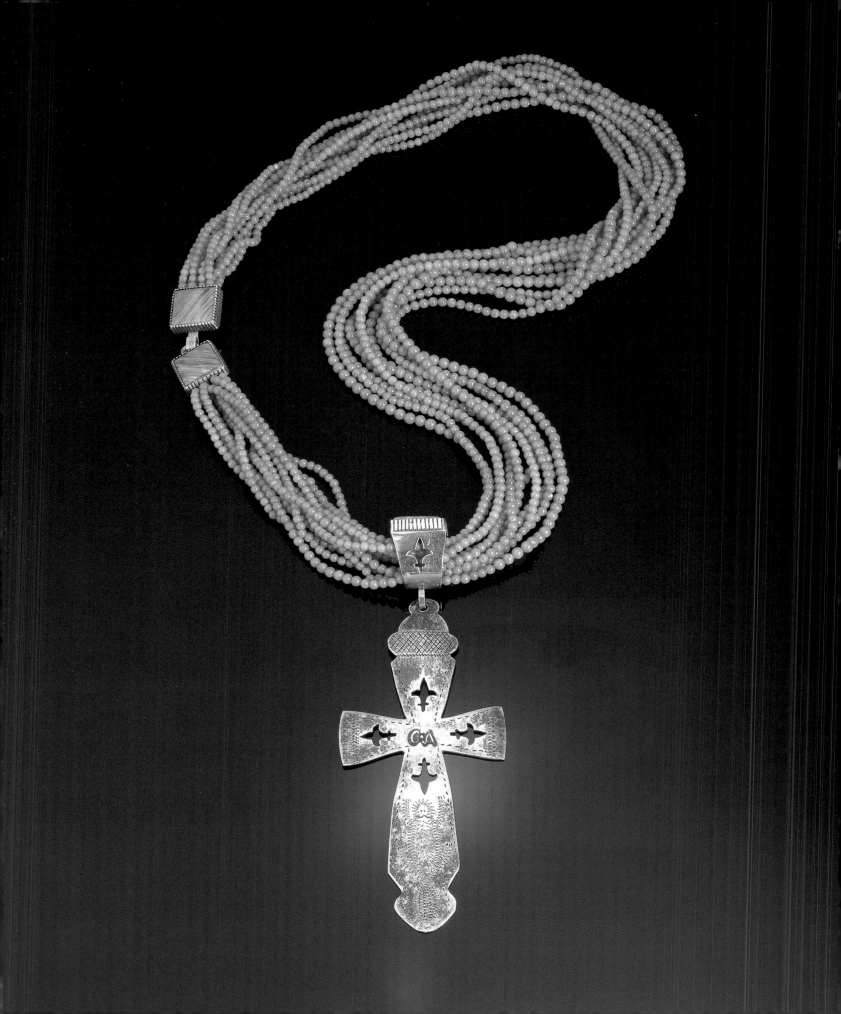

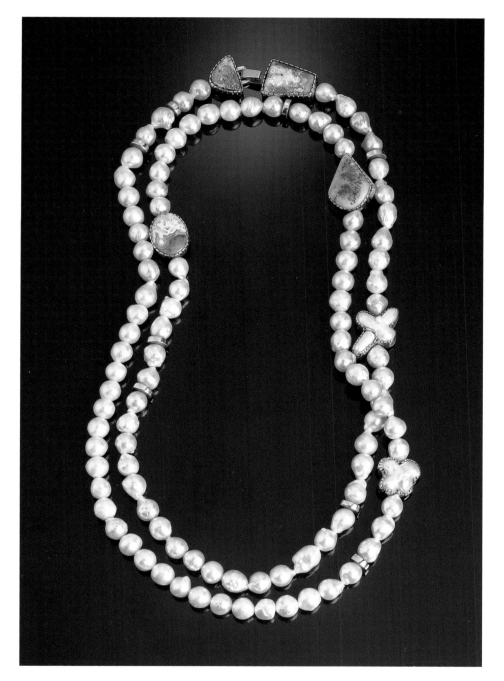

Opposite: 68. Eleven-strand coral and silver necklace with spiney oyster shell clasps, 1991, 39 inches long. The pendant, c. 1900, is a German silver trade cross from the Northeast. The clasp and pendant top have orange spondylus shell, and on the clasp reverse is a beaver made by awl-rocker engraving that echoes the beaver on the trade cross. Cross-shaped designs were cut out of the pendant to resemble those on the cross. Martha H. Struever Collection.

69. Single-strand silver baroque pearl necklace with satellites of two X-shaped pearls, a double-sided satellite of lace agate and abalone, a double-sided satellite of silver in quartz and opal, clasps of silver in travertine and lace agate, 18k gold, 1993, 40 inches long. Reverse satellite designs of clouds, lightning bolts, and stars. The necklace was lengthened and more satellites were added in 1997. Martha H. Struever Collection.

70. Three-strand keshi freshwater pearl necklace with five double-sided satellites: moonstone and freshwater pearl, Holley Blue agate and overlay petroglyph design, blue chalcedony and Holley Blue agate, amethyst and freshwater pearl, a single Keshi pearl and spiral petroglyph, clasps of lavender boitroydal quartz, 18k gold, 1993–94, 32 inches long. Private Collection.

Opposite: 71. Five-strand onyx and freshwater pearl necklace with a satellite of Montana agate and clasps of Brazilian agate and plume agate, 18k gold, 1995, 34.5 inches long. The reverse designs are a Mimbres-style turkey and a grasshopper with a small animal on the top of its head. Private Collection.

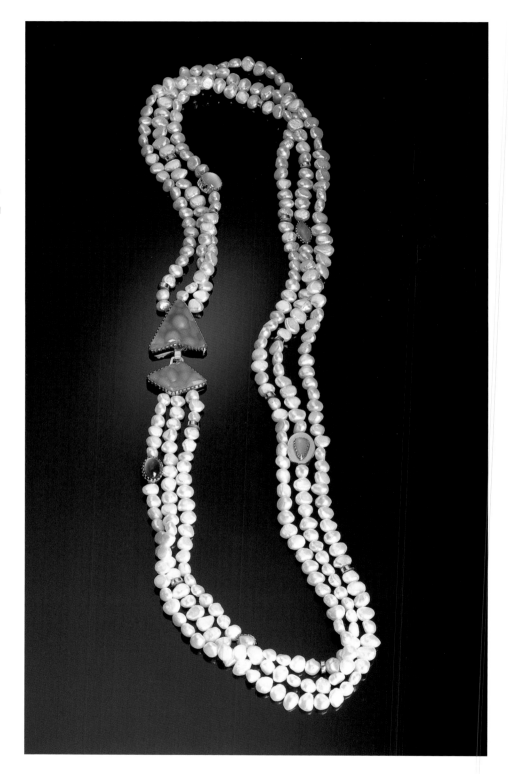

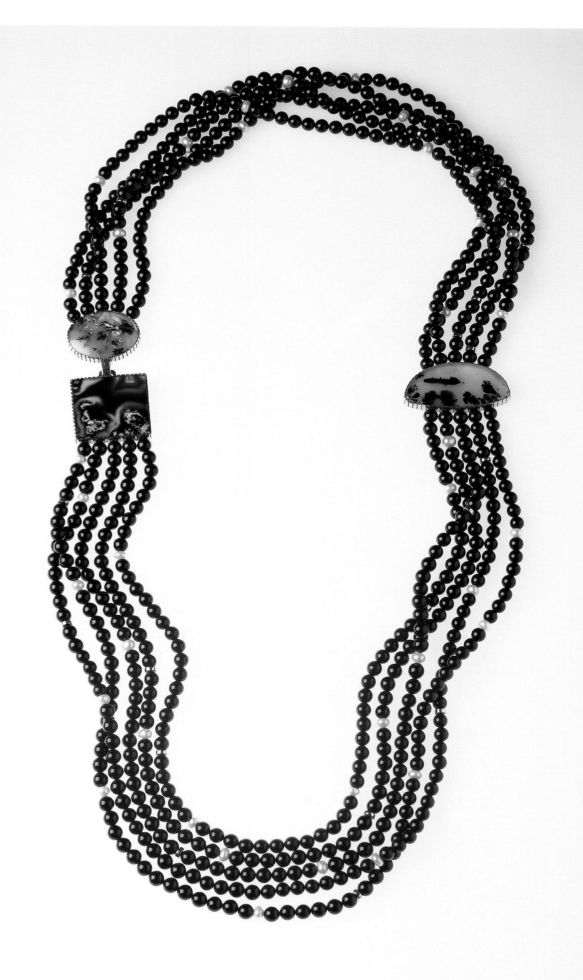

72. Dendritic agate, silver, and 14k gold pin, 1993, 1.125 x 3 inches. Montana agate, drusy quartz, silver, and 14k gold earrings, 1996, 1.625 x .875 inches. Martha H. Struever Collection.

73. Montana agate and tufa-cast 18k gold pin, 1996, .67 x 3.5 inches. HMC Collection.

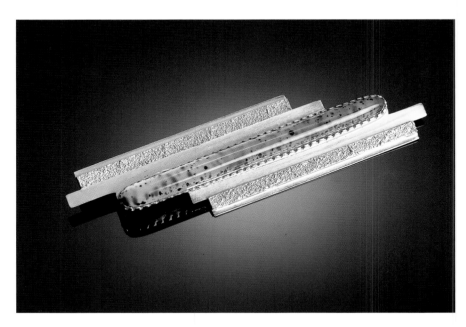

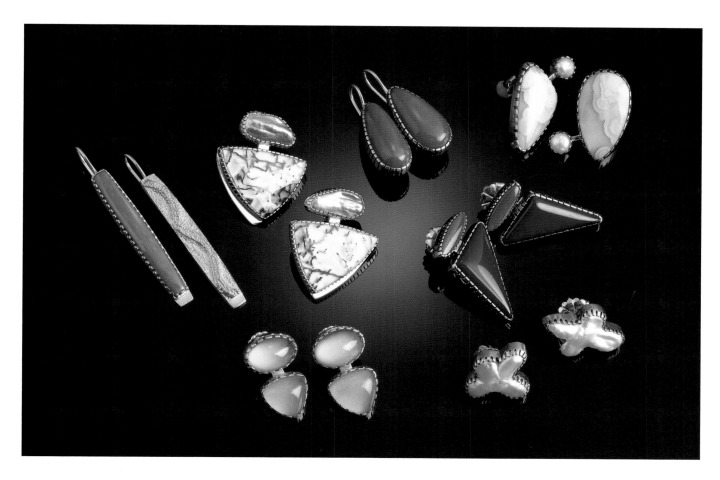

74. Clockwise from top: Coral and tufa-cast 18k gold earrings. Biwa pearl, agatized dinosaur bone, and 18k gold earrings. Coral and 14k gold earrings. Pearl and agate earrings. Coral, lapis lazuli, and 18k gold earrings. Freshwater X-shaped pearls and 18k gold earrings. Green garnet and blue chalcedony earrings, all 1980s–1990s. Private Collections.

75. Detail of overlay design on the reverse of the freshwater X-shaped pearl and 18k gold earrings.

76. Detail of overlay design on the reverse of the coral and 14k gold earrings.

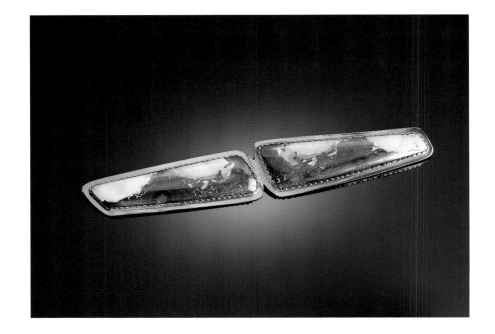

77. Yowah opal and 18k gold pin, 1999,
1 x 5 inches. Private Collection.

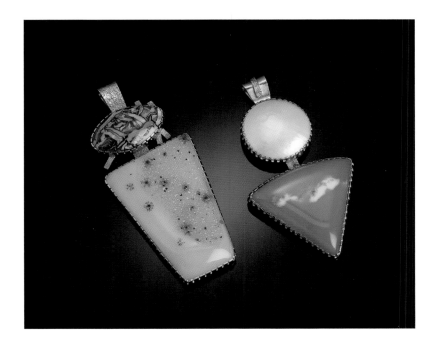

78. Yowah opal, dendritic agate, and tufa-cast
18k gold pendant, 1996, 3 x 1.25 inches. Blister
pearl, chrysocolla, and 18k gold pendant, 1996,
2.625 x .875 inches. Martha H. Struever
Collection.

Opposite: 79. Eleven-strand necklace of
lavender potato pearls, coral, garnet with clasps
of coral and Yowah opal, 18k gold, 2001, 18
inches long. Double coral and 18k gold pin,
2001, 2.5 x .5 inches. David and Suzy Pines
Collection.

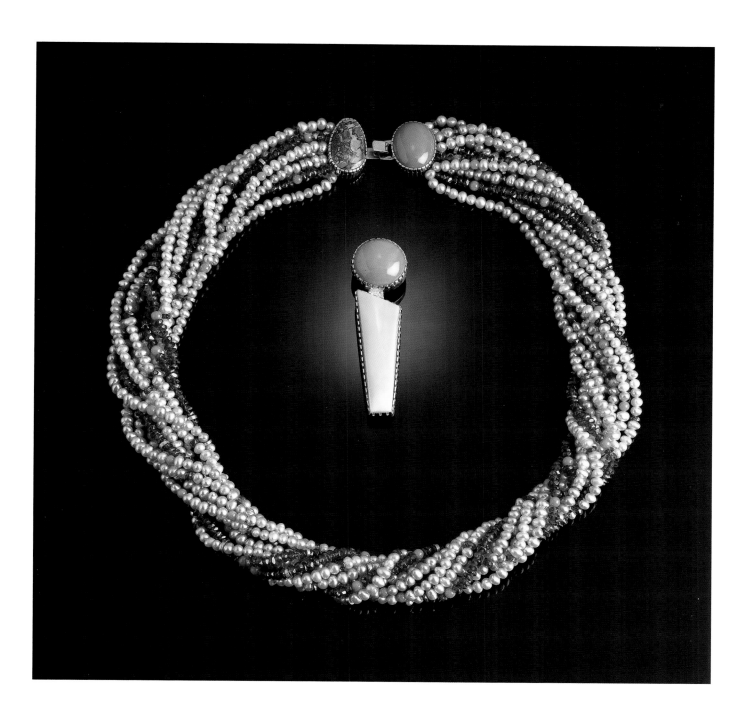

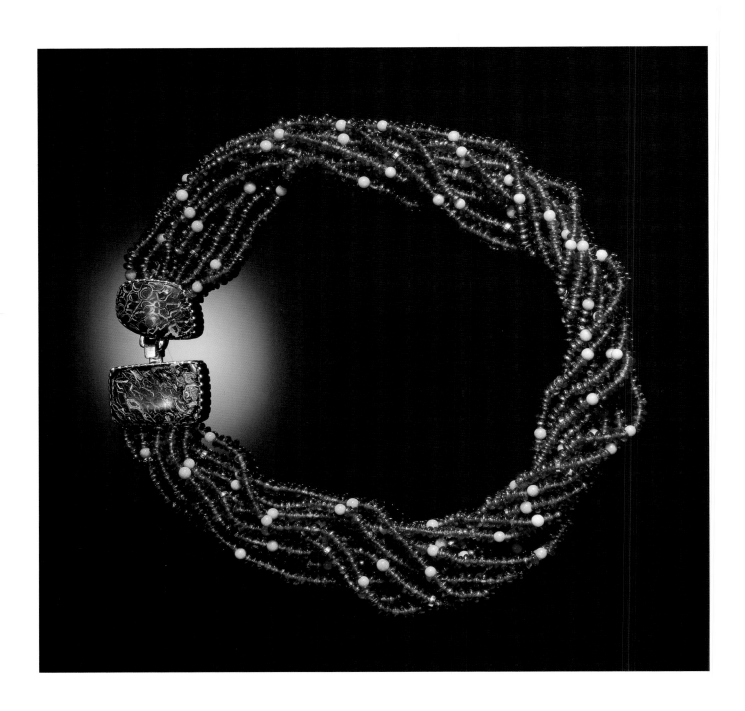

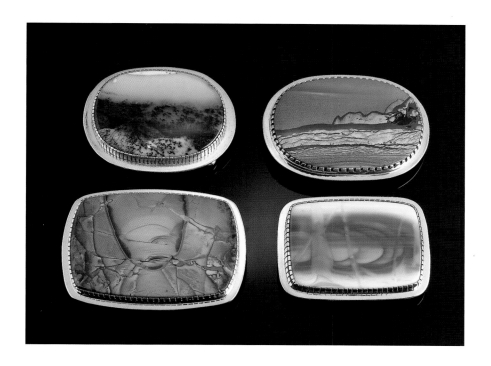

Opposite: 80. Garnet and coral necklace with Yowah opal clasps, 18k gold, 1999, 16 inches long. Private Collection.

81. Clockwise from top right: Parrel plume agate and silver buckle, 1998, 2 x 2.5 inches. Deschutes jasper and silver buckle, 1990, 2 x 2.75 inches. Imperial jasper and silver buckle, 1990s, 1.75 x 2.5 inches. Morrisonite, silver, and 14k gold buckle, 1992, 2 x 3 inches. Charles Diker Collection. Reverse, designs in silver overlay, clockwise from top: Hearts surround a pottery bobcat with stamp work and a 14k gold drop for his eye. Two mountain lions in a thunderstorm. A stylized Hopi pottery bird above a lightning cloud from a painting. A deer from Zia pottery in a hailstorm, with a 14k gold tufa-cast bar mid-body and a 14k gold drop for an eye.

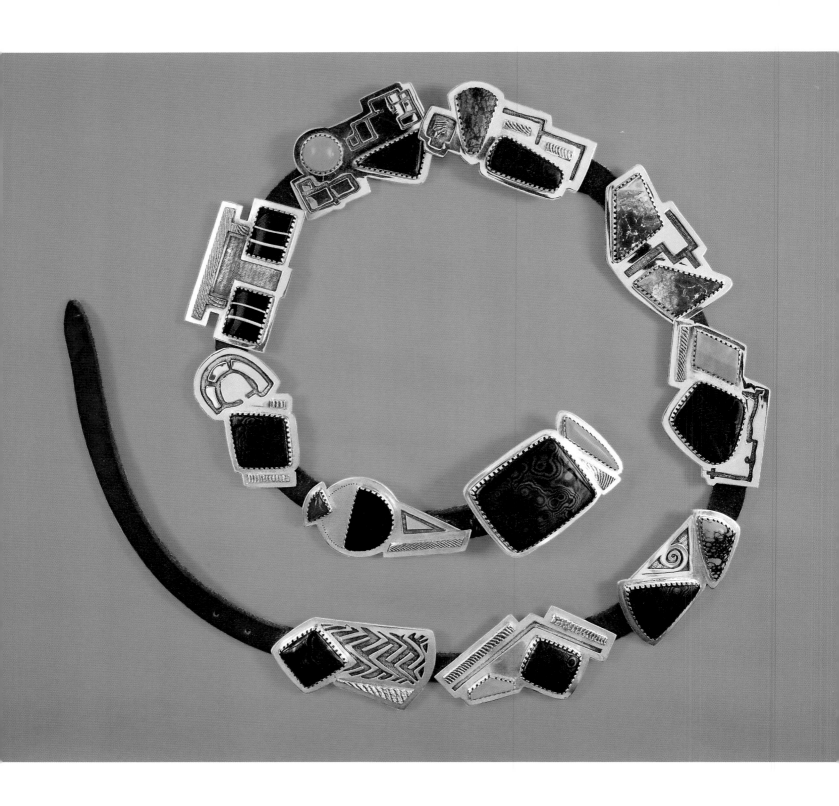

Opposite: 82. "Chaco Canyon Belt,"
December 1989. Photograph by Tom Gessler.

83. Clockwise from left: Coral and 18k gold
ring, 1990. Blue chalcedony and 18k gold ring,
2003. Lapis lazuli, silver, and 14k gold ring,
1978, Y hallmark. Private Collection.

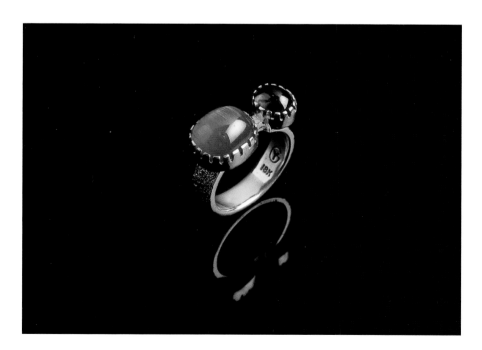

84. Sapphire, cat's eye tourmaline, and 14k gold
ring, 1990s. This was Johnson and Bird's first
ring to incorporate two stones. Private
Collection.

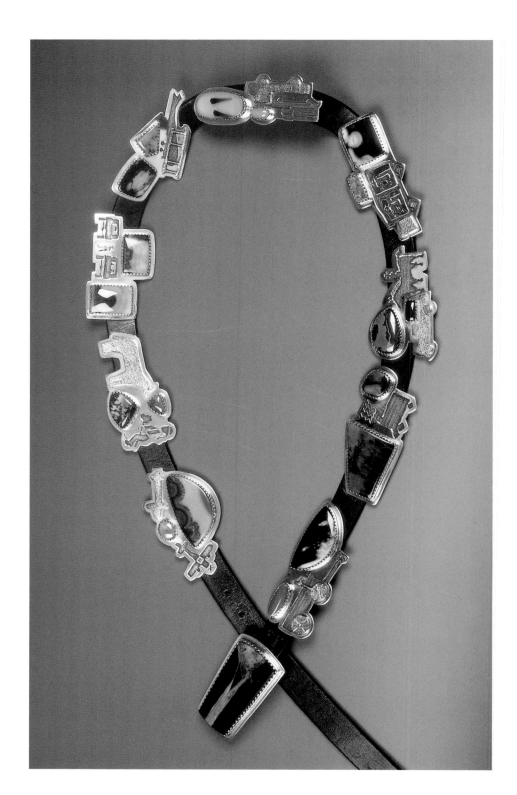

85. "Transportation (Going Home) Belt,"
August 1998. Photograph by Kevin L.
Suckling.

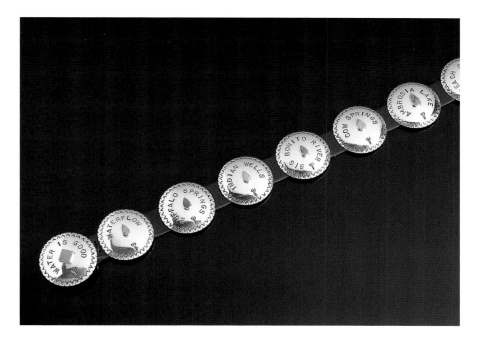

86. "Four Corners Water Belt," silver and turquoise, 1981. This belt was made for the "Water Show" at Owings/Dewey Gallery. Nat Owings envisioned a series of shows based on the elements of earth, water, fire, and air, of which the "Water Show" was the first. The belt and canteen were displayed on a New Mexico pine shelf below a vintage New Mexico map that contained the place names stamped on each concho. Each turquoise represents a drop of water. David and Suzy Pines Collection.

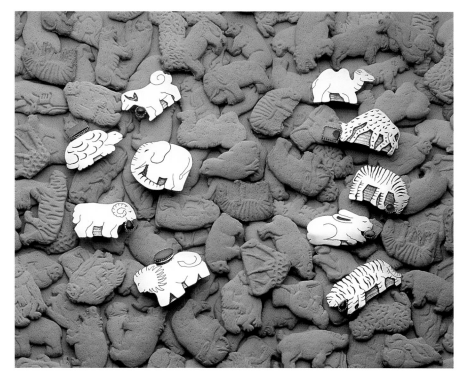

87. "Animal Crackers Belt," silver, lapis lazuli, coral, Bisbee turquoise, Montana agate, carnelian, amethyst, Manassa turquoise, 1988–89, buckle 5 x 1.75 inches. This was made for an auction to benefit the Santa Fe Children's Museum. The belt parts are photographed with their inspiration, animal crackers. Photograph by Richard L. Faller. Private Collection.

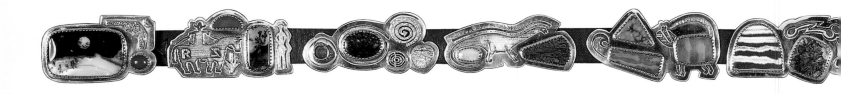
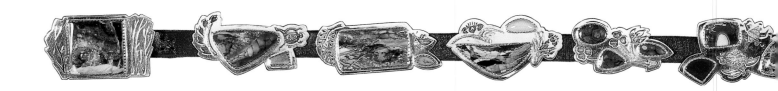
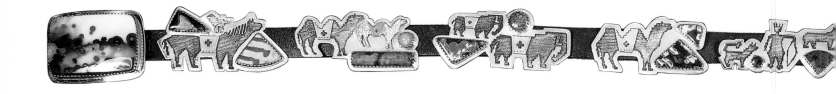
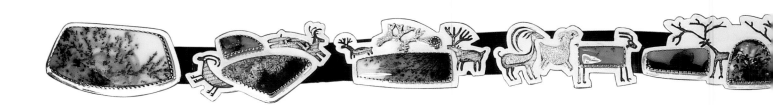

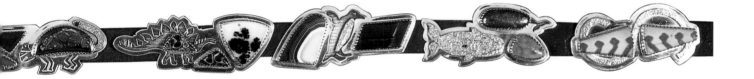

88. "Collector's Belt," June 1995

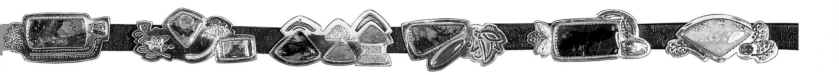

89. "Four Seasons Belt," July 1996

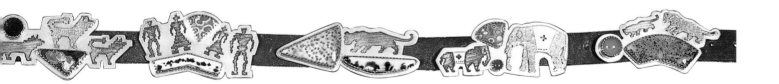

90. "Circus Basket Belt," August 1997

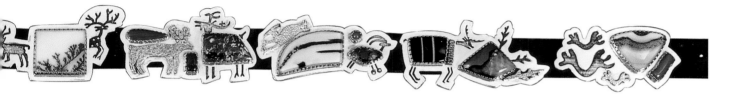

91. "Antlers Belt," February 1998

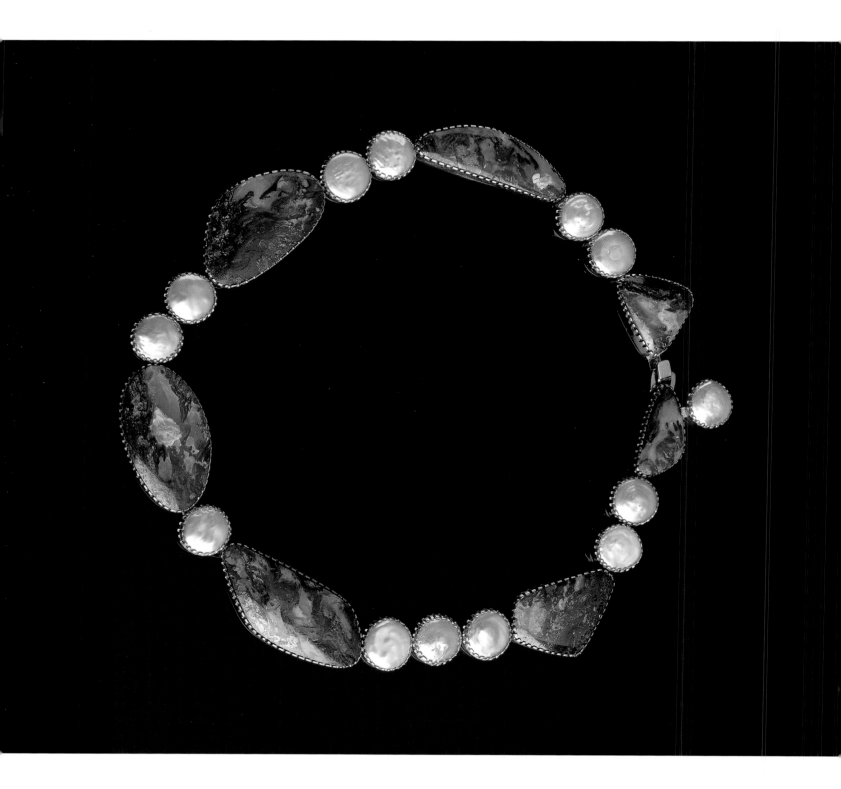

Refining Direction

I N HER LETTER that accompanied the 1995 "Route 66/Tourism Belt," Gail Bird referred to it as playful; it marked a transition to lighter and more whimsical themes. The "Protein Belt" in 1999 continued this whimsy, with Johnson's portrait of a cow on the reverse of the buckle (figure 93). This was the first time they added a large appliqué of gold on the reverse, although they had used small accents in prior years. The image of the cow was surrounded by a design of a gold appliquéd picture frame because, according to Bird, "the belt was starring the cow." The 2000 belt "Spots and Dots" has lively movement and more action than the prior belts (figure 94). Tails curl, chickens abound, and the stones perfectly exemplify the theme. Johnson and Bird's sense of humor is well known to friends, some of whom received anonymous Y2K kits on their doorsteps prior to New Year's Day 2000. Each kit included a manual flashlight, a bucket to collect rainwater, a one-ounce ingot pendant of silver for barter, and six Hershey's candy bars for nourishment and possible trade. The kit was to be held until an emergency, but several recipients have confessed to eating the candy bars almost immediately. The couple's other witty creations include the "No Coyote" pins that show a coyote with a bar slashed through it. They made a series of individual heart pins one

92. Yowah opal, coin pearls, and 18k gold necklace, 2001, 7 inches in diameter. Seven of the larger pendants have designs on the reverse in overlay that include birds from Hopi pottery, a dragonfly with three stars, and stylized birds. The reverse of the pearls is textured 18k gold. James and Jeanne Manning Collection.

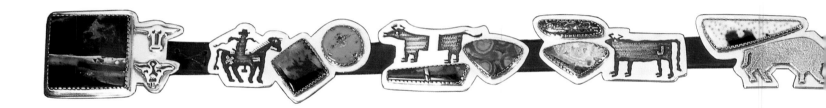

93. "Protein Belt," August 1999

Valentine's Day that featured a heart with holes through it called "Heart Like a Sieve," heart with a hotel broken in the middle called "Heartbreak Hotel," and a heart with a line slashed through it called "No Love Heart."

The trend toward playfulness in the belts was interrupted by the creation of the elegant "Butterfly Belt" in 2001 (figure 95). That year the artists were asked to be guest curators for an exhibit drawing from the permanent collection at the Heard Museum. As the second in a series of three sequential exhibits titled "Be Dazzled! Masterworks of Jewelry and Beadwork from the Heard Museum," it included metal jewelry selected by Johnson and Bird and beadwork selected by Maynard Lavadour. Johnson and Bird reviewed approximately 3,000 items in the Heard's jewelry collection and chose about 150 for the exhibit. Their comments were recorded as they reviewed the jewelry. Those pertaining to the items selected were included in the exhibit labels and the catalogue text. Bird also wrote an article for the exhibit catalogue in which she talked about the historic uses of jewelry and the selection process for the exhibit. She and Johnson provided detailed descriptions of the jewelry-making techniques for individual works based on their review. In summer 2001, Johnson and Bird assisted Martha Struever in leading a small group of people to visit museums, artists, and galleries in Arizona and New Mexico for the purpose of studying jewelry. The colorful inlaid Zuni

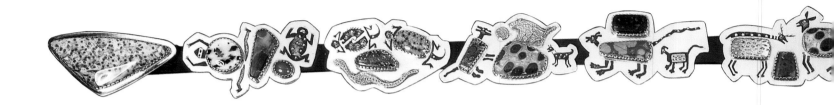

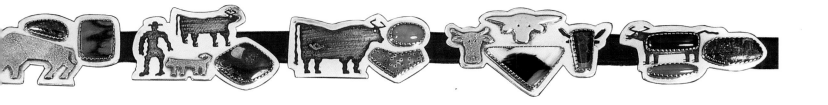

jewelry with butterflies the group saw at the Heard Museum and in other collections served as inspiration for the "Butterfly Belt."

Johnson and Bird have used the butterfly theme in pins, but they never repeat designs from the individual conchos they make for their belts. They look at each belt to consider its composition and total visual impact. For that reason, they do not re-create individual conchos to sell separately. The year they made the "Wildflowers and Butterflies Belt" they used the same color concept and some of the same stones, Laguna agates, for a butterfly pin, but it is distinguishably different from the belt (figure 96). Johnson and Bird have created a variety of butterfly-themed jewelry, particularly pins, throughout the years. Most recent examples are combined with tufa-cast 18k gold (figures 98, 99).

As Johnson and Bird have made more pearl necklaces, their designs have become both more sophisticated and more distinctive. They began to use an assortment of pearls in the late 1980s in exotic shapes, sizes, and natural colors, all with exquisite luster. Johnson and Bird's pearl necklaces became more diverse as they began to select a variety of freshwater pearls such as the flat, round coin pearls and the flat, rectangular shapes. Initially, Lake Biwa in Japan was a primary source of pearls; in recent years a range of pearls in natural colors and unusual shapes have been cultivated in China. The couple has also used South Sea pearls since 1998, when they created their first necklace of black Tahitian pearls (figure 100).

94. "Spots and Dots Belt," August 2000

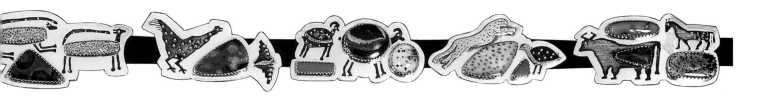

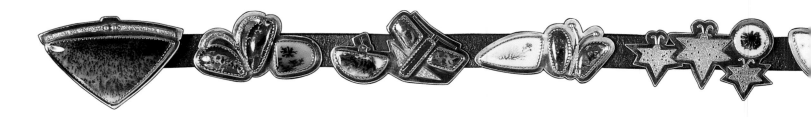

95. "Butterfly Belt," August 2001

96. Butterfly-shaped pin in Laguna agates and silver, 1986, 2 x 3 inches. Johnson and Bird have depicted butterflies in several pins as well as in belts made in 1985 and 2001. Because they view the belts as a unit, they do not re-create any of the conchos as pins, buckles, or other forms. Private Collection.

97. Morenci turquoise, lapis lazuli, azurite, and 14k gold pin, 1987, 1.25 x 2 inches. Johnson and Bird can see monarch and tiger swallowtail butterflies in their garden and they often depict butterflies on pins. Penny Freund Collection.

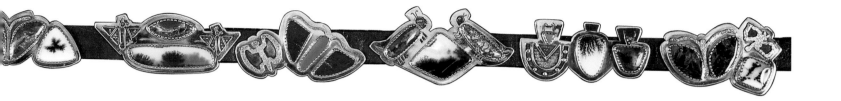

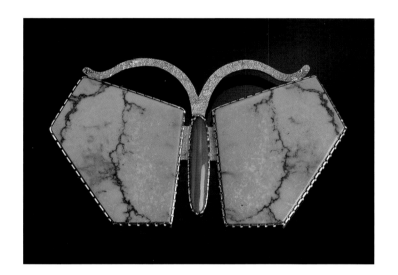

98. Butterfly pin of Tyrone turquoise, coral, and tufa-cast 18k gold, 2006, 2 x 3 inches. Private Collection.

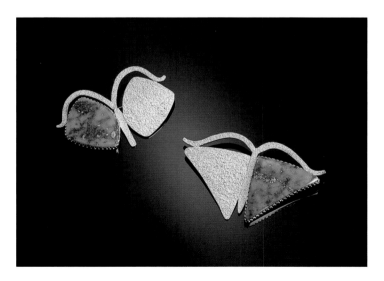

99. Butterfly pins of Morenci turquoise and tufa-cast 18k gold, 2005, 1.5 x 2.25 inches and 1.75 x 2.75 inches. Gift of the magazine *American Indian Art* in honor of the Heard Museum's seventy-fifth anniversary.

100. Single-strand baroque Tahitian black pearls with satellites of Yowah opal and black jade and clasps of black star sapphire and Yowah opal in 18k gold, 1998, 21 inches long. Reverse of larger clasp has a design of a hawk spreading stars. Reverse side of satellites is textured. Mary Cavanaugh Collection.

Opposite, top: 101. Mabe pearls and tufa-cast 18k gold earrings, 1997. Freshwater pearls and tufa-cast 18k gold pin, 1997, 4 inches long. The earrings were the first Johnson and Bird made in this style and were the prototype for the ones that appeared on the invitation for a sale at the Heard Museum on December 14, 2000. The pin, made for the same event, is the prototype for the earrings and was cast in two pieces. Private Collections.

Johnson and Bird's pearl necklaces retain the distinctive quality of their other jewelry through the incorporation of agates, jaspers, and a wide variety of stones. No other jewelers have combined precious and semiprecious materials in such a bold way. For more than a century American Indian jewelers in the Southwest have set traditional materials like turquoise in bezels, but Johnson and Bird were the first artists to incorporate satellites of bezel-set stones in pearl necklaces.

Another type of necklace combines bezel-set stones with detailed designs in 18k gold overlay, or "underlay" as the artists prefer to call it. Using the natural contour of the stones, Johnson and Bird have selected Yowah opals, placed them in 18k gold bezels, and combined them with bezel-set pearls or black jade to form unique necklaces. Some of the stones have designs in overlay on the reverse sides of the bezels, at times alternating with textured gold bezels that hold pearls (figures 92, 135). One necklace has an overlay design under each of the bezel-set stones (figure 103).

Designs in one jewelry form often inspired another. A pair of tufa-cast gold earrings in a curved shape with mabe pearls was a prototype for a pin, then for longer, more dramatic earrings (above). When asked by a customer if the shape was an arrow, Johnson replied, "No, they're love daggers." The piece was actually

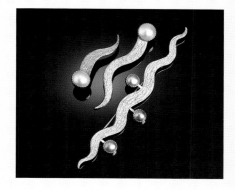

PEARLS

Johnson and Bird choose pearls for their natural color and luster as well as shape and size. They purchase them from reputable dealers who specialize in pearls and gemstones. It generally takes Bird one to three days to grade pearls for a necklace.

Bird uses graph paper to design, plan, and arrange pearls for a necklace of Akoyo pearls from Japan. During this process, she selects stones for individual settings, or satellites, as well as for clasps. Next, she draws the necklace on graph paper. On her desk sits the pearl necklace, graph paper, notebooks of drawings, two boxes of colored pencils and a container of colored pencils, a triangle for measuring and drawing straight lines, raw stones, the finished drawing, and a tray with stones for earrings.

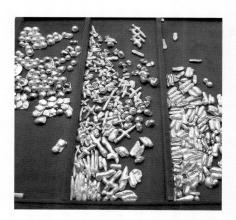

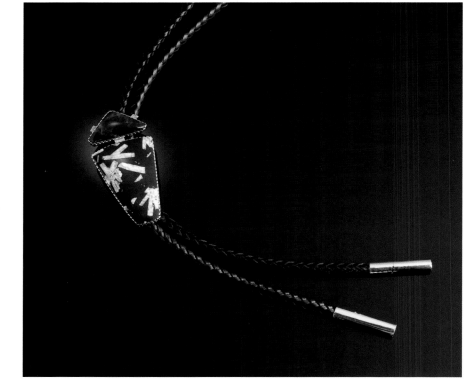

102. Bolo tie of spectrolite and Writing Rock jasper, 18k gold, 2004, 3 x 1.5 inches. Purchased at the Heard Museum Guild Indian Fair and Market. Lanny Hecker and Mavis Shure Collection.

BEZELS

To form a bezel, or a setting for a stone or pearl, a thin strip of metal is cut and shaped around individual stones, then soldered to form a casing. The casing is soldered to a flat sheet and cut to shape. Johnson uses a dremmel and separating disk or a traditional saw to create prong-like edges. The stone is placed in the setting, then the metal is pushed around the stone using pressure to hold it in place. No fixatives are used.

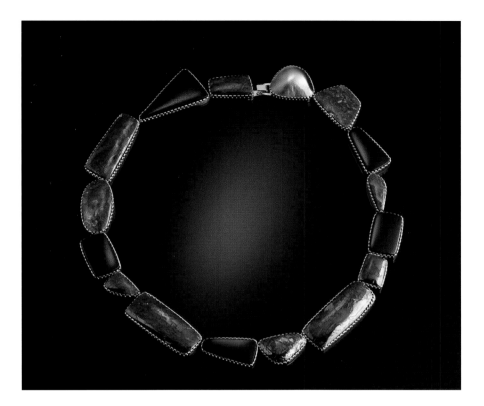

103. A Bezel-set necklace of Yowah opal and black jade with clasps of mabe pearl and Yowah opal in 18k gold, 2002, 7 inches in diameter. This is the first necklace to have a design on the reverse of each setting. Designs include birds, a moth, a dragonfly, and a hand. Private Collection.

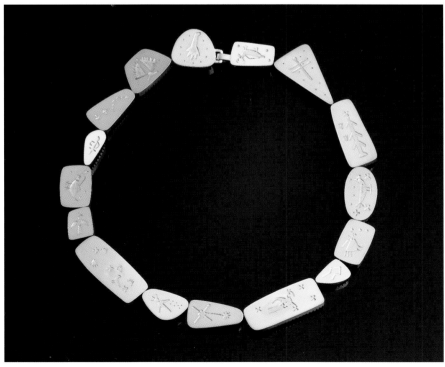

104. South Sea keshi pearl necklace with rutilated quartz and aquamarine clasps and 18k gold, 2004, 17 inches long. Clouds, birds, and stars are on the reverse sides in overlay. Gary, Brenda, and Harrison Ruttenberg Collection.

Opposite: 105. Two-strand lavender freshwater pearl necklace with satellites of Holley Blue agate, blue chalcedony, rainbow garnet (Transvaal garnet), mabe pearl, smithsonite, and lavender freshwater pearls and clasps of blue chalcedony and Yowah opal with 18k gold, 2004, 20 inches long. Private Collection.

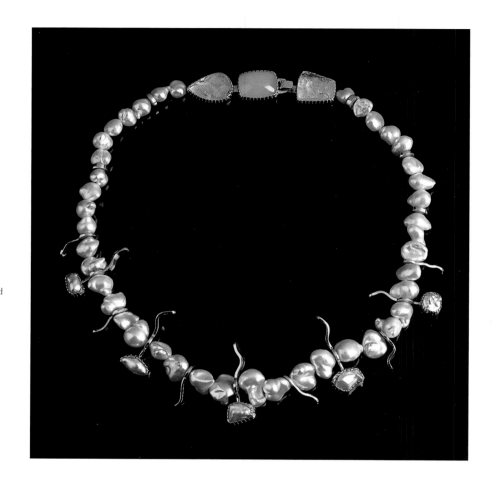

cast as two parts that were joined to form the pin. Johnson tufa cast smaller shapes to form earrings. Also, he cast similar but smaller shapes in 18k gold; he polished them, then Bird strung them with South Sea keshi pearls for an unusual necklace (figure 104). In some pearl necklaces, Johnson and Bird have combined a variety of stones, such as Holley Blue agates, smithsonite, chalcedony, and rutilated quartz, with pearls to emphasize the color and luster of the pearls (figure 105).

Perhaps the least known of the couple's jewelry are their bolo ties, probably because they make only a few each year. They combine unusual shapes and colors in

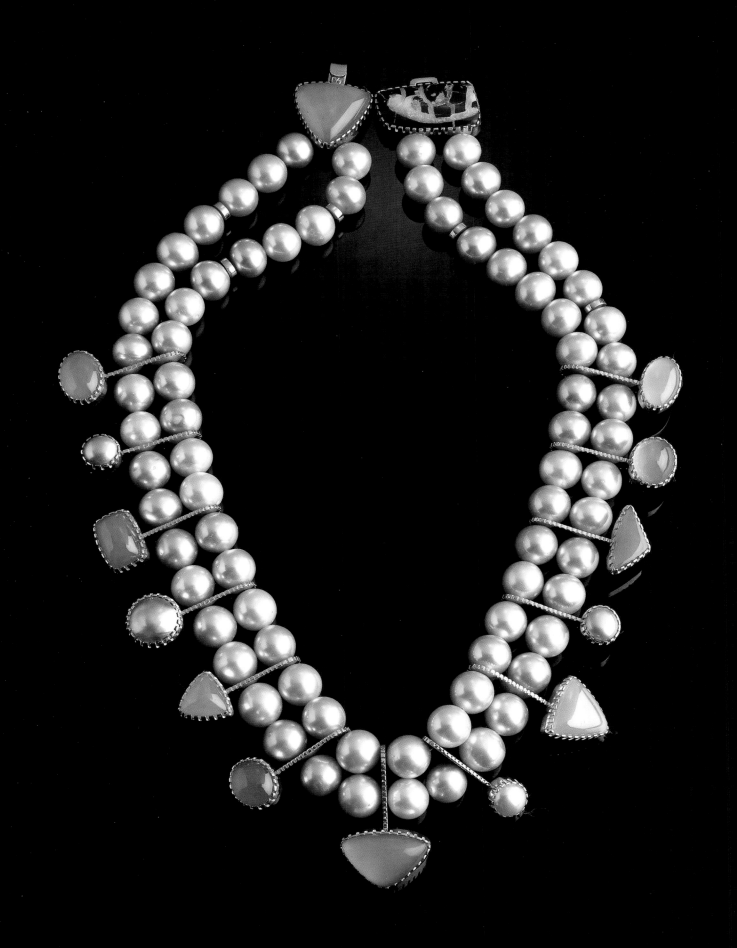

BOLO TIPS

The bolo tips that Johnson and Bird have designed are distinctive. Usually working with gold, Johnson sometimes uses a roller to flatten it and sometimes chooses to texture the surface. He cuts out small four-point stars patterned after Navajo textiles for the design. He forms the hollow tube for the tip by placing a metal sheet over a piece of wood with a half-round groove filed into it, holding a steel rod over the metal and hammering it around the rod.

Yowah opal, Mexican lace agate, and 18k gold bolo tie, 2000, 2.875 x 1.75 inches. Private Collection.

this favorite type of southwestern neckware. Johnson makes the bolo tips and incorporates a signature design of scattered four-point stars cut out of the bolo tips.

In recent years, Johnson and Bird have designed and created new forms of metalwork. In November 2001, the director of the Wheelwright Museum in Santa Fe, Jonathan Batkin, invited Johnson and Bird to see the collection of Navajo spoons being assembled at the museum for an exhibit scheduled to open in 2003. The artists found the spoons with their elaborate stamped designs intriguing and began working on a belt with that theme for the 2003 Indian Market. They were pleased when the Wheelwright approached them to commission a belt, and they agreed to make one but specified the same restriction as in previous commissions: the artists would determine the theme. They decided that the Wheelwright was the best home for the "Tourist Spoons Belt" (figure 109) because of the museum's role in inspiring them to make it and the large number of Navajo spoons in the Wheelwright's collection. Johnson and Bird used designs from the spoons and incorporated stones as they always do in their belts. They chose petrified wood, old turquoise, and coral to reflect jewelry made for tourists from the 1930s to the 1950s. Johnson often makes his own stamps, and he made many of the stamps used for this belt. A single design could require as many as seven to eight stamps, each added individually to re-create the complexity of one older design. The belt was delivered in June 2003 and included in the museum's exhibition "A Stirring Story: Navajo and Pueblo Spoons," which had opened that May.

Johnson and Bird's belt was displayed in a special case along with spoons that had been created and donated by different artists for a Wheelwright benefit auction, including two of their own. They based their spoons on the historic profile spoons they had seen in the Wheelwright collection and called the pair "Batkin at Your Service." They depicted Jonathan Batkin in profile wearing different clothing. One was titled "Batkin at Work" and the other "Batkin at Play" (figure 107). When they decided to sell to the Wheelwright the belt they had planned for Indian Market, Johnson and Bird stepped up work on a belt of a different theme. That year they based their belt for Indian Market, "Frogs and Dogs," on their two

dogs, Ernie and Dot, who liked to play a game of catch and release with frogs they found near their home. The artists returned to their playful mode and used Mimbres-style frogs, which appear to be hopping across the conchos as the dogs bark at them (figure 110).

That same year, Johnson and Bird were asked to donate service ware for a benefit auction held in conjunction with an exhibit at the Heard Museum North, a satellite museum in North Scottsdale. The exhibit, "Metalworks: Containers of Form, Function and Beauty," included predominately silver containers by a diverse group of artists. Johnson and Bird designed and made a serving spoon and fork out of forged and hammered sheet silver, the first they had made in their careers (figure 106).

Johnson and Bird served as both staff and participants during Martha Struever's educational seminar in the Four Corners area in summer 2003. According to Bird, "While driving the van through Monument Valley, Yazzie was asked, 'What do children do here?' The discussion revived childhood memories of playing near rocks and sheepherding. Sheep and sheepherding became the subject for the 2004 Indian Market belt" (figure 111).

Johnson and Bird often have an idea for a belt years before they actually make it. They might work on three or four ideas at a time before choosing the one they think is the strongest for that year. They keep old drawings and pictures

Left: 106. Serving set of forged and hammered sheet silver, 2004, 10 inches long. This was the first example of serving utensils made by Johnson. Private Collection.

Right: 107. "Batkin at Your Service" pair of spoons and untitled spoon, forged and stamped coin silver, 2004, 8 inches long. The spoons represent Jonathan Batkin, director of the Wheelwright Museum: "Batkin at Play" (top) and "Batkin at Work" (center). They are stamped "IHM" (Indian Hand-Made) and "AWMI" (And We Mean It). Johnson and Bird gave the untitled spoon at the bottom to Jonathan and Linda Batkin in a bowl of mashed potatoes on Thanksgiving 2004. The image is based on a photograph that Bird took in which Jonathan Batkin wears a party hat. Wheelwright Museum of the American Indian Collection and Jonathan and Linda Batkin Collection.

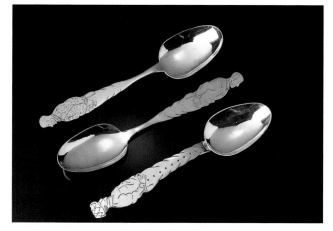

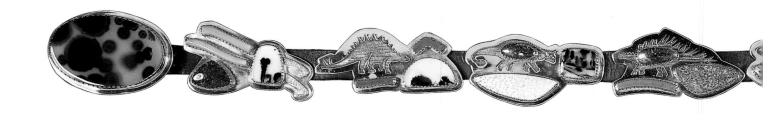

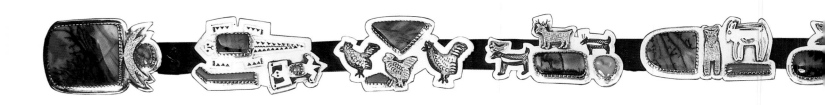

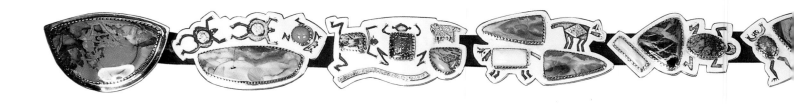

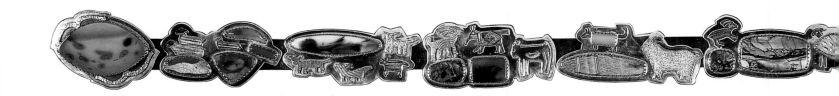

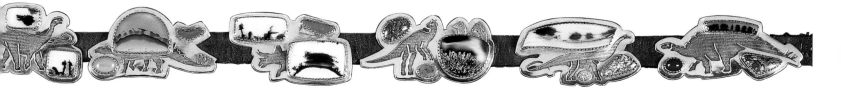

108. "Dinosaur Belt," August 2002

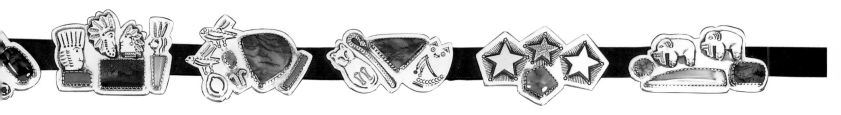

109. "Tourist Spoons Belt," June 2003

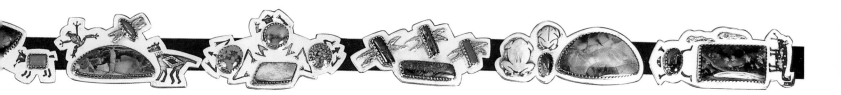

110. "Frogs and Dogs Belt," August 2003

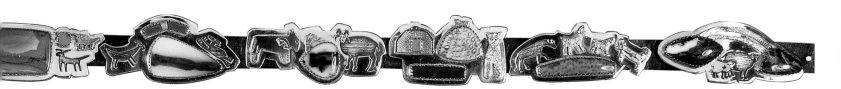

111. "Sheepherding Belt," August 2004

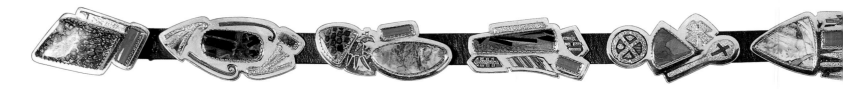

around as catalysts for new ideas. Bird makes a series of notes on graph paper, including lists of what they could use and what could change. She also makes notes on stone choices. They wanted to use only dinosaur bone in the 2002 "Dinosaur Belt," but then they felt the stones together were too dark and too small in scale. So, in addition to dinosaur bone, they included Montana and dendritic agates because the markings can resemble plants and animals. They also used branch coral in one instance to represent the curved necks of two brontosaurus (figure 108). Sometimes the lists are long. Sometimes Bird just jots down an idea on the corner of a page.

In 2004, Johnson and Bird began a belt for longtime friend Martha Struever, who has represented their jewelry since 1978. Over the years they had often joked about making a "dealer" belt with "lots of everything," so they titled this one the "All Things Hopi Belt" (figure 112). As with all of the other belts, they kept the theme and choice of materials to themselves. In the preparation of this publication, however, they did allow photography of the finished drawings. Johnson and Bird used their familiarity with Struever's experience as a dealer, and her sense of color, specifically as it related to fashion. She has been recognized as an authority on Hopi pottery, especially the Tewa potter Nampeyo, and on twentieth-century jewelry, most notably that of Charles Loloma. Over a period of six years, beginning in 2000, Struever curated two shows for the Wheelwright Museum in Santa Fe and wrote two catalogues, one on Dextra Quotskuyva, the great-granddaughter of Nampeyo, and the other on Loloma. Johnson and Bird were familiar with Loloma's

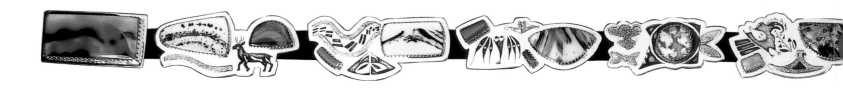

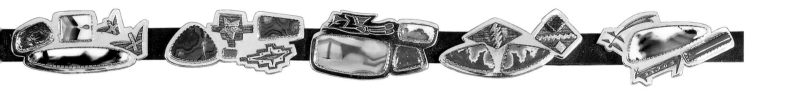

jewelry and, in particular, his references to the landscape in his inlaid stone bracelets, but when they began examining the Hopi pottery in Struever's book on Quotskuyva, they realized that there were parallels between the abstraction of Hopi pottery and Loloma's jewelry.

The rich browns and earthy reds of the landscape, Hopi pottery, and the early work of Charles Loloma became the guiding themes for this belt. The painted abstract forms on Hopi pots recall the positioning of stones and color in Loloma's later work. Johnson and Bird chose red, brown, and gold Montana and Brazilian agates along with other stones that were reminiscent of the mesas, flying birds, parrot beaks, and wings that are depicted in Hopi pottery. The vivid images in Struever's two books also guided the complex arrangement of stones and symbols. One of the stones in the belt is a pebble Johnson picked up outside of Loloma's Hopi studio, which he cut and polished. Johnson joked that it would be the only stone Struever would remember.

The range of colors in the "All Things Hopi Belt" led Johnson and Bird to plan a belt for the 2005 Indian Market based on Laguna and Acoma pottery colors and designs. "Much has been written about the influence of trade goods to explain the appearance of realistic representations on pottery and other Native arts," says Bird. "Outside influences could share credit with the naturalistic images coinciding with highly abstract depictions of floral and plant images, but we feel it is more a measure of individual artistic imagination present from Mimbres-era pottery to the present. Since much of our work is based on prehistoric and historic art, we

113. "Laguna-Acoma Pottery Belt," August 2005

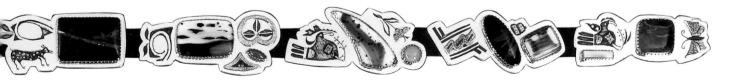

are firm believers in individual genius and originality. This belt is a declaration of that belief."

Bird begins a belt by making sketches so that she and Johnson can refer to them as the design changes. The early belts were based on original drawings. Johnson described the early drawings and the process in a 1981 interview with John Adair: "They are just little stick figures. From them we will have a basic idea of what we are going to do on a belt—theme for a belt—then we work from that. Then Gail does all the drawings and labels them as antelope or whatever it is going to be. . . .[She] cuts them out—sometimes when we wait to see how the stones work with each other and the shapes—[she] will cut out the drawings that Gail has done—and then like paper dolls [she] will just lay them out and see how the designs and shapes go with each other after that we will redraw it."[1]

For more recent belts, they have used the photocopy machine to enlarge or reduce drawings or designs from a book. Bird draws individual conchos on graph paper, but not in the final order they will be arranged for the belt. She cuts them out, arranges them, and pastes them in order. She colors the drawings, which are actual size, with pencils. After she draws the belt, Johnson and Bird may go back and decide on details to be added.

In the early belts, the conchos were two inches wide, while conchos in recent belts may be as wide as three inches. Bird designs twelve conchos with the idea that she and Johnson will eliminate two of them when they review and add to the design. Johnson makes designs for the reverse sides of the buckles used on the thematic belts and for the buckles that are sold separately. Over the years, these designs have included flowers, birds, geometric shapes, and a series of early American quilt designs. Frequently they have used designs from petroglyphs for the reverse sides of buckles.

Each belt has a connection to the prior ones, perhaps in the use of a similar image, similar stones, or similar color palettes. Sometimes the themes are directly related, as with the first belt, "Before the Hunt," and the second, "After the Hunt." The next two belts both incorporated Mimbres-style male figures, as did

Bird at the drawing board for "All Things Hopi Belt."

the first two, but in a different format. Often a design used on one belt refers to an earlier belt.

Throughout their careers, Johnson and Bird have been interested in southwestern jewelry, both historic and contemporary. Bird gives lectures about southwestern jewelry, in which she discusses the development of jewelry in the Southwest, shows the jewelry of contemporaries, and talks about the inspirations

The anvil Johnson now uses is a new 125-pound Nimbus model of old Italian design.

for their own work. With some artists she shows the correlation between their jewelry designs and the landscape. She has been a guest speaker for the Crow Canyon seminars organized by Martha Struever in the late 1980s, Recursos de Santa Fe in 1986, and for museums including the Millicent Rogers Museum in Taos, the Field Museum in Chicago, and the Heard Museum. For the Crow Canyon seminars and the Field Museum, Johnson provided information on their jewelry construction and techniques, while Bird and Martha Struever both lectured on historic and contemporary jewelry.

In 1986, Bird was preparing her ideas about contemporary Indian jewelry for a presentation on Southwest Indian arts sponsored by Recursos de Santa Fe. Rather than discussing the difference between traditional and contemporary work, she planned to focus on individual style. During an interview at this time, she said, "One person with a great independent mind changes the course of history. Trends that are now thought of as categories began with one person doing

In 2004, Johnson's notebook shows his sketch of petroglyphs from Arroyo del Tejo and a coin pearl necklace (figure 138) with one of the drawings used on the back of the clasp that rests on Bird's original design for the necklace.

something new. People aren't really given that chance now, because they are classified as traditional or contemporary. I am slotted, for this seminar, as a contemporary artist. And yet I have always seen our work as both."[2]

By the early 1990s, Johnson and Bird were deeply knowledgeable about the history of southwestern jewelry, as well as the materials and techniques used to make it. This knowledge came from years of study and from direct work with museum jewelry collections. In 1991 Bird co-curated an exhibit of work by Charles Loloma and Charles Lovato at the Wheelwright Museum in Santa Fe. That same

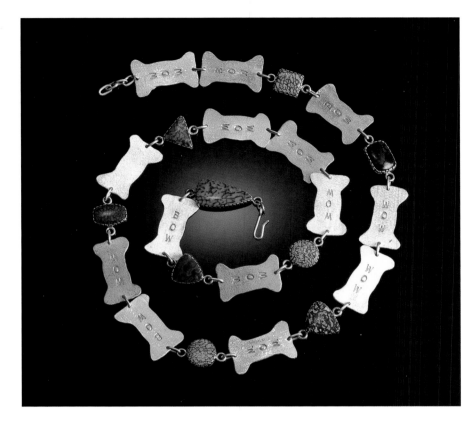

114. "Wow Bow" necklace of silver, dinosaur bone, and 18k gold, 2005, 30 inches long. The reverse of the clasp is a barking dog. The artists donated this necklace in 2005 to an auction called the Bow Wow Pow Wow, which was a benefit for the Wheelwright Museum and the Santa Fe Animal Shelter. Private Collection.

year Johnson and Cippy Crazyhorse co-curated the exhibit "Steady Hand and White Metal: Time and Tools in Southwest Indian Jewelry" at the Museum of Indian Arts and Culture in Santa Fe. Crazyhorse is a highly respected silversmith, whose father, Joe Quintana, was also a well-known jeweler. Because two jewelers worked in collaboration as the curators, this was a landmark exhibit. Abbreviated versions of Johnson and Crazyhorse's comments about the pieces were included in the show's object labels.

Johnson and Bird believe that their thematic belts define their work. Santa Fe Indian Market has given them the impetus to complete one every year since 1979. The only year one was not displayed at Indian Market was 1984, the year they made the "Mimbres Black and White Belt," which was so complicated they

did not complete it in time. Through the years, their belts have shown a wide variety of themes, from those made to appeal to the southwestern collector to more light-hearted works with whimsical animals. Every year their belts capture the imaginations of those who have the opportunity to gather at their booth on the north side of the plaza in downtown Santa Fe.

For Johnson and Bird, their jewelry is just one aspect of their lives, which center on art, community, home, their family and friends, and their garden. They express their ideas about color, design, beauty, and humor through the jewelry that they make with meticulous craftsmanship. Their collaboration is a true partnership of shared ideas. Each brings creativity and innovation to a foundation of knowledge of traditional jewelry and a willingness to explore and experiment.

"I think what I like most about working is surprising myself and others with what Yazzie and I do and why we do it," Bird said in 1985. "Most people have a preconceived idea of what Indian jewelry is and when they see our work, they're not sure if it's Indian or not. I like that. I also like working with Yazzie, sharing ideas, growth and credit. Our jewelry is a collaborative effort. Even though Yazzie is the silversmith and I am the designer, our individual efforts become the work of one." [3]

Yazzie Johnson and Gail Bird at their booth, Santa Fe Indian Market, 2004. Photograph by T. G. Mittler.

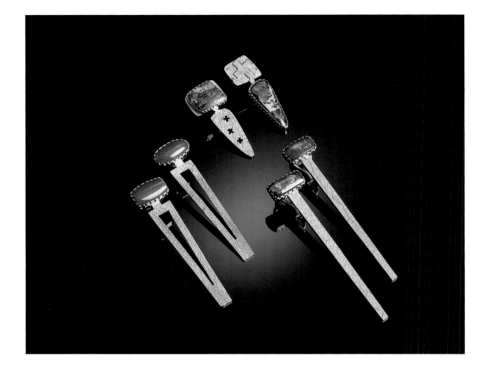

115. Clockwise from top: Yowah opal and tufa-cast 18k gold earrings. Yowah opal and tufa-cast 18k gold earrings. Coral and tufa-cast 18k gold earrings, 2003. HMC Collection and Private Collection.

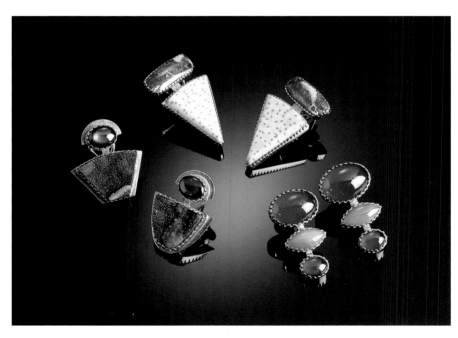

116. Clockwise from top: Yowah opal, petrified palm wood, and 18k gold earrings, late 1990s. Garnet, coral, and 18k gold earrings, 1999. Black star sapphire, drusy, and 18k gold earrings, late 1990s. Private Collection and HMC Collection.

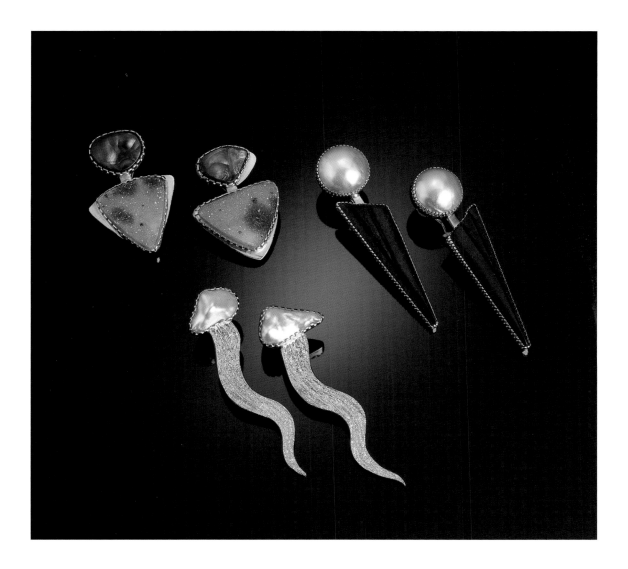

117. Clockwise from top: Fire agate, drusy quartz, and 18k gold earrings, 2001. Mabe pearl, Dieter Lorenz carved black onyx, and 18k gold earrings, 2002. Australian keshi pearls and 18k gold tufa-cast "love dagger" earrings, 1999. At this point, earring pairs of varying sizes are more typical than not. Martha H. Struever Collection.

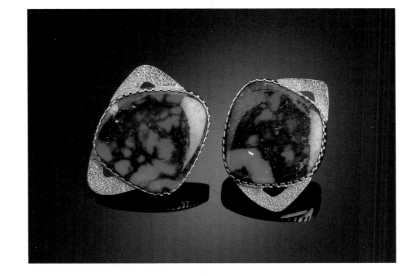

118. Bisbee turquoise and tufa-cast 18k gold earrings, 2002. Martha H. Struever Collection.

119. From top: Yowah opal and 18k gold pin, 2003, .5 x 2 inches. Brecciated jasper and 18k gold pin, 2005, 1 x 2.75 inches. Dieter Lorenz carved dendritic agate, fire agate, and 18k gold pin, 2003, 1 x 2.75 inches. Michelle H. Serra and Brad Tompkins Collection and Martha H. Struever Collection.

120. Left to right from top: Gem silica and stalactites in quartz, 18k gold, 2005. Yowah opal and 18k gold earrings, 1998. Queensland opal, iolite, citrine, and 18k gold earrings, 1995. Oxblood coral and 18k gold earrings, 2000. Yowah opal, pearl, and 18k gold earrings, 2003. Freshwater pearls and silver earrings, 2005. Gary, Brenda, and Harrison Ruttenberg Collection.

121. Priday Plume Ranch agate and 14k gold buckle with a design from a Cochiti bowl in overlay on the reverse, 1996, 2 x 2.75 inches. This is one of two buckles Johnson and Bird made in gold. David and Suzy Pines Collection.

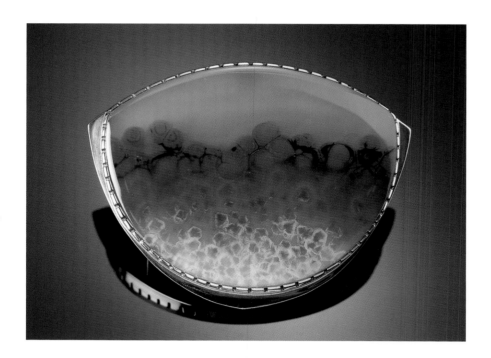

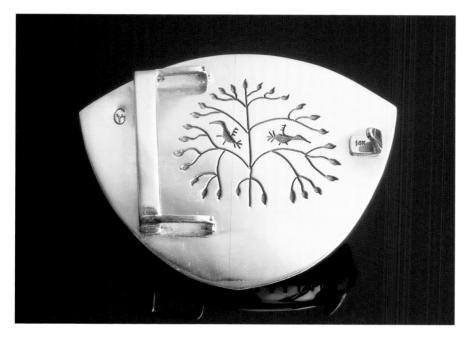

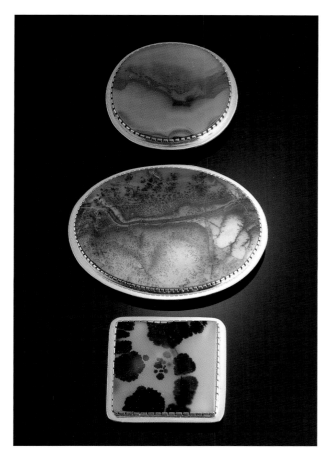

122. From top: Brazilian agate and silver buckle, 1998, 2.5 x 2.625 inches. Burro Creek agate, silver, and 18k gold buckle, 2005, 3 x 4 inches. Montana agate, silver, and 18k gold buckle, 2005, 2.125 x 2.125 inches. George and Lynn Goldstein Collection and Gary, Brenda, and Harrison Ruttenberg Collection. Reverse: A deer dreaming of five deer. A Zia deer and four stars. A bat and four dragonflies.

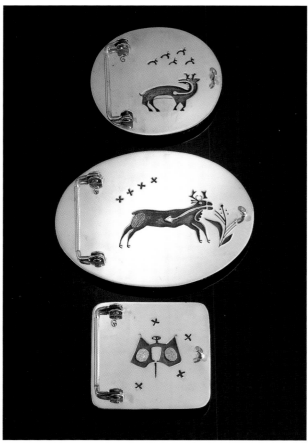

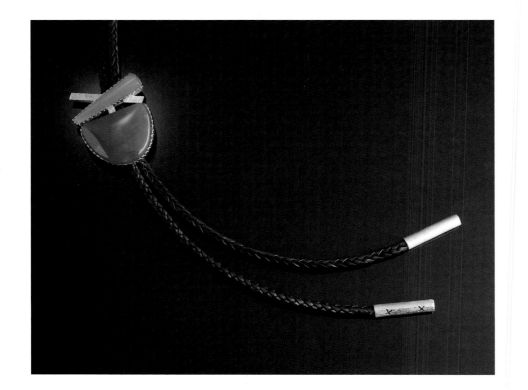

123. Bolo tie of blue chalcedony, tufa-cast 18k gold with textured gold tips, 2000, 2.5 x 2 inches. James and Jeanne Manning Collection.

124. Bolo tie of Koroit opal and petrified palmwood, 18k gold, 2002, 3.75 x 1.5 inches. Purchased at the Heard Museum Guild Indian Fair and Market. Lanny Hecker and Mavis Shure Collection.

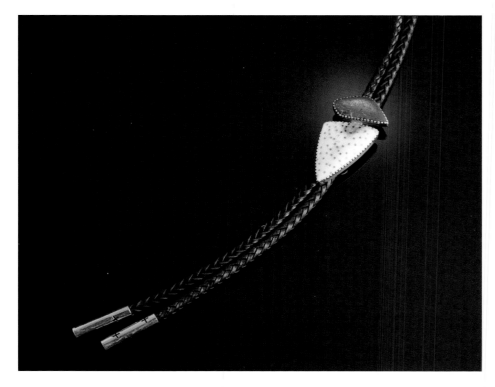

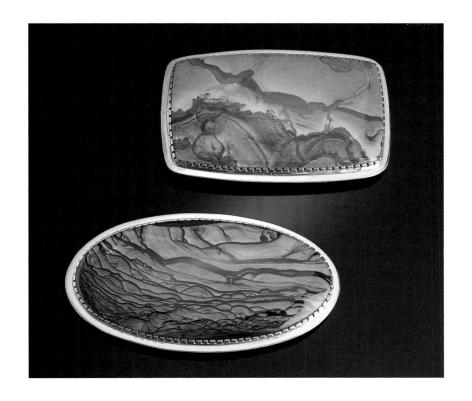

125. From top: Wild Horse picture jasper, silver, and 18k gold buckle, 2005, 2.25 x 3.5 inches. Biggs jasper, silver, and 18k gold buckle, 2006, 2.25 x 4.25 inches. Private Collection and Lamar Meadows Collection. Reverse, in silver overlay with 18k gold appliqué, from top: A deer, plants, and five stars. Animals from a field of petroglyphs.

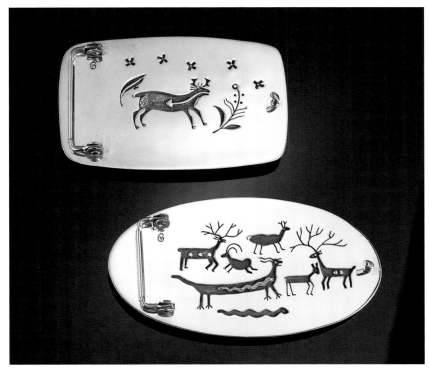

126. Three-strand coral necklace with coral clasps and 18k gold, 1998, 32 inches long. This was the second necklace Johnson and Bird made to meet the criteria of the Indian Market rules that limited coral to 50 percent of the jewelry composition. Dr. and Mrs. E. Daniel Albrecht Collection.

Opposite: 127. Eight-strand coral bead necklace with satellites of black jade, onyx, and snowflake obsidian and clasps of mabe pearl and opal, 18k gold, 2000, 28 inches long. A design of a fox is in overlay on the reverse of one of the clasps. Gary, Brenda, and Harrison Ruttenberg Collection.

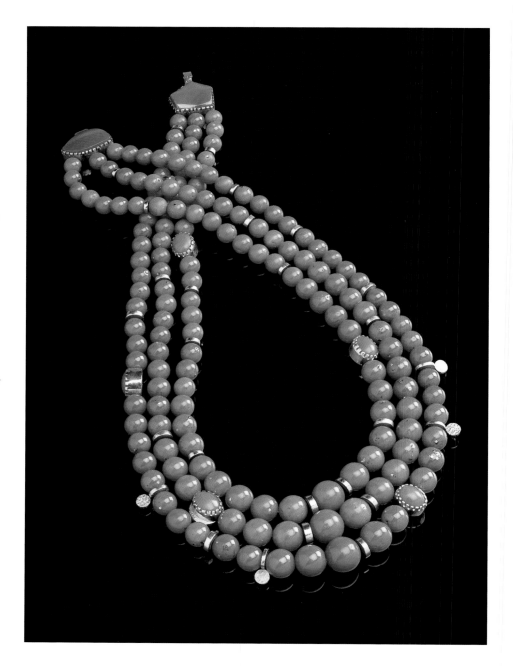

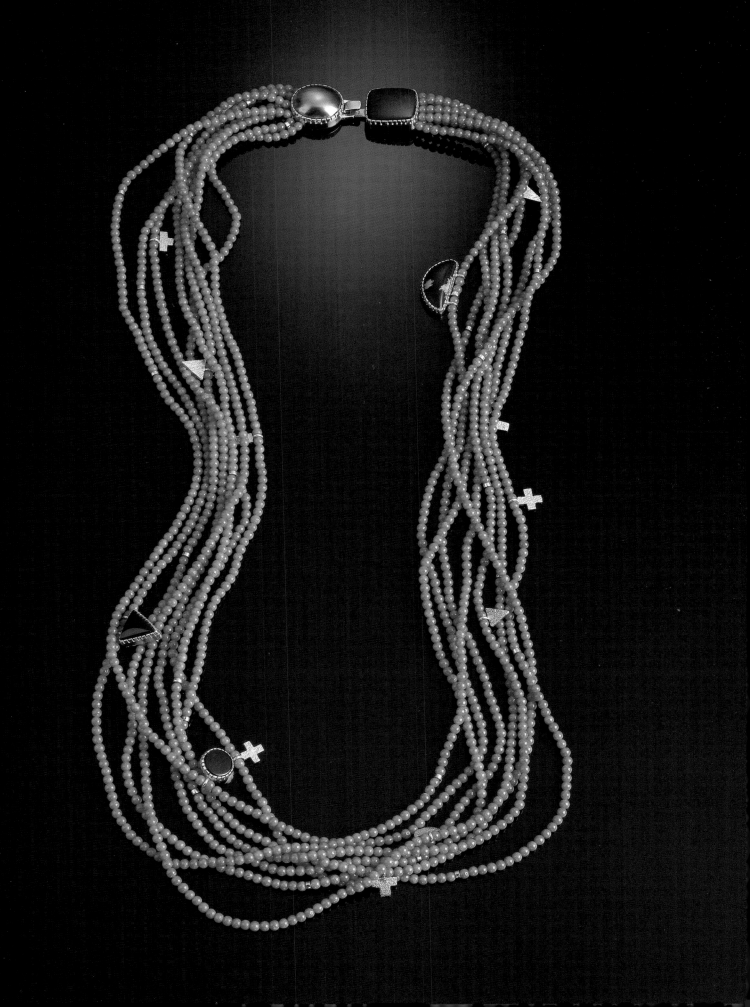

128. Double-strand necklace of Black Tahitian pearls with spectrolite clasps and satellites of spectrolite, blue chalcedony, and rainbow moonstones, 18k gold, 2003, 18 inches long. South Sea blister pearl, black star sapphire, and 18k gold earrings. Martha H. Struever Collection.

Opposite: 129. Single-strand amethyst necklace with a single satellite of black Mexican mabe pearl, a double-sided satellite of black sugilite and black onyx, and a double-sided satellite of Holley Blue agate and a dragonfly design, clasps of amethyst and black sugilite, 18k gold, 1996, 36 inches long. Eileen Wells Collection.

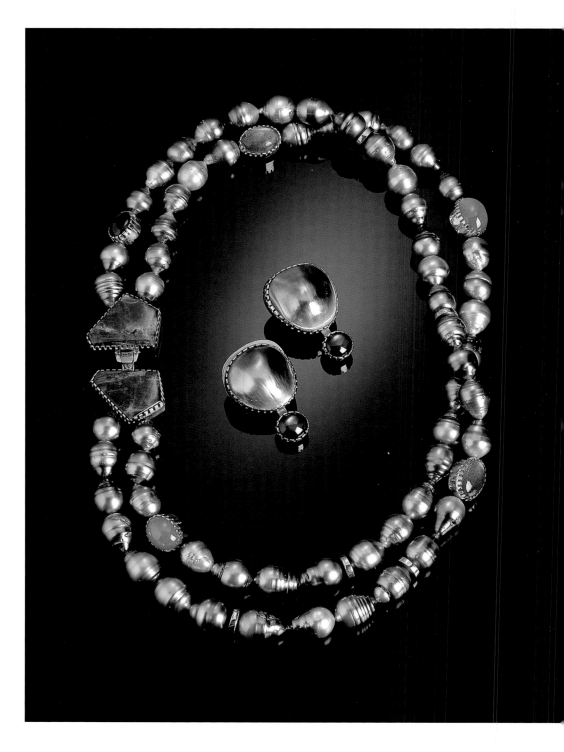

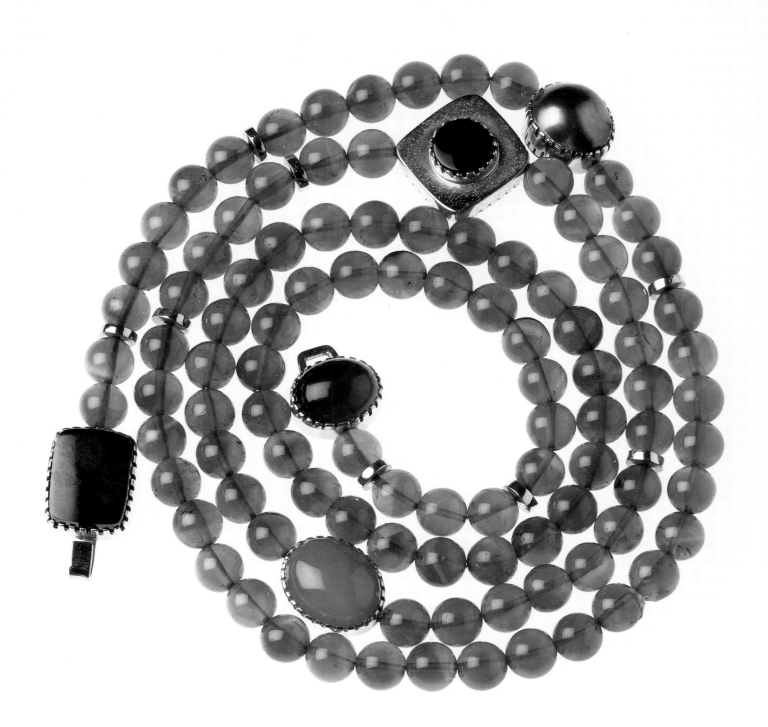

130. Single-strand flat Biwa pearl necklace with satellites of lapis lazuli, sugilite, drusy Brazilian quartz, a double-sided satellite of plume agate with tufa-cast back, a double-sided satellite of Coyomito agate with tufa-cast back, a double-sided satellite of drusy Brazilian quartz with tufa-cast back, Yowah opal clasp, 18k gold, 1997–98, 37 inches long. Eileen Wells Collection.

Opposite: 131. Gold baroque pearl rope with satellites of rutilated quartz and rainforest jasper, a double-sided satellite of Yowah opal and yellow opal, clasps of gold mabe pearl and Laguna agate, 18k gold, 1994, 36.5 inches long. Petroglyphs and tufa cast on reverse. Earrings of mabe pearl, rutilated quartz, and 18k gold. Private Collection.

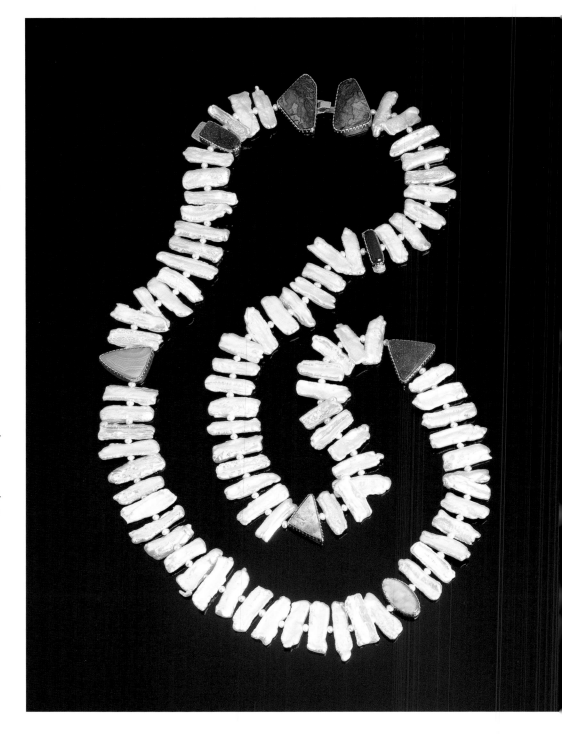

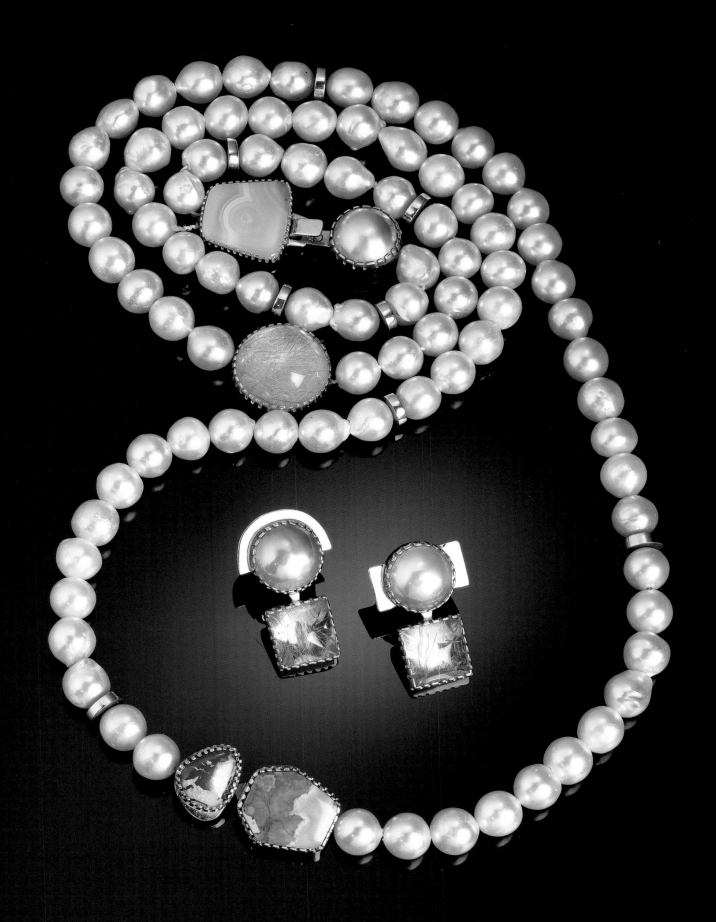

132. Three-strand coral necklace with satellites of coral, black star sapphires, and black jade and clasps of mabe pearl and coral, 18k gold, 2000, 23 inches long. The reverse of the mabe pearl clasp is a naturalistic dragonfly while the reverse of the coral clasp and satellites have stylized dragonflies. JoAnn and Robert Balzer Collection.

Opposite: 133. Five-strand necklace of Biwa pearls with Yowah opal clasps, 18k gold, 2003, 25 inches long. Reverse of clasps have bird petroglyphs from the Albuquerque escarpment. Satellites are blue chalcedony, tourmaline, Holley Blue agate, rainbow garnet, spessartite garnet, smithsonite, and Yowah opal. Reverse of the satellites are roller-mill textured with sandpaper. JoAnn and Robert Balzer Collection.

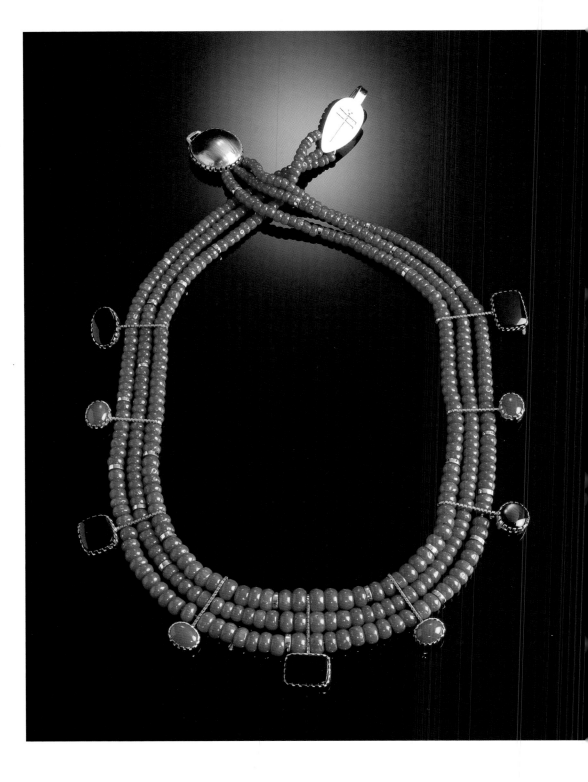

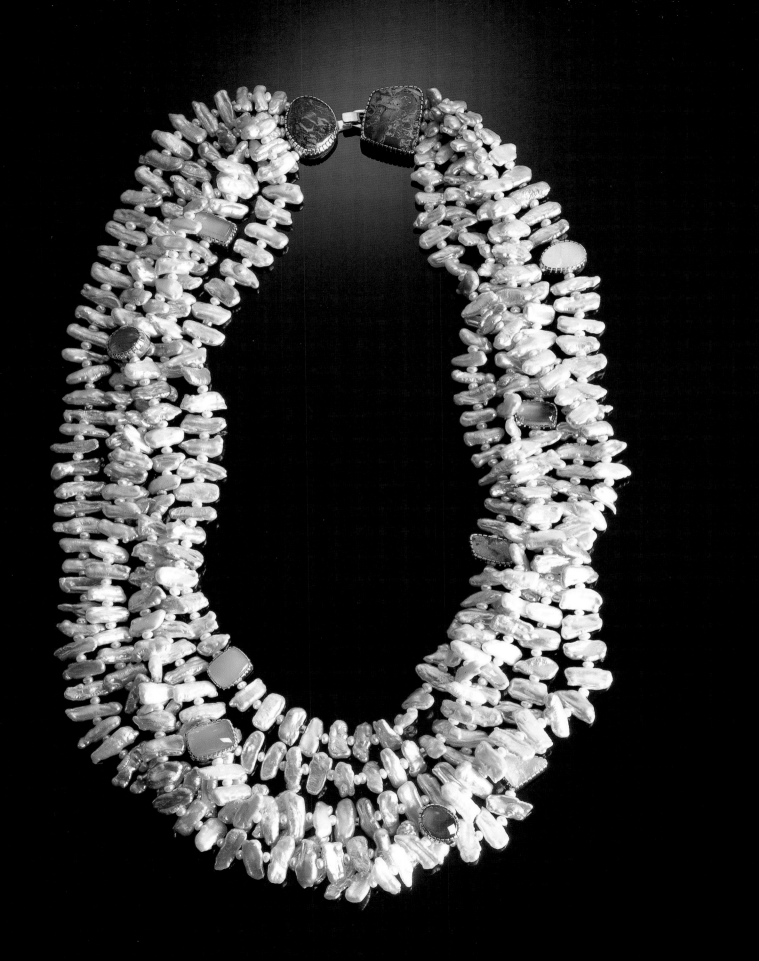

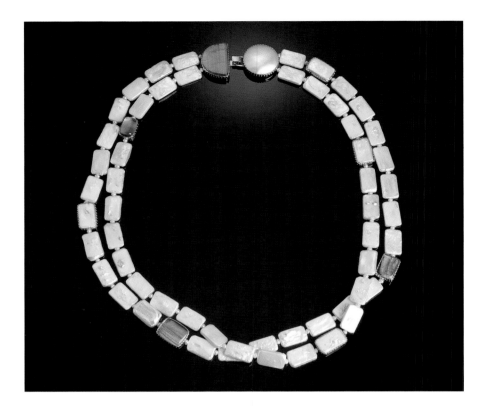

134. Two-strand necklace of pearls, with clasps of mabe pearl and stones and satellites of dendritic agate, tourmalines, and 18k gold, 1998, 21 inches long. Private Collection.

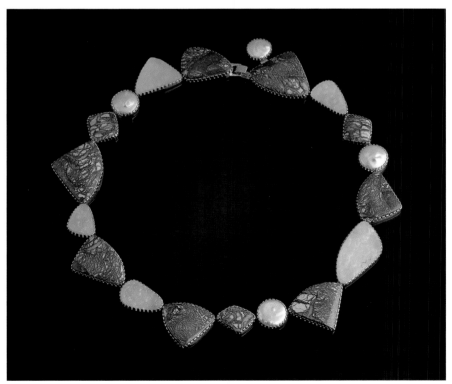

135. Yowah opal, smithsonite, coin pearls, and 18k gold necklace, 2002, 7 inches in diameter. Nine of the large stones have designs on the reverse that are varying depictions of dragonflies surrounded by stamped dots representing mist. A flower and a half flower are included in two of these. The reverse of the pearls and small opals are textured 18k gold. Private Collection.

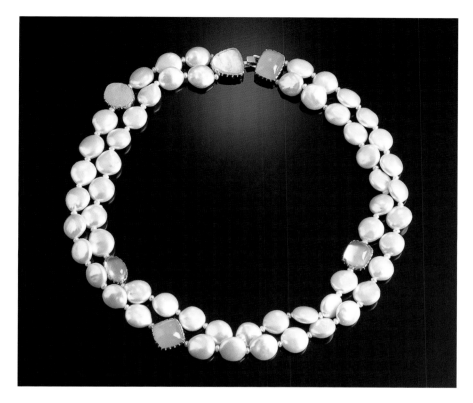

136. Double strand of keshi coin pearls, aquamarine surface, and aquamarine cabochons, 18k gold, 2004, 20 inches long. The reverse design in overlay is of a tree. Private Collection. Reverse showing the overlay designs of the satellites in 18k gold.

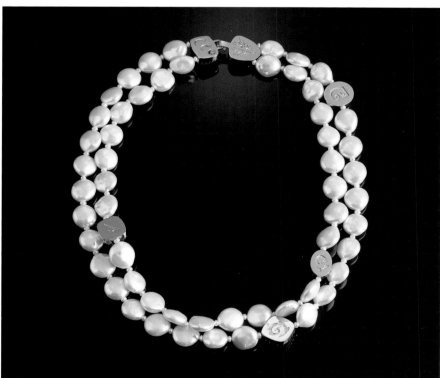

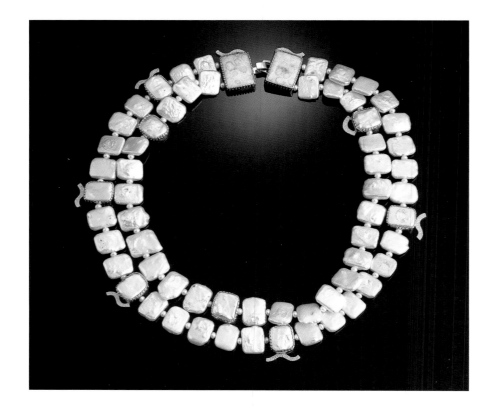

137. Necklace of rectangular coin pearls with clasps of fossil coral and 18k gold, 2003, 18 inches long. Gary, Brenda, and Harrison Ruttenberg Collection.

138. Single-strand necklace of coin pearls, lapis lazuli, chrysoprase, coral, and aquamarine and clasps of Yowah opal and blue chalcedony and 18k gold, 2005, 18 inches long. A design of a petroglyph man is on the reverse of the clasp. This necklace was originally made in 2002 for the American Craft Museum exhibit "Changing Hands I: Art Without Reservations." It was remade and all pearls were bezel-set in 18k gold for the 2005 Indian Market. Marcia and Alan Docter Collection.

139. Double-strand necklace of keshi coin pearls with clasps of blue chalcedony, 18k gold, 2004, 19 inches long. Rona C. Rosenbaum Collection.

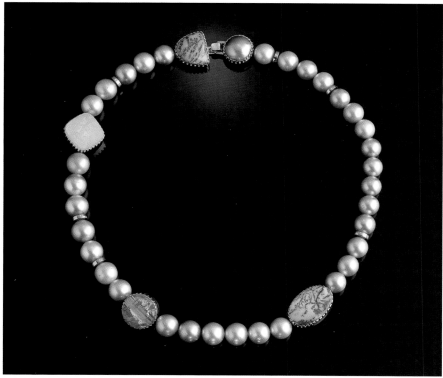

140. Single-strand silver freshwater pearl necklace with satellites of rutilated quartz, yellow smithsonite, and dendritic jasper and clasps of mabe pearl and dendritic jasper in 18k gold, 2005, 17 inches long. Each clasp and satellite has an overlay design on the reverse that includes a butterfly/moth, hand, tree, and turtle. Purchased at the Heard Museum Guild Indian Fair and Market. Lanny Hecker and Mavis Shure Collection.

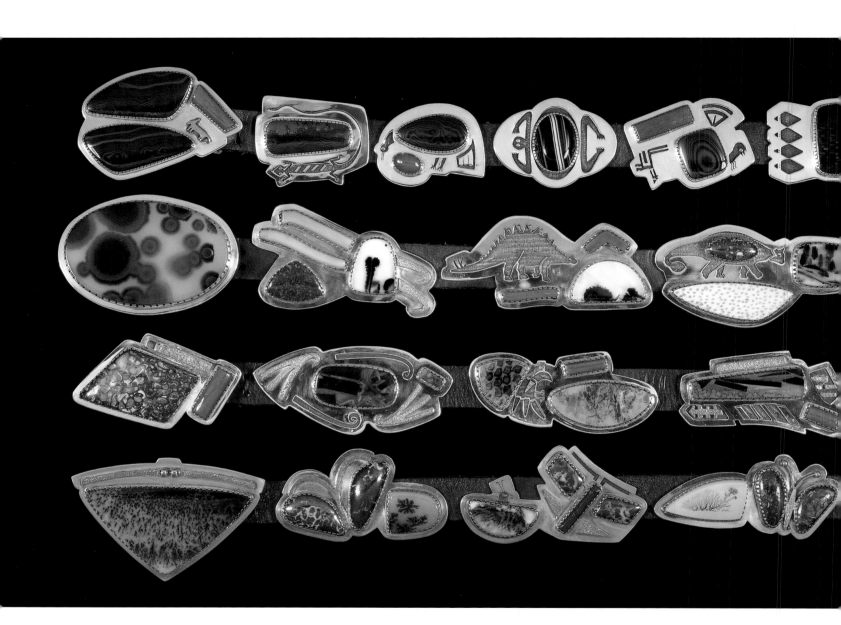

Appendix
Thematic Belts in Chronological Order

Belts by figure numbers showing buckle reverses

9. "BEFORE THE HUNT," JANUARY 1979
This belt was made for and sold during the inaugural exhibit "One Space, Three Visions" at the Albuquerque Museum in New Mexico. Johnson and Bird started working on the belt in the summer of 1978. Each concho is stamped with a Y hallmark but subsequent belts would have the hallmark only on the buckle.

BUCKLE: Owyhee jasper in a brass bezel. Buckle reverse: The head of this figure, made in silver overlay, appears in pictographs at Bandelier National Monument and also on Mimbres pottery designs. This belt is about interrelationships between the hunter and the animals and birds he encounters. The hunter begins his journey with prayer.

1ST CONCHO: Biggs jasper and petrified wood in brass bezels and a deer in silver overlay.

2ND CONCHO: Rocky Butte jasper and a lace agate in brass bezels, Morenci turquoise in a 14k gold bezel, and a red-tailed hawk in silver overlay.

3RD CONCHO: Two Wild Horse picture jaspers in brass bezels and stamp work of a man's footprints.

4TH CONCHO: Bruneau jasper and mastodon ivory in brass bezels and an antelope in silver overlay.

5TH CONCHO: Wild Horse jasper in a brass bezel, Number 8 turquoise in a 14k gold bezel, and an eagle in silver overlay.

6TH CONCHO: Two Rocky Butte jaspers in brass bezels and a 14k gold appliquéd arrow. The top of the concho follows the shape of the smaller stone making this concho more curvilinear and less rectangular.

7TH CONCHO: Wild Horse jasper in a brass bezel, Fox spiderweb turquoise in a 14k gold bezel and stamp work of a man's footprints.

8TH CONCHO: Sodalite in a brass bezel, two Chicken Track jaspers in 14k gold bezels, and a bobcat in silver overlay.

9TH CONCHO: Biggs jasper in a brass bezel, lapis lazuli with quartz inclusions in a 14k gold bezel, and stamped meandering bear tracks.

10TH CONCHO: Rocky Butte jasper and variscite in brass bezels and six sandhill cranes in silver overlay.

11TH CONCHO: Deschutes picture jasper in a brass bezel, coral in a 14k gold bezel, and a bear and bear tracks in silver overlay.

12TH CONCHO: Bruneau jasper in a brass bezel, Number 8 spiderweb turquoise in a 14k gold bezel, and an appliquéd 14k gold overlay of a turtle. This concho has what would become the signature terminal shape for the next several belts. It has a wedge-shaped upper portion and contains three stamped lines and two stones. This is Johnson and Bird's first belt and probably the first time any American Indian jeweler used a combination of various stones and metals in nonmatching concho combinations. Private Collection.

**11. "PETROGLYPH MAKER BELT,"
FEBRUARY 1980**

New York art dealer Joachim Jean Aberbach commissioned this belt after he saw the first belt at Indian Market in 1979. Large stones are used on five of the conchos, distinguishing this belt from the first that Johnson and Bird made. The petroglyph figure on the reverse of the buckle references that of the first and second belts.

BUCKLE: Two Owyhee jaspers from Idaho in brass bezels. A 14k gold arrow is appliquéd below the smaller stone. Buckle reverse: A Mimbres pottery figure making petroglyphs in silver overlay. Johnson used a nail to punch in the surrounding designs. The hallmark is a Y.

1ST CONCHO: Owyhee picture jasper in a brass bezel, carved coral in a 14k gold bezel, and a petroglyph design in 14k gold appliqué.

2ND CONCHO: Owyhee picture jasper and Willow Creek jasper in brass bezels with an antelope in silver overlay; textile-derived stars and the antelope's trail formed by stamp work. This concho extends upward with the shape following the shape of the Willow Creek jasper.

3RD CONCHO: Rocky Butte picture jasper in a brass bezel and a Mexican red lace agate in a silver bezel. The design of a red-tailed hawk spreading stars is formed of 14k gold overlay appliqué. The stars are from Navajo textile designs.

4TH CONCHO: Rocky Butte picture jasper and Deschutes jasper in silver bezels and lapis lazuli in a 14k gold bezel. The silver overlay design is of a field of petroglyphs.

5TH CONCHO: Biggs jasper in a brass bezel and three variscites in 14k gold bezels.

6TH CONCHO: Rocky Butte picture jasper and Mexican lace agate in brass bezels and coral in a 14k gold bezel. Johnson carved and made file marks on the coral. Since Aberbach sold sculpture, Johnson altered the stones to make them more sculptural. Also appliquéd to the concho is a silver overlay turtle with a textile cross in the interior.

7TH CONCHO: Wild Horse picture jasper in a brass bezel, Montana agate in a silver bezel, and stamped bear tracks.

8TH CONCHO: Owyhee jasper and Laguna agate in silver bezels and Morenci turquoise in a 14k gold bezel. The design is of buffalo petroglyphs and was inspired by a buffalo seen on a Sioux shield.

9TH CONCHO: Two Rocky Butte picture jaspers in silver bezels and Morenci turquoise in a 14k gold bezel.

10TH CONCHO: Biggs jasper in a silver bezel and a bobcat in silver overlay with a trail formed by stamp work.

11TH CONCHO: Bruneau jasper in a brass bezel, Laguna agate in a 14k gold bezel, and a silver overlay design of six flying sandhill cranes. This Bruneau jasper is an atypical pink color. The concho has the signature terminal shape with three stamped lines at the tip and contains two stones. Jason Aberbach Collection.

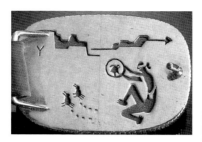

14. "BIRDWATCHER BELT," JULY 1980

This belt was first shown at the Dewey-Kofron Gallery and then shown and sold at Indian Market where it won the Otero Award for Creative Excellence and a Best of Division award. Saw marks were added to several bezels to accentuate the stones, and they were also added on the top edge of the eleventh concho. The petroglyph figure on the reverse of the buckle references that of the first three belts, and an appliquéd gold arrow on the fifth concho of this belt is similar to the one on the buckle of the prior belt. Both belts have the design of the hawk spreading stars.

BUCKLE: Owyhee jasper in a silver bezel. 1.875 x 2.5 inches. Buckle reverse: Johnson and Bird researched Mimbres pottery in numerous published sources and adapted the stylized male figure depicted in various poses. The man with the hoop and bird is portrayed in overlay. There are stylized landscape designs above.

1ST CONCHO: Lapis lazuli in a 14k gold bezel, carved coral in a 14k gold bezel, and Owyhee Junction jasper in a silver bezel. The bird design in silver overlay is from a Peruvian textile.

2ND CONCHO: Morrisonite (also known as Morrison Ranch jasper) in a silver bezel and designs of swallows based on a Quincy Tahoma painting in silver overlay.

3RD CONCHO: Owyhee Junction jasper in a silver bezel and three garnets set in 14k gold. At this point, Johnson was working with a hand grinder, and he could shape the stones if they were broken.

4TH CONCHO: Chilean azurite in a 14k gold bezel, a Mexican Dryhead agate in a brass bezel, and two hummingbirds in silver overlay from *The Sibley Guide to Birds* by David Allen Sibley.

5TH CONCHO: Two Owyhee jaspers in silver bezels and a design of a stylized water serpent appliquéd in 14k gold.

6TH CONCHO: Deschutes jasper and a white moonstone in silver bezels. The stamped design is of bear tracks and an appliquéd tufa-cast field of stars. In this early belt, Johnson was experimenting with tufa casting.

7TH CONCHO: Bruneau jasper in a 14k gold bezel and Deschutes jasper in a silver bezel. A stamped design of a roadrunner is appliquéd to the surface, and a field of stars is in silver overlay.

8TH CONCHO: Rocky Butte picture jasper in a brass bezel, Morenci turquoise in a 14k gold bezel, and a Santo Domingo pottery bird in silver overlay.

9TH CONCHO: Rocky Butte picture jasper in a brass bezel with a stamped design of bear tracks. A hawk with a waning moon in 14k gold was appliquéd.

10TH CONCHO: Ivory in a silver bezel, a Mexican lace agate in a brass bezel, and a Santo Domingo pottery bird in silver overlay. The edge of concho has saw marks.

11TH CONCHO: Rocky Butte picture jasper and variscite in silver bezels. The silver overlay design is of a Mimbres-style bird standing on an egg, which is shaped of variscite. This is the first time Johnson and Bird designed an animal to touch a stone, merging the two into one design. The edge of the concho is stamped.

12TH CONCHO: Willow Creek jasper and lapis lazuli in silver bezels and sandhill cranes in silver overlay. The concho has the signature terminal shape and the tip has three stamped lines. Jean Seth Collection.

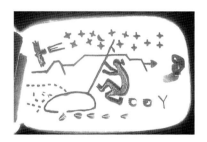

25. "HAWK SPREADING STARS AND MOON OVER THE DESERT BELT," DECEMBER 1980
This belt was sold through Martha Struever's gallery, the Indian Tree, in Chicago. It has a tufa-cast arrow on the buckle similar to the arrows used on the two prior belts. The silver overlay turtle on the eighth concho is similar to but smaller than the one of the sixth concho of the "Petroglyph Maker Belt." The tufa-cast silver field of stars on the fourth concho is like the one on the sixth concho of the previous belt, and this belt has a design of a hawk spreading stars that is somewhat different from the prior belt.

BUCKLE: Wild Horse jasper in a brass bezel with an appliquéd 14k gold tufa-cast arrow. Buckle reverse: Below a star-filled sky, the Mimbres figure holds a spear next to a watering hole surrounded by footprints of night animals. All images are in silver overlay. The hallmark is a Y.

1ST CONCHO: Owyhee picture jasper and a Montana agate in silver bezels. Silver overlay designs of a bighorn sheep, stars, and a mountain that surrounds one star and the sheep.

2ND CONCHO: Morrisonite in a silver bezel and three garnets in 14k gold bezels with two swallows and stars from a Quincy Tahoma drawing in silver overlay.

3RD CONCHO: Deschutes jasper in a silver bezel, Morenci turquoise in a 14k gold bezel, and a stamp-work appliquéd roadrunner and three stars in silver overlay.

4TH CONCHO: Deschutes jasper and a moonstone in silver bezels. There is a tufa-cast appliquéd bar of silver with a design of a comet and six shooting stars and a lizard in silver overlay.

5TH CONCHO: Deschutes jasper in a silver bezel and lapis lazuli in a 14k gold bezel. The design in silver overlay is of a Mimbres-style deer standing on an abstract cliff. Overhead are four stars and a waning moon in silver overlay.

6TH CONCHO: Two Owyhee Junction jaspers in brass bezels and a water serpent from San Ildefonso pottery in silver overlay.

7TH CONCHO: Rocky Butte picture jasper in a silver bezel and a fire agate in a 14k gold bezel. A hawk spreading stars in 14k gold overlay is appliquéd above silver overlay stars.

8TH CONCHO: Bruneau jasper in a silver bezel, azurite in a 14k gold bezel, and a turtle in silver overlay.

9TH CONCHO: Rocky Butte picture jasper in a silver bezel, coral in a 14k gold bezel, and designs of an antelope and two stars with a stylized landscape in silver overlay.

10TH CONCHO: Owyhee jasper in a brass bezel and a bobcat with tracks in silver overlay.

11TH CONCHO: Morrisonite in a silver bezel, variscite in a 14k gold bezel, and six flying sandhill cranes in silver overlay. The concho has the signature terminal shape with three stamped lines at the tip and contains the characteristic two stones. Penny Freund Collection.

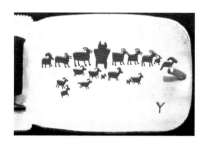

26. "PETROGLYPH MIGRATION," AUGUST 1981

This was the third belt entered at Indian Market and followed the awarding of one of the first SWAIA fellowships to Johnson and Bird in 1980. Bird planned the belt as a report chronicling the photographic visits to various petroglyph sites she and Johnson made during their study of rock carvings and paintings. The belt won Best of Division – Non-Traditional Jewelry, Best of Class – Jewelry and Best of Show at Indian Market. Collection Erving and Joyce Wolf.

BUCKLE: Rocky Butte Picture jasper, fire agate and tufa cast appliqué of three petroglyph stars and a migration symbol. Reverse: A field of petroglyphs. Photo Joseph Coscia Jr.

1ST CONCHO: Moonstone, Deschutes jasper and a bear with stars.

2ND CONCHO: Bruneau Mountain jasper, lapis lazuli, and a mesa outline in silver overlay.

3RD CONCHO: Bruneau Mountain jasper, carved coral and a mother and baby antelope.

4TH CONCHO: Tyrone turquoise, Rocky Butte jasper and three big horn sheep.

5TH CONCHO: Two Owyhee Junction jasper and an appliquéd tufa-cast 14k gold arrow.

6TH CONCHO: Rocky Butte jasper, lapis lazuli and three running deer.

7TH CONCHO: Three garnets in 14k gold bezels, Laguna agate, and an appliquéd silver bar with a design of a water serpent.

8TH CONCHO: Morrisonite and stamp work rain with mesa outlines.

9TH CONCHO: Tiger Iron, stamp work lines, an appliquéd tufa-cast 14k gold sunrays, and three silver overlay mountain lions.

10TH CONCHO: Rocky Butte jasper and stamp work.

11TH CONCHO: Brazilian agate and lapis lazuli in a 14k gold bezel. The concho has the signature terminal shape with 3 stamped lines and sandhill cranes.

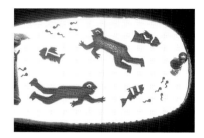

27. "WATER BELT," OCTOBER 1981

Water is a precious commodity in the arid Southwest. Bird and Johnson used stones that either had water imagery or came from sources of water such as coral or fossils. This belt has more stamp work and more complexity than prior belts and was the first belt to have a stone form the body of an animal. Many of the bezels holding the stones have saw marks in different patterns that serve to further accentuate the stones. The belt was shown at the Festival of the Arts in Santa Fe and was sold at Joanne Lyon Gallery in Aspen, Colorado.

BUCKLE: Morrisonite in a silver bezel. Buckle reverse: Two stylized Mimbres figures with gold pierced eyes are swimming with fish and pollywogs in silver overlay. The hallmark is a Y.

1ST CONCHO: Blue Mountain jasper in a silver bezel with saw marks at varying intervals and coral in a 14k gold bezel. Johnson carved the coral so that it looks like fish scales, and coral makes up the body of the fish with stamped designs on the body and dorsal fin.

2ND CONCHO: Bruneau jasper in a brass bezel. The concho has a stamp-work edge on one side and the other has an appliquéd silver overlay design that represents waves.

3RD CONCHO: A fire agate in quartz with a silver bezel and a blue moonstone with a 14k gold bezel. The fire agate is placed above the silver overlay design of a mesa to represent a storm cloud. The small, blue moonstone represents a drop of rain.

4TH CONCHO: Moss agate in a silver bezel and abalone in a 14k gold bezel. Surrounding them in overlay are two Mimbres-style fish, whose body interiors are accented with drops of 14k gold.

5TH CONCHO: Azurite in quartz in a 14k gold bezel and Blue Mountain jasper in a silver bezel. Below the smaller stone is an appliquéd stamp-work fish in 14k gold. Above the larger stone is a silver overlay design of a water serpent that has been textured.

6TH CONCHO: Blue Mountain jasper and morrisonite in brass bezels with stamp-work lines above the rectangular stone. A school of fish in overlay is positioned between the two stones.

7TH CONCHO: Two imperial jaspers in 14k gold bezels. The stones look like rainbows with stamp-work designs of rain falling below. Between the clouds are overlay designs of a mesa outline and ten stars.

8TH CONCHO: Montana agate and fossil coral in silver bezels. Silver overlay designs are of a Mimbres-style fish and smaller fish based on small three-dimensional pottery fish that Nora Naranjo-Morse made and traded to Bird and Johnson at the Eight Northern Pueblos show.

9TH CONCHO: Morrisonite in a silver bezel and Number 8 turquoise in a 14k gold bezel. Swimming up toward the top is a family of turtles in overlay. The large turtle and three small turtles were adapted from Mimbres pottery designs.

10TH CONCHO: Morrisonite in a silver bezel with saw marks. To the side in overlay is a Mimbres water bird, and inside the bird is a 14k gold appliquéd fish.

11TH CONCHO: Morrisonite in a silver bezel, lapis lazuli in a 14k gold bezel, and six flying sandhill cranes in silver overlay. The concho has the signature terminal shape with three stamped lines at the tip and the characteristic use of two stones. Joan W. Harris Collection.

28. "TRAVELING/NEW DIRECTIONS/ NEW IDEAS BELT," JULY 1982
Bird and Johnson made this belt after their first trip to New York and Washington, D. C.; it was sold at Dewey-Kofron Gallery. All of the designs were sketched by Johnson during visits to the Heye Foundation, the Metropolitan Museum of Art, the American Museum of Natural History in New York, and the Smithsonian in Washington, D. C. While some of the designs were similar to those used previously, all were new variations, such as the San Ildefonso water serpent design on the third concho, which is similar to that on the fifth concho of the prior belt. The shapes of the conchos on this belt are more angular and less rectangular, particularly the first, seventh, and eighth.

BUCKLE: Mexican lace agate in a 14k gold bezel. Buckle reverse: Traveling symbol in silver overlay with a 14k gold center and swallows. The hallmark is a Y.

1ST CONCHO: Two Mexican lace agates in silver bezels with a design in silver overlay of an African bird adapted from a rattle at the Metropolitan Museum of Art.

2ND CONCHO: Blue Mountain jasper in a silver bezel and Montezuma turquoise in a 14k gold bezel. The design in silver overlay is of an Acoma parrot with 14k gold drops appliquéd for eyes and on the tail feathers and a 14k gold star on the parrot.

3RD CONCHO: Brazilian agate in a 14k gold bezel and Owyhee jasper in a silver bezel with stamp work of rain and an appliquéd sand-cast water serpent.

4TH CONCHO: Coyomito agate in a silver bezel and a Ceylon moonstone and Tyrone turquoise in 14k gold bezels.

5TH CONCHO: Owyhee Junction jasper in a silver bezel and a Coyomito agate in a 14k gold bezel. The top bird design was adapted from the burnished key slot on the meter of a New York taxi. The slot formed an abstract pattern that Johnson sketched as a bird; the original owner of the belt referred to it as a "Picasso" bird. The bottom bird is from a Northwest Coast design. Beside it is the pattern that echoes the back of the buckle; it is a Mimbres pottery symbol in overlay.

6TH CONCHO: Two Biggs jaspers in silver bezels and a white moonstone in a 14k gold bezel.

7TH CONCHO: Two Priday polka dot agates. The design in silver overlay is of a loon. This bird design was adapted from a Northwest Coast gourd rattle.

8TH CONCHO: Priday polka dot agate in a silver bezel and three garnets in 14k gold bezels.

9TH CONCHO: Biggs jasper and lapis lazuli in 14k gold bezels with an Acoma double bird design in silver overlay.

10TH CONCHO: Two Ochoa lace agates. The large one is in a silver bezel and the smaller in a 14k gold bezel. There is a Zuni butterfly design in 14k gold overlay and appliqué.

11TH CONCHO: Laguna agate and white moonstone in 14k gold bezels with six sandhill cranes in overlay and stamp work. The concho has the signature terminal shape and two stamped lines at the tip and contains two stones. Heard Museum Collection.

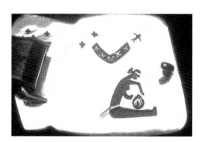

29. "POTTERY MAKER BELT," AUGUST 1982

Johnson and Bird paid homage to great southwestern pottery makers through the theme of this belt. All of the larger stones are Rocky Butte picture jaspers with yellow skies and rust-colored land demarcations. Johnson made saw marks on the edges of many of the conchos to further accentuate them. The San Ildefonso water serpent design on the third concho is similar to that of the prior belt, and the small bird with the raised foot on the fourth concho is like that on the second concho of the previous belt.

This belt won a first-place ribbon and Best of Division for Non-Traditional Jewelry at Indian Market. This was the first year that people waiting to purchase at Johnson and Bird's booth signed a list as they arrived. A pottery collector began the list.

BUCKLE: Tyrone turquoise in a 14k gold bezel and Rocky Butte jasper in a brass bezel. An appliquéd tufa-cast piece has three stars and a design from ancestral Pueblo pottery. Buckle reverse: Most Mimbres figures are men, but Johnson and Bird depicted a woman because contemporary southwestern pottery is most often made by women. The design in overlay and appliqué is taken from Jody Folwell pottery. The hallmark is a Y.

1ST CONCHO: Rocky Butte picture jasper in a silver bezel, coral in a brass bezel, and a design from the interior of a Cochiti dough bowl of a tree with birds resting on limbs in silver overlay. There are saw marks on the edges of the concho.

2ND CONCHO: Rocky Butte jasper in a silver bezel, Bisbee turquoise in a 14k gold bezel, and Santo Domingo pottery designs of a bird and flower in silver overlay. Saw marks accentuate the edges of the conchos.

3RD CONCHO: Two Rocky Butte jaspers, one in a silver bezel and another in a brass bezel. A 14k gold tufa-cast appliquéd bar has a design of a water serpent from San Ildefonso pottery.

4TH CONCHO: Two Rocky Butte jaspers in silver bezels. The top bird is an Acoma parrot, and the bottom design is a Zia bird. Both have rainbows over them and are in silver overlay with small 14k gold appliqué inside. The edges of the conchos have saw marks.

5TH CONCHO: Rocky Butte jasper in a brass bezel, coral and three lapis lazulis in 14k gold bezels, and a Zuni deer in silver overlay with a heartline in 14k gold.

6TH CONCHO: Rocky Butte jasper in a silver bezel and a bar of coral in 14k gold. Above the coral is a Margaret Tafoya bear claw design from Santa Clara Pueblo in silver overlay.

7TH CONCHO: Rocky Butte jasper in a brass bezel, Number 8 turquoise in a 14k gold bezel, and three lapis lazulis in 14k gold bezels. In silver overlay are a Mimbres pottery design of a stylized ram and a border design from a Mimbres pottery bowl. The top edge of the concho has saw marks.

8TH CONCHO: Two Rocky Butte jaspers, the larger in silver and the smaller in a brass bezel and Tyrone turquoise in a 14k gold bezel. A Hopi pottery design of a stylized bird is in silver overlay.

9TH CONCHO: Two Rocky Butte picture jaspers, the larger in brass and the smaller in a silver bezel and lapis lazuli in a 14k gold bezel. A design of a bird from Pinedale pottery was tufa cast in 14k gold, pierced, and then appliquéd.

10TH CONCHO: Lapis lazuli in a 14k gold bezel and Rocky Butte jasper in a brass bezel. The silver overlay designs are of a large bird from Hopi pottery and three small ones from Zuni pottery. This concho has the signature terminal shape with three stamped lines on the tip and the characteristic use of two stones. This is the first time the artists chose to use a bird other than a sandhill crane. Caroline Boeckman Collection.

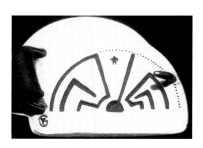

30. "BASKET BELT," AUGUST 1983

This belt was designed following a basketry seminar at the Laboratory of Anthropology in Santa Fe, and the year SWAIA gave the basket weavers a booth at Indian Market. Johnson and Bird had created the "Pottery Belt" to honor southwestern potters the year before and decided to do the same thing with basketmakers. Replicating basket designs was a challenge, since so many of them are in the round. They chose Bruneau jaspers since they have soft, round lines, and the colors are similar to those of baskets that have turned golden with age. According to Bird, "We were thinking about shapes and how the baskets are woven. We wanted to use those ideas and the techniques of basketry. We thought of curves in the selection and placement of stones." This was the first use of the GY hallmark on a belt, a hallmark that has been used on all of their jewelry since then.

BUCKLE: Bruneau jasper in a silver bezel and a line of Apache figures, possibly dogs, in silver overlay. This was the first buckle that was not a rectangle. Buckle reverse: Pima basket with the man in the maze design. The designs are in silver overlay except for areas of the outer rim that are textured with an awl to represent basketry coils.

1ST CONCHO: Bruneau jasper in a silver bezel, Tyrone turquoise in a 14k gold bezel, and Washo basketry designs in silver overlay.

2ND CONCHO: Two black Bruneau jaspers in silver bezels and Pima basket designs in silver overlay.

3RD CONCHO: Bruneau jasper in a silver bezel, coral in a 14k gold bezel, and a Navajo basket design in silver overlay.

4TH CONCHO: Bruneau jasper in a silver bezel, Tyrone turquoise in a 14k gold bezel, and an appliquéd Apache basket design in 14k gold.

5TH CONCHO: Bruneau jasper in a silver bezel and designs of a Pima basket and a Yavapai basket in silver overlay.

6TH CONCHO: Bruneau jasper in a silver bezel and an Apache basket design in silver overlay. The jasper is the central part of the basketry design.

7TH CONCHO: Bruneau jasper in a silver bezel forms a basket pattern next to a Yavapai basket in appliqué and pierce work.

8TH CONCHO: Two black Bruneau jaspers in silver bezels, Tyrone turquoise in a 14k gold bezel, and Apache basket designs in silver overlay. The top of the concho is the center of the basket.

9TH CONCHO: Two Bruneau jasper in silver bezels and a Navajo basket design in silver overlay.

10TH CONCHO: Two black Bruneau jaspers in silver bezels and a Chemehuevi basket design in silver overlay.

11TH CONCHO: Bruneau jasper in a silver bezel, lapis lazuli in a 14k gold bezel. This has the signature terminal shape, but rather than sandhill cranes, the design represents the basketry plaiting technique. Valerie T. Diker Collection.

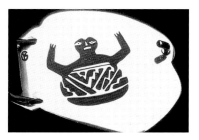

32. "MIMBRES BLACK AND WHITE BELT," SEPTEMBER 1984

This belt was not completed in time for Indian Market because the complexity and larger sizes of the conchos took more time than the artists anticipated. Because they had been invited to participate in the "Arts of New Mexico" exhibit. Johnson and Bird decided to save the belt for the exhibit; The theme of the belt was in keeping with southwestern themes Johnson and Bird used for belts made for Indian Market. The geometric and animal designs were taken from Mimbres pottery. The color palette of this belt is a dramatic shift from the yellow and brown earth tones of the stones used in earlier belts. The black stones are primarily psilomelane with additions of deep red coral for contrast. The conchos on the belt are curved, whereas the earlier ones were more rectangular. The stones frequently form the bodies of animals, a design feature which, combined with the curved lines of the individual conchos and the incorporation of larger animal forms, gives the belt the appearance of movement. Using stones to form the bodies was an important innovation that Johnson and Bird would not employ again until later belts such as the "Canines and Felines Belt" in 1992 and the "Drought and Desert Belt" in 1994.

BUCKLE: Two psilomelanes in silver bezels, coral in a 14k gold bezel, and a tufa-cast 14k gold appliquéd animal. The unusual shape of this buckle makes it different from prior

ones, as does the use of three stones. Buckle reverse: Mimbres male figure emerging from a big Mimbres pot in silver overlay.

1ST CONCHO: Psilomelane in a silver bezel and a lizard in silver overlay with appliquéd gold eyes.

2ND CONCHO: Psilomelane in a silver bezel forms the body of a Mimbres-style bird. Below is an oval of coral in a 14k gold bezel that looks like an egg.

3RD CONCHO: Banded agate in a silver bezel makes the body of a frog in silver overlay with 14k gold drops for eyes.

4TH CONCHO: Psilomelane in a silver bezel forms the body of a Mimbres-style turkey, coral in a 14k gold bezel and a skunk in silver overlay with a 14k gold eye.

5TH CONCHO: Petrified wood in a silver bezel and water bugs in silver overlay.

6TH CONCHO: Tyrone turquoise and coral in 14k gold bezels and psilomelane in a silver bezel. A quail in silver overlay has a 14k gold drop for an eye and another in the center of the body. Below is a silver overlay design of a staff piercing the psilomelane and coral.

7TH CONCHO: A psilomelane in a silver bezel forms the body of one of two Mimbres-style birds in silver overlay. The birds are positioned like those painted on Mimbres pottery. The other bird is formed in silver overlay.

8TH CONCHO: Psilomelane in a silver bezel, coral in a 14k gold bezel, and a Mimbres-style fish in overlay with a 14k gold appliqué eye.

9TH CONCHO: Mahogonite in a silver bezel surrounded by a Mimbres-style worm in silver overlay.

10TH CONCHO: Two banded agates in silver bezels and two Mimbres-style rams in silver overlay with 14k gold drops for eyes.

11TH CONCHO: Psilomelane in a silver bezel, two corals in 14k gold bezels, and two appliquéd 14k gold pieces in geometric Mimbres-style designs.

12TH CONCHO: Psilomelane in a silver bezel and a Brazilian agate in a 14k gold bezel; the agate has a spot of red in it. This concho has the signature terminal shape with three stamped lines on the tip. The bird is a Mimbres-style duck instead of the typical sandhill crane. Private Collection, Dallas.

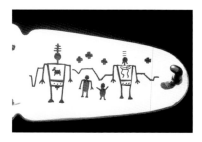

36. "BIRTHDAY BELT," APRIL 1985
This belt was commissioned by Ray Dewey for Judy Dewey's birthday.

BUCKLE: Montana agate in a silver bezel and coral in a 14k gold bezel, 1.25 x 2.5 inches. Buckle reverse: These are stylized petroglyph figures from Butler Wash standing against a stylized mesa outline. The figures are a male, a female, and two male children and the four stars to represent their family. Although stars had been used in prior belts, this was the first extensive use of stars on a belt.

1ST CONCHO: Montana agate in a silver bezel and Tyrone turquoise in a 14k gold bezel with a design in silver overlay of a deer from a pottery design.

2ND CONCHO: Montana agate and Botswana agate in silver bezels and four stars.

3RD CONCHO: Botswana agate in a silver bezel and rutilated quartz in a 14k gold bezel with a constellation with seven stars to represent the Pleiades, or the Seven Sisters.

4TH CONCHO: Botswana agate in a silver bezel, blue chalcedony in a 14k gold bezel with six stars, and designs from Apache pictorial baskets Judy Dewey had once owned.

5TH CONCHO: Montana agate in a silver bezel and coral and rutilated quartz in 14k gold bezels. Designs of three stars and a rabbit with extra large ears leaping over a stylized quarter moon are in silver overlay. The rabbit represents a funny shared memory between the Deweys and the artists.

6TH CONCHO: Three Montana agates, two of which are in 14k gold bezels and one in silver. The design is of a Peruvian textile bird from the "Birdwatcher Belt" to represent the first time Johnson and Bird showed a belt at Dewey Kofron Gallery, and four stars.

7TH CONCHO: Montana agate in a silver bezel and rutilated quartz in a 14k gold bezel with a design of the logo from the first business card of the Dewey-Kofron Gallery. In the body of the deer are two 14k gold dots.

8TH CONCHO: Botswana agate and psilomelane in silver bezels with Apache basket designs.

9TH CONCHO: Montana agate in a silver bezel and coral in a 14k gold bezel.

10TH CONCHO: Tyrone turquoise and blue chalcedony in 14k gold bezels with a design from a Santo Domingo dough bowl to represent a bowl once owned by the Deweys, and three stars.

11TH CONCHO: Botswana agate in a silver bezel and blue chalcedony and lapis lazuli in 14k gold bezels, and two stamp-work stars.

12TH CONCHO: Plume agate in a silver bezel with designs of Hailey's comet, which appeared that year, a whirling log from a design on an Apache basket, and six stars. The belt was given to Judy Dewey at a surprise birthday party. The stars mark her fortieth birthday. Ray and Judy Dewey Collection.

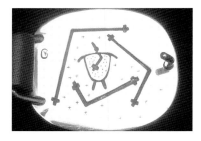

33. "NIGHT ANIMALS AND STARS BELT," AUGUST 1985

The theme of this belt pertains to constellations. It follows and is connected thematically to the "Birthday Belt," with its forty stars. The shape and the use of large stones is reminiscent of the design of belts made before the "Mimbres Black and White Belt," but three of the conchos are very angular and indicate future changes in concho shapes. This belt was made for and sold at Indian Market. The bezels holding the stones are silver unless otherwise noted.

BUCKLE: Deschutes jasper. Buckle reverse: Petroglyph man with a line in the center in silver overlay. Johnson made similar stylized lines surrounding him and a field of stars by pierce work.

1ST CONCHO: Deschutes jasper, coral divided into three sections by two 14k gold bars in a 14k gold bezel. A raccoon is in silver overlay with stamp work, and in his body is a depiction of an appliqué hand, star, and bursting star in 14k gold to represent a super nova. A stamp-work star is above the raccoon eating a branch.

2ND CONCHO: Deschutes jasper.

3RD CONCHO: Deschutes jasper inlaid with a piece of gold and a Mimbres-style rabbit in overlay with a pierce-work star overhead.

4TH CONCHO: Tyrone turquoise in a 14k gold bezel and Deschutes jasper. Above a silver overlay design of a petroglyph bear from Galisteo Gap, New Mexico, are three stars. The bear has three stars in his body.

5TH CONCHO: Coral in a 14k gold bezel, two Deschutes jaspers, and three stamp-work stars and three textile stars in silver overlay.

6TH CONCHO: Lapis lazuli in a 14k gold bezel, Biggs jasper, and a Mimbres bat in silver overlay above. The bat has two gold textile stars appliquéd to its textured body. Six stamped stars are nearby.

7TH CONCHO: Deschutes jasper in a silver bezel and coral in a 14k gold bezel.

8TH CONCHO: Tyrone turquoise in a 14k gold bezel, Deschutes jasper, and a skunk and a textile star in silver overlay.

9TH CONCHO: Deschutes jasper in a silver bezel, lapis lazuli in a 14k gold bezel with a gold bar, and a gliding bat in silver overlay with a 14k gold textile star appliquéd to his body.

10TH CONCHO: Deschutes jasper in a silver bezel and two lapis lazulis in 14k gold bezels. A gold stamped star and two pierce-work stars are appliquéd to one side. The jasper looks like an erupting volcano, and the lapis and stars appear to be flowing out of the volcano.

11TH CONCHO: Deschutes jasper, lapis lazuli in a 14k gold bezel, and a fox in silver overlay with a stamped drop of gold and a stamped star.

12TH CONCHO: Deschutes jasper, Tyrone turquoise in a 14k gold bezel, five sandhill cranes flying above, and a stamp-work star. This concho has the signature terminal shape and three stamped lines on the tip and includes the characteristic two stones. Katherine Boeckman Howd Collection.

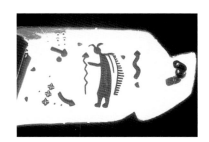

37. "CONSTELLATION BELT," DECEMBER 1985

This belt is thematically connected to the "Birthday Belt" and the "Night Animals and Stars Belt." The bear on the first concho resembles the one on the fourth concho of the "Night Animals and Stars Belt." The color palette, with its soft purple and blue tones, however, is very different from prior belts. The conchos, although angular, are not rectangular like most of the previous belts, but instead follow the shapes of the stones. The belt was sold through Joanne Lyon Gallery in Aspen.

BUCKLE: Laguna agate in a silver bezel and sugilite quartz in a 14k gold bezel. Buckle reverse: A hunter from a petroglyph design with stars overhead represents Orion, in silver inlay.

1ST CONCHO: Rutilated quartz in a 14k gold bezel, lace agate in a silver bezel, and a bear from a Galisteo Gap petroglyph with three stars above and three in his body in silver overlay.

2ND CONCHO: Laguna agate in a silver bezel and Holley Blue agate in a 14k gold bezel with four textile stars in silver overlay.

3RD CONCHO: Montana agate in a silver bezel, coral in a 14k gold bezel, and ten textile and pottery stars of different shapes in silver overlay.

4TH CONCHO: Coyomito agate in a silver bezel, blue chalcedony in a 14k gold bezel, and seven stamp-work stars representing the Pleiades, or Seven Sisters.

5TH CONCHO: Montana agate in a silver bezel, coral in a 14k gold bezel, and a star, a waning moon, and a hand in silver overlay.

6TH CONCHO: Two Laguna agates in silver bezels and a peach moonstone in a 14k gold bezel with three stamp-work stars.

7TH CONCHO: Ocho alace agate in a silver bezel, lapis lazuli in a 14k gold bezel, and a bat and star in silver overlay.

8TH CONCHO: Lapis lazuli in a 14k gold bezel, Dryhead agate in a silver bezel, and silver overlay designs of Galisteo Gap petroglyphs.

9TH CONCHO: Brazilian agate in a silver bezel, blue chalcedony in a 14k gold bezel, and eight textile stars in silver overlay.

10TH CONCHO: Ochoa lace agate in a silver bezel, Holley Blue agate in a 14k gold bezel, and a Mimbres-style cat standing on a waning moon in silver overlay with two stamp-work stars nearby. The skunk design references the prior belt.

11TH CONCHO: Dryhead agate in a silver bezel, Tyrone turquoise in a 14k gold bezel, and seven stamp-work stars. The shape of the last concho has changed for the first time, and the design is stars rather than sandhill cranes. Gail Neeson and Stefan Edlis Collection.

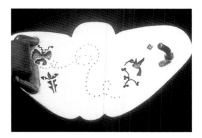

38. "WILDFLOWERS AND BUTTERFLIES BELT," AUGUST 1986

This belt was created after heavy spring rains following years of drought resulting in a season of remarkable flowers. Bird and Johnson bought wildflower books to identify the flowers they saw. The color palette of soft pastels is very similar to that of the previous belt, the "Constellation Belt." The conchos are not rectangular but follow the shapes of the stones, many of which have been placed to resemble butterflies. It was made for and sold at Indian Market.

BUCKLE: Three Laguna agates, two in silver bezels and the center one in a 14k gold bezel. This unusual buckle is the only one in the shape of an animal. Buckle reverse: The designs in silver overlay are of a butterfly, butterfly trails, and a hummingbird. The butterfly is taken from a Harold Littlebird pottery design, the flowers are from a Santo Domingo pottery design, and the hummingbird is realistic. Conchos 1, 3, 5, 6, 7, 9, 11 are stylized butterflies.

1ST CONCHO: Two Coyomito agates (Mexico) in silver bezels and a rose quartz in a 14k gold bezel.

2ND CONCHO: Coyomito agate in a silver bezel and naturalistic flowers in silver overlay.

3RD CONCHO: Two lace agates in silver bezels and a garnet in a 14k gold bezel.

4TH CONCHO: Two Coyomito agates in silver bezels and a wild iris design in silver overlay.

5TH CONCHO: Two Dryhead agates in silver bezels and a moonstone in a 14k gold bezel.

6TH CONCHO: Two Laguna agates, the large one in a silver bezel and the small in a 14k gold bezel.

7TH CONCHO: Coyomito agate in a silver bezel and a rutilated quartz in a 14k gold bezel. The right wing is formed of 14k gold and appliquéd. It has a cutout of a circle that reflects the circle in the natural agate that forms the left wing. There is a stamped design of antennae.

8TH CONCHO: Laguna agate in a silver bezel and Tyrone turquoise in a 14k gold bezel. Many of the butterflies in the belt were adapted from Hopi pottery designs while the flowers and vegetal images in silver overlay from Santo Domingo pottery were researched using Kenneth Chapman's 1938 book *The Pottery of Santo Domingo Pueblo*. According to Gail Bird, "Collectors and scholars view the highly abstract interpretation of natural forms in Hopi pottery as high artistic achievement. Often the black-and-white images boldly painted on large forms by Santo Domingo potters seem simplistic or clumsy by comparison. Hopi potters add and build; Santo Domingo painters simplify complexity. Both create highly abstract images. We chose to use both in this piece along with realistic depictions. The choice of accompanying metal or stone color reflects the respective pottery's design origin."

9TH CONCHO: Dryhead and Laguna agates in silver bezels and a garnet in a 14k gold bezel.

10TH CONCHO: Pink orbicular agate (called such because of the circular patterns in the stone) in a silver bezel. Silver overlay design of evening primroses, which are wild and grow more abundantly in wet years.

11TH CONCHO: Two lavender lace agates in silver bezels and a Holley Blue agate (Oregon) in a 14k gold bezel.

12TH CONCHO: Two lapis lazulis in 14k gold bezels and a Laguna agate in a silver bezel. Another evening primrose is in silver overlay. The two lapis represent another butterfly. This has the signature terminal shape, but the designs are not typical. Private Collection.

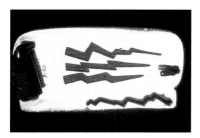

39. "LIGHTNING BELT," AUGUST 1987
The theme of rain links the "Lightning Belt" to the prior belt. Johnson and Bird chose morrisonites because the stones appear to have movement and give the sense of turbulence as well as the feeling of water. Some have patterns that look like lightning bolts striking the land. All overlay appliqué and stamp-work designs involve lightning bolts in various guises. This belt has fourteen conchos—more than the usual eleven or twelve, but they are smaller. It was made for and sold at the 1987 Indian Market.

BUCKLE: Blue Mountain jasper in a silver bezel and a Holley Blue agate in a 14k gold bezel with three small 14k gold appliquéd lightning bolts. Along the bottom, the shape of a bolt is cut out of the silver going across

the landscape rather than down. Buckle reverse: Three lightning bolts in silver overlay. Engraved "Johnson and Bird."

1ST CONCHO: Plume agate and two gold appliqué lightning bolts and four overlay lightning bolts.

2ND CONCHO: Two morrisonites in silver bezels and a Holley Blue agate in a 14k gold bezel. The small Holley Blue agates represent raindrops. The small overlay design at the top is a cloud with lightning, which may be taken from a petroglyph and is also found in Pueblo kilts. Designs include a 14k gold overlay lightning bolt, stamped designs of raindrops, and two lightning bolts in silver overlay.

3RD CONCHO: Morrisonite in a silver bezel and blue chalcedony in a 14k gold bezel. Designs include an appliquéd 14k gold lightning bolt with small stamped designs of raindrops and a silver overlay lightning bolt.

4TH CONCHO: Morrisonite in a silver bezel and three Holley Blue agates in 14k gold bezels with a skunk in silver overlay. According to Bird, "As the belt neared the finished design stage, I realized there weren't any animals included. Yazzie and I remembered that during lightning and thunderstorms there were often frequent visits by skunks; hence the skunk spraying lightning bolts."

5TH CONCHO: Morrisonite with a pattern that appears to have a demarcation between land and sky, variscite in silver bezels, and a Holley Blue agate in a 14k gold bezel with a rainbow in silver overlay and stamp-work rain.

6TH CONCHO: Botswana agate and blue chalcedony in silver bezels and two Holley Blue agates in 14k gold bezels with a gold appliqué lightning bolt.

7TH CONCHO: Morrisonite in a silver bezel. The dark pattern of the stone is at the bottom and the light pattern above looks like clouds. The top design in silver overlay is a water serpent from San Ildefonso pottery. The bottom design is a lightning bolt reminiscent of a water serpent design from cave painting at Bandelier National Monument.

8TH CONCHO: Two morrisonites in silver bezels, stamp-work designs of rain, and an appliqué of a 14k gold lightning bolt that is stamped with small raindrops.

9TH CONCHO: Morrisonite in a silver bezel and two Holley Blue agates in 14k gold bezels and an overlay lightning bolt.

10TH CONCHO: Brazilian agate in a silver bezel and Tyrone turquoise in a 14k gold bezel with stamp-work rain and an appliqué of a 14k gold lightning bolt.

11TH CONCHO: Morrisonite in a silver bezel with a pattern that looks like a lightning bolt. A silver overlay lightning bolt and two larger bolts on the side were taken from petroglyphs.

12TH CONCHO: Botswana agate in a silver bezel and two Holley Blue agates in 14k gold bezels with an appliquéd 14k gold lightning bolt with raindrops stamped on it.

13TH CONCHO: Two morrisonites in silver bezels, two silver overlay lightning bolts, stamped rain, and a 14k gold appliquéd lightning bolt.

14TH CONCHO: Chrysacolla with tenorite, lapis lazuli, and a Holley Blue agate in 14k gold bezels with a silver overlay lightning bolt and a 14k gold appliqué bolt. Pat and Martin Fine Collection.

40. "SANTO DOMINGO POTTERY BELT," DECEMBER 1987
This is one of three black-and-white belts along with the "Mimbres" and "Chaco Canyon" belts. The "Santo Domingo Pottery Belt" is the most geometrically graphic of them all and represents the floral motifs used in Santo Domingo pottery. The belt represents a definitive move from the earlier rectangular conchos to more fluid and curvilinear forms. It was sold through Joanne Lyon Gallery.

BUCKLE: Psilomelane in a silver bezel and variscite in a 14k gold bezel. Buckle reverse: Two Santo Domingo pottery designs. For reference, Johnson and Bird used Kenneth Chapman's book and photos Bird had taken of historic and contemporary pottery.

1ST CONCHO: Variscite in a 14k gold bezel and psilomelane in a silver bezel. The large tufa-cast appliquéd oval represents a pottery design.

2ND CONCHO: Psilomelane in a silver bezel, variscite and coral in 14k gold bezels, and geometric pottery designs in stamp-work overlay. Coral is used to bring color to the otherwise dark tones of the belt.

3RD CONCHO: Botswana agate forms one-half of the pottery design with the other in silver overlay.

4TH CONCHO: Variscite in a 14k gold bezel and psilomelane in a silver bezel. The design is adapted from Santo Domingo pottery.

Stamp-work dots go around the perimeter of the stones in a manner similar to dots on the handles of Santo Domingo pitchers or the dots in foliage patterns on pottery.

5TH CONCHO: Botswana agate and hematite in silver bezels. The curvilinear design in silver overlay is surrounded by stamp work and was inspired by pottery designs.

6TH CONCHO: Two variscites in silver bezels and black jade in a 14k gold bezel. A stylized pottery design is appliquéd in tufa-cast 14k gold.

7TH CONCHO: Botswana agate positioned by a stylized pottery design in overlay similar to the one in the third concho.

8TH CONCHO: Psilomelane in a silver bezel with variscite and coral in 14k gold bezels. The silver overlay design is one often used in Santo Domingo dough bowls.

9TH CONCHO: Black jade and coral in 14k gold bezels and marcasite in a silver bezel. The black jade has a piece of 14k gold inset. Johnson at times will add a gold bar if the stone has an imperfection or if the stone breaks. The design is in silver overlay with stamp work.

10TH CONCHO: Psilomelane in a silver bezel and an abstraction of a design of plants or flowers from Santo Domingo pottery created in silver overlay and appliquéd.

11TH CONCHO: Black onyx and variscite in 14k gold bezels with a pottery design in silver overlay.

12TH CONCHO: Psilomelane in a 14k gold bezel. The design, a tufa-cast piece of gold, is geometric with abstract triangles with a stem and leaves on each side in overlay. The shape of the concho is a stylized version of the early ones. Joan W. Harris Collection.

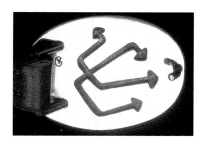

41. "ROAD SIGNS BELT," JUNE 1988
This belt did not have a design or thematic connection to southwestern collectors or to nature, but illustrates Bird and Johnson's interest in designs of all forms and types. It was sold through Martha Struever in November 1989.

BUCKLE: Deschutes jasper in a silver bezel, 1.75 x 2.25 inches. Buckle reverse: free-form designs based on directional arrows.

1ST CONCHO: Biggs jasper in a silver bezel and Tyrone turquoise in a 14k gold bezel with a design of "divided routes ahead."

2ND CONCHO: Biggs jasper in a silver bezel and rutilated quartz and turquoise in 14k gold bezels with a "routes converge" design.

3RD CONCHO: Biggs jasper in a silver bezel and lapis lazuli in a 14k gold bezel with a design in gold appliqué to represent a "right turn ahead" sign.

4TH CONCHO: Deschutes jasper in a silver bezel and Bisbee turquoise in a 14k gold bezel with a design in 14k gold appliqué of the "routes divide" sign.

5TH CONCHO: Deschutes jasper in a silver bezel and Tyrone turquoise in a 14k gold bezel with a design to represent "slow, turns ahead."

6TH CONCHO: Biggs jasper in a silver bezel and moss agate in a 14k gold bezel with a "merge, lane ends" sign.

7TH CONCHO: Biggs jasper in a silver bezel and Imperial jasper and Holley Blue agate in 14k gold bezels. Designs include the sign for "slippery when wet" and a lightning bolt which references the "Lightning Belt."

8TH CONCHO: Deschutes jasper in a silver bezel and Tyrone turquoise in a 14k gold bezel with tufa-cast gold bars and crossroads.

9TH CONCHO: Biggs jasper in a silver bezel and a design for "twisted curves." (Years later, they saw this road sign in the Great Smokey Mountains in North Carolina).

10TH CONCHO: Deschutes jasper in a silver bezel and coral in a 14k gold bezel with stylized turn signs.

11TH CONCHO: Biggs jasper in a silver bezel and a design from a "deer crossing" sign.

12TH CONCHO: Deschutes jasper in a silver bezel and Tyrone turquoise in a 14k gold bezel with the sign for "steep grade." The wheels and cab of the truck are tufa-cast 14k gold. The last concho starts to have a stylized shape of the prior ones. Private Collection.

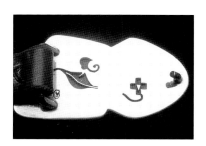

43. "KATE PECK KENT PUEBLO TEXTILE BELT," AUGUST 1988
This belt was made as a tribute to textile scholar Kate Peck Kent and sold at Indian Market. All designs are from Pueblo textiles including historic and contemporary mantas and kilts. Many are from body, shoulder, and border designs of shirts. Bird combined designs from Peck Kent's book and designs on textiles she had photographed. The artists purchased a manta from Pueblo weaver Ramoncita Sandoval and gave it to the Wheelwright Museum in memory of Kate Peck Kent. The belt is silver and all bezels are in 14k gold.

BUCKLE: Tyrone turquoise and psilomelane, a stone from New Mexico that is a nickel/manganese mix. Buckle reverse: Manta (shawl) designs in silver overlay.

1ST CONCHO: Two Tyrone turquoise from southern New Mexico, gold saw-work appliqué from a manta design.

2ND CONCHO: Alaskan jade. This is a manta design with the green representing an embroidered area on the manta. It is positioned at an angle to represent movement when worn.

3RD CONCHO: Tyrone turquoise, overlay, stamp work, and gold appliqué.

4TH CONCHO: Tyrone turquoise, overlay, stamp work.

5TH CONCHO: Manassa turquoise from Manassa King Ranch in southern Colorado, overlay.

6TH CONCHO: Tyrone turquoise, overlay, stamp work, and gold appliqué.

7TH CONCHO: Black jade, which the artists prefer to use because the jade gets a high polish and is a hard stone suited for a belt. The silver is in overlay with stamp work.

8TH CONCHO: Tyrone turquoise, overlay, and gold appliqué.

9TH CONCHO: Gold appliqué, overlay, and stamp work.

10TH CONCHO: Tyrone turquoise, coral, silver overlay, stamp work, and gold appliqué of a design from a shirtsleeve.

11TH CONCHO: Psilomelane, Manassa turquoise, silver overlay, and stamp work of a design from a man's kilt. Dr. and Mrs. E. Daniel Albrecht Collection.

44. "WILD HORSE BELT," AUGUST 1989

This belt includes the first cast-gold appliquéd figure, a horse. Johnson used cuttlefish bone casting to get the surface ridges that would add dimension to the figure of the horse rather than the tufa-casting technique that he more frequently used. The belt is markedly different from prior ones as each concho contains an animal design, and each animal is as large and powerful as the stone it accompanies. This belt marks a transition toward a stronger emphasis on pictorial designs in metal, although the pictorial elements in the stones continue to be a major aspect of the belts. Designs were drawn from Plains beadwork and ledger drawings and Southwest petroglyphs. The belt was sold at Indian Market.

BUCKLE: Wild Horse picture jasper in a silver bezel. Buckle reverse: The design of a horse is in silver overlay and the saddle is 14k gold appliqué. The design comes from a petroglyph Johnson and Bird saw at Bluff, Utah, of a horse with saddlebags and brands. The image was painted on a large, red rock that was positioned at the back of a corral.

1ST CONCHO: Coral in a 14k gold bezel, Owyhee jasper in a 14k gold bezel with a cuttlefish bone-cast piece of 14k gold below. In silver overlay are two horses, one surrounded by designs of hooves and the other from petroglyphs of running horses.

2ND CONCHO: Owyhee jasper in a silver bezel, coral in a 14k gold bezel, and a spotted horse in silver overlay.

3RD CONCHO: Owyhee jasper in a silver bezel, coral in a 14k gold bezel, and a petroglyph horse in silver overlay. Johnson used an awl to texture the body and a 14k gold drop to form the eye.

4TH CONCHO: Owyhee jasper in a silver bezel, coral in a 14k gold bezel, and a bob-tailed horse cut out of a sheet of cuttlefish bone-cast 14k gold.

5TH CONCHO: Montana agate and polka dot jasper in 14k gold bezels with four petroglyph horses in silver overlay.

6TH CONCHO: Two Wild Horse picture jaspers in silver bezels and a ledger horse with eagle feathers braided into the tail in silver overlay.

7TH CONCHO: Wild Horse picture jasper in a silver bezel, coral in a 14k gold bezel, and two horses from a Navajo pictorial rug in silver overlay.

8TH CONCHO: Wild Horse picture jasper in a silver bezel and an Appaloosa in silver overlay.

9TH CONCHO: Two Owyhee jaspers, one in a silver bezel and the other in a 14k gold bezel. The horse has a winter coat and curly hair that has been stamped in patterns that look like horse hooves. A 14k gold cuttlefish bone-cast bar is appliquéd.

10TH CONCHO: Coral and Owyhee jasper in 14k gold bezels. One horse is in silver overlay and the other in appliquéd 14k gold. The design came from a quilt seen in *American Indian Art Magazine*. The concho has the signature terminal shape. Susan G. Schwartz Collection.

82. "CHACO CANYON BELT," DECEMBER 1989

Chaco Canyon pottery and floor plans for buildings at Chaco Canyon compose the theme of this belt. The stones are black and white to represent the coloration of the pottery. Like the pottery, the designs are very geometric. Johnson and Bird accentuated the kiva shapes and swirls. Many of the designs are taken from drawings of settlements at Chaco Canyon. The T-shape doorways are also present in both overlay and gold appliqué. This belt was sold through JoAnne Lyon Gallery.

BUCKLE: Psilomelane in a silver bezel and coral in a 14k gold bezel and a cuttlefish bone-cast 14k gold appliquéd piece.

1ST CONCHO: Onyx in a silver bezel and lapis lazuli in a 14k gold bezel with a cuttlefish bone-cast 14k gold bar and a geometric design in silver overlay.

2ND CONCHO: Psilomelane in a silver bezel and a silver overlay design of a plaza site at Chaco Canyon and two 14k gold cuttlefish bone-cast bars.

3RD CONCHO: Two banded agates and a 14k gold cuttlefish bone-cast bar to represent the floor plan of a building at Chaco Canyon.

4TH CONCHO: Psilomelane in a silver bezel, coral in a 14k gold bezel, and a silver overlay design that represents the floor plan of a building.

5TH CONCHO: Agatized hematite in a silver bezel, a fire agate in a silver bezel, and silver overlay and cuttlefish bone-cast bars that form a building floor plan.

6TH CONCHO: Two fire agates in silver bezels and a silver overlay design of a floor plan.

7TH CONCHO: Psilomelane in a silver bezel, coral in a 14k gold bezel, a bar from cuttlefish bone-cast 14k gold, and a silver overlay design of a floor plan.

8TH CONCHO: Psilomelane in a silver bezel, turquoise in a 14k gold bezel, and a pottery design in silver overlay.

9TH CONCHO: Psilomelane in a silver bezel, coral in a 14k gold bezel, two cuttlefish bone-cast bars. and a silver overlay design.

10TH CONCHO: Psilomelane in a silver bezel, a cuttlefish bone-cast 14k gold bar, and a pottery design in silver overlay. Photograph by Tom Gessler. William and Hazel Hough Collection.

42. "NAVAJO GEOMETRIC TEXTILES BELT," AUGUST 1990
This belt was based on historic Navajo textile designs. Bird studied books and publications on Navajo textiles, particularly those from J. B. Moore's trading post, which operated in Crystal, New Mexico, in the early 1900s, and Lorenzo Hubbell's post in Ganado, Arizona. The belt was made for and sold at Indian

Market. The belt is silver with 14k gold bezels and accents.

BUCKLE: Coral and Tyrone turquoise with a textile star pattern on front. Reverse: Spider Woman cross, which the artists refer to as a star, 1.25 x 3 inches.

1ST CONCHO: Natural Chinese turquoise. The overlay and appliqué was accomplished in cuttlefish bone cast rather than tufa cast. The stars were formed by overlay, but smaller cut-out stars fit inside so they look like they are floating. This also references the change in wool color that defines weaving edges and changes in pattern.

2ND CONCHO: Lapis lazuli and coral. The design may be of a J. B. Moore Crystal rug.

3RD CONCHO: Hubbell revival of a chief blanket design with lapis lazuli in the center and stars around. Again, this is in silver overlay with cuttlefish bone appliqué in the center.

4TH CONCHO: Coral.

5TH CONCHO: Lapis lazuli.

6TH CONCHO: Tyrone turquoise and agates. The stones represent a textile pattern.

7TH CONCHO: Coral and Tyrone turquoise.

8TH CONCHO: Coral.

9TH CONCHO: Coral and Tyrone turquoise.

10TH CONCHO: Tyrone turquoise and lapis lazuli. This concho has a stylized V-shape on the end. Nancy and Hiroshi Murata Collection.

(PAGE 75) "NAVAJO PICTORIAL TEXTILES BELT," NOVEMBER 1990
This belt incorporates Rocky Butte picture jasper, German-cut onyx, coral, Montana moss agate, lapis lazuli, Tyrone turquoise, Bisbee turquoise, banded onyx, silver, and 14k gold. Large sections of cuttlefish bone-cast 14k gold were used to represent train tracks and smoke above the train on the buckle, which also contains Rocky Butte jasper. This was the first thematic belt to fully incorporate cuttlefish bone-cast designs. The belt was sold through Martha Struever. Bird's father, Tony, worked on the Southern Pacific Railroad in California. When the family traveled, it was by train. The design on the second concho was from a textile at the School of American Research. Johnson and Bird thought it looked like the view of the housetops during a dance when people are standing on the flat roofs. According to Bird, "This is the view, but what you hear are the trains going by." Bird wrote the following about this belt in 1990: "The designs for this belt are adapted from pre-1900s Navajo pictorial weavings. I've always been interested in the use of trains, cows, and horses in these early textiles and the frequent inclusion of these pictorial designs in Navajo wearing blankets. Often you'll find a single figure or row of figures combined with the lined pattern. The train, pueblo, and caboose were taken from a single textile Yazzie and I saw in the Hearst Collection on view at the Textile Museum in Washington, D. C., last fall. The row of human figures is from another blanket, but it seemed appropriate to include. The conchos with the chickens and horses are from a textile in the School of American Research's collection."

45. "PARROTS AND CORAL TRADE BELT," SPRING 1991

This belt is about two important trade items for southwestern Pueblo people—coral and parrot feathers. It was sold through Martha Struever. The belt is silver with 14k gold bezels and accents.

BUCKLE: Salmon and pink coral, 1 x 3 inches. Buckle reverse: The design is of a framed Mimbres pottery bird. The frame portends the 1999 "Protein Belt."

1ST CONCHO: Two salmon corals, one darker than the other. The designs of parrots are from Hopi Sityatki pottery.

2ND CONCHO: Salmon and pink coral. The parrots are from Mimbres pottery and the oval coral represents an egg.

3RD CONCHO: Red coral with a design of an Acoma parrot.

4TH CONCHO: Two red corals with a parrot from a kiva wall painting.

5TH CONCHO: Two Acoma parrots from two different pieces of pottery and a tufa-cast gold rainbow. The pink and red coral give the look of old pottery that fired a peachy-cream color with a blush of pink. The idea of mixing colors in a concho like this was meant to recognize the natural colorization of pottery.

6TH CONCHO: Two pale orange coral pieces with a Hopi Sityatki pottery parrot.

7TH CONCHO: Orange and pink coral with an Acoma parrot.

8TH CONCHO: Orange coral and a stylized Hopi parrot.

9TH CONCHO: Orange and red coral with an old Hopi Sityatki design.

10TH CONCHO: Zia bird and orange and pink coral.

11TH CONCHO: Two Mimbres parrots and orange coral.

12TH CONCHO: Acoma parrot and two pieces of orange coral; tufa-cast gold and two corals echo the fan of the feathers on the tail of the parrot. Private Collection.

46. "HUMAN FIGURES BELT," AUGUST 1991

While depictions of humans had always been an element on the reverse of the belt buckles, they had not been used on conchos prior to this one. This belt was made for and sold at Indian Market. The belt is silver with 14k gold bezels and accents.

BUCKLE: This buckle has an unusual shape with the two Botswana agates that are side cuts placed on either side of the figure. The linear qualities of the cuttlefish bone-cast

gold was used in the "Navajo Pictorial Textiles Belt." In this belt, the cast pieces were cut crosswise to make use of the curvilinear qualities of the cast to resemble the curve of baskets. The top half of the appliquéd figure is cuttlefish bone-cast 14k gold, and the bottom half is in silver with lines made by an awl, a tool commonly used in basketry. Buckle reverse: Basketry figures with triangular heads made from awl work, also called rocker engraving. This is the same technique Johnson uses for texture in overlay.

1ST CONCHO: Coral, Bisbee turquoise, Montana agate, and a Mimbres-style crouching figure with silver overlay head and legs. As with the "Mimbres Black and White Belt" made in 1984, Johnson and Bird used a stone to replace part of the design of a figure.

2ND CONCHO: A Mimbres-style figure with a Botswana agate forming its body. Mimicking its shape in a mirror reflection is a Botswana agate and a curve in appliqué cuttlefish bone-cast 14k gold. According to Bird, "This was based on a photo we took at Rio Grande Gorge at sunset. Feathery rabbit bush was in full bloom as the sun was going down. The combinations of the soft pinks, grays, lavenders, and blues created an appealing palette which we used in this belt."

3RD CONCHO: Two Montana agates and a line of male and female figures from Pima baskets in silver overlay. The star in the center represents a design sometimes seen at the center of baskets. The Montana agates have designs that are similar to the human figures, and the line of figures appears to continue into the stones.

4TH CONCHO: Botswana agate and coral and two female figures from Navajo textiles in silver overlay. One skirt has an appliquéd cuttlefish bone-cast 14k gold design, and the figure has gold drops for eyes.

5TH CONCHO: Two Brazilian agates, coral, and a Navajo textile design of a male figure with upraised hands in silver overlay. He has stars in his hands.

6TH CONCHO: Botswana agate, coral, and three male figures. These straight-bodied figures are from basket designs. They are made in overlay with awl work similar to that of the back of the buckle. The curved edge of the concho is reminiscent of a curve formed by a basket rim.

7TH CONCHO: Tyrone turquoise, Montana agate, and coral. Three basketry stars are in silver overlay, and a male figure was cut from a sheet of cuttlefish bone-cast 14k gold. Johnson and Bird used basketry imagery on the "Birthday Belt" in 1985 and the "Basket Belt" in 1983, but this belt required more sophistication in determining how to use the images.

8TH CONCHO: Three Montana agates. The two figures in silver overlay are cowboys from Navajo textiles. The technique of early pictorial weavings resulted in images that are slightly fuzzy. This reminded Bird of the fuzzy chaps that cowboys wore, and she used black-and-white Montana agates to look like the fuzzy chaps. The top Montana agate looks like a man wearing a cowboy hat.

9TH CONCHO: Coral and a design of three basketry figures, two males and one female; both in silver overlay. The largest figure has an appliqué of cuttlefish bone-cast bars on his chest to represent textiles. This was taken directly from a basketry design. This concho was originally a part of the belt and later converted to a pin.

10TH CONCHO: Botswana agate and coral with two figures, who represent Chinese railroad workers in silver overlay. This is the link to the "Navajo Pictorial Textiles Belt" of 1990. Like the ninth concho, this one was later converted to a pin.

11TH CONCHO: Tyrone turquoise and three Mimbres warrior figures in silver overlay. Bird used a photocopy machine to make images bigger and smaller, manipulating the image and ultimately creating a series of the same figure. The shape of the last concho is unlike those of earlier belts, but the abstract figures form a wedge shape to resemble prior belts. Anne Kern Collection.

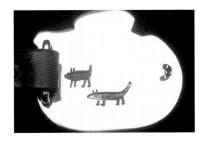

52. "CANINES AND FELINES BELT," AUGUST 1992
Johnson and Bird had three cats and two dogs, which were the inspiration for some of the design on this belt; others are from petroglyphs. An important feature of the belt is the elongated, curved tails of the animals, which adds movement to the belt. All figures have punched 14k gold drops for eyes, which give them a life-like quality, and all bezels are 14k gold.

BUCKLE: Montana agate makes up the body of the cat, and the head is from a Mimbres pottery design. The tail is tufa-cast 14k gold. One coral is above. Buckle reverse: A petroglyph cat and dog are in silver overlay.

1ST CONCHO: Coral in a 14k gold bezel. A small tufa-cast gold animal is on top of the coral, and a larger animal is below. The design is from Mimbres pottery. The larger animal is in silver overlay with a tufa-cast gold tail appliquéd.

2ND CONCHO: Pink coral, a Montana agate with a pattern that looks like a stylized rabbit, and Tyrone turquoise in 14k gold bezels. Designs in silver overlay are of two dogs facing one another.

3RD CONCHO: Montana agate with a pattern of a stylized rabbit, coral, and a silver overlay design of a cat with a tufa-cast angular tail over its back.

4TH CONCHO: Montana agate that looks like an animal, Tyrone turquoise, coral, and a design of two cats facing each other. The turquoise forms the body of one cat. Both have gold appliquéd tails with heads, legs, and feet in silver overlay.

5TH CONCHO: Two Montana agates and coral. One Montana agate forms the body of a big cat; its head is looking toward the second agate. The cat's feet are on the coral and its long gold appliquéd tail (with saw marks) curves around the coral.

6TH CONCHO: Plume agate and two dogs in silver overlay facing the same direction. The first has a long tufa-cast tail, and a fish tail at the end is from a Mimbres pottery design. The second dog, with a geometric inclusion in its body, is climbing up a rock to look over at the other dog.

7TH CONCHO: Tyrone turquoise, coral, and a dog with short ears in silver overlay.

8TH CONCHO: Coral and Montana agate. The design is of a dog and a ball. The dog has a tufa-cast tail in the air and a geometric inclusion in cuttlefish bone-cast gold. Johnson sawed and stamped designs on the tail. The coral represents a ball.

9TH CONCHO: Montana agate and plume agate form the bodies of two animals with heads and feet in silver overlay. Johnson and Bird used Montana agate because it echoes the shape of the Mimbres-style head of the dog. The design looks like it was taken from a petroglyph image of a mountain lion, and it has paw prints included.

10TH CONCHO: Montana agate, coral, and a design of a cat. Johnson and Bird changed them to give them cat and dog-like features. The tail has stamped geometric patterns.

11TH CONCHO: Black-and-white Brazilian agate. The dog is looking at a skunk; both are in silver overlay with gold accents. The agate symbolizes the skunk's spray and the dog is alarmed. Private Collection, Dallas.

53. "PUEBLO GARDEN BELT,"
AUGUST 1993
According to Gail Bird, "This belt centers around the symbols that have been present in Pueblo pottery from prehistoric Mimbres times through the present, representing plants and the importance of gardening as a way of sustaining life." Johnson and Bird's own garden is also portrayed. The belt is silver with 14k gold bezels and accents.

BUCKLE: Amethyst sage agate. The dendrites in the agate look like plant growth. The tufa-cast bar echoes the curve of the stone. The line sawed into it is used in Acoma pottery to represent plants. Buckle reverse: Mimbres-style grasshopper in silver overlay.

1ST CONCHO: Two moss agates and a tufa-cast gold hand from a Mimbres pottery design. The green of the moss agates symbolizes plant life and growth. The designs in overlay and appliqué are from bean-leaf designs on Santo Domingo stew bowls made by the Melchor family and owned by collector and potter Rick Dillingham.

2ND CONCHO: Dendritic agate with inclusions that look like plant growth. Designs are of two turkeys, one in overlay and the other tufa cast. They appear to be eating bugs formed by the inclusions in the stone.

3RD CONCHO: Coral, Montana agate, and silver overlay designs of bean leaves and mosquitoes from Mimbres pottery.

4TH CONCHO: Dendritic agate with an inclusion that resembles a rabbit. On one side of the stone is a design of a Mimbres-style rabbit and on the other is a raccoon standing on a plant eating. Both are silver overlay with gold-drop appliqué.

5TH CONCHO: The two dendritic agates are German-cut stones. They have inclusions that resemble bugs. The turkey in overlay has his tail feathers spread in a fan; a piece of gold and a diamond-shaped piece of lapis lazuli are included in the body.

6TH CONCHO: Montana agate and plume agate. The Montana agate has an inclusion that looks like a horizon line and in the center the pattern looks like storm clouds. The silver overlay design from a petroglyph looks like lightning bolts. The center echoes the inclusion in the center in the Montana agate. Leaves are in gold appliqué with negative black triangles in overlay to represent the Santo Domingo black-and-white pottery designs of corresponding plant imagery.

7TH CONCHO: Montana agate and Tyrone turquoise. The Montana agate has a pattern that looks like a horizon line with bushes or trees. Above the agate in silver overlay is a branch with fruit on it. Turquoise makes up the body of an overlay deer looking at the fruit.

8TH CONCHO: Tyrone turquoise, dendritic agate, and a Montana agate. The stones were chosen for their inclusions that look like plants. Above in silver overlay is a Mimbres-style worm.

9TH CONCHO: A moss agate with corn plants in overlay on each side. The designs were taken from petroglyphs near Hopi. The ears of corn can be seen on the corn plants. There are designs of a bird and an overlay skunk. Below the agate, a corn plant is formed from tufa-cast gold.

10TH CONCHO: Two Montana agates, an Indian Mountain spider web turquoise, and two rabbits. One Montana agate makes up the body of a rabbit, and the markings look like the rabbit's body. Its feet and tail are in silver overlay, and the other rabbit is in overlay.

11TH CONCHO: Two coral and a black-and-white Brazilian agate. This agate matches the stone in the "Drought and Desert Belt" (1994). Inclusions look like branches. In overlay is a design of a deer with gold-dot appliqué. This belt was created the year Johnson and Bird planted apple trees. Deer would come into the orchard to eat apples, and the deer on the belt appears to eat the apple illustrated by coral. The deer design was inspired by a Plateau beaded bag with an elk design that Ray and Judy Dewey featured on a Christmas card one year. Valerie T. Diker Collection.

54. "DROUGHT AND DESERT BELT," AUGUST 1994

This belt recorded a drought like the "Wildflowers and Butterflies Belt" and "Lightning Belt" recorded rain. Those belts noted the presence of water, whereas this belt referred to the lack of rain by using similar symbols in a hotter color palette. Johnson and Bird symbolized sun and heat by using agates with hot colors—reds and yellows. Petrified wood and earth-toned stones portray the desert. This was a year without much rain, so the frogs near Johnson and Bird's home jumped from pond to pond because the river was dry. Yowah opals represent water and were used for the first time in a belt. The belt is silver. 18k gold was also used for the first time for all bezels and accents. The belt was made for and sold at Indian Market.

BUCKLE: Brazilian agate with flame-like qualities and coral. A Mimbres-style pottery design with cut-out stars in tufa-cast gold has a silver overlay star. Buckle reverse: A series of stars in silver overlay. One has an 18k gold drop in the center.

1ST CONCHO: Tyrone turquoise, pink coral, orange coral, and two frogs in silver overlay. The stones make up the body of the frogs with pink coral between them. These frogs are more whimsical than those of the "Mimbres Black and White Belt," which reflected the painted style of Mimbres pottery.

2ND CONCHO: Plume agate and two tufa-cast designs. One is a spiral and the other is a snake. The spiral represents heat and the sun, and the snake is a reminder of the desert.

3RD CONCHO: Owyhee jasper and two corals. The jasper is the body of a horned toad, and his head, legs, and tail are in silver overlay with 18k gold drops for eyes. The coral is in the center of a silver overlay Mimbres-style star that represents the sun.

4TH CONCHO: Petrified wood and a Brazilian agate. The Brazilian agate is graphic with a black line that looks like a landscape and a sun surrounded by a cloud of gold that looks like dust. Another cloud of dust looks like the moon. A silver overlay Mimbres snake coils around echoing the curved line of the stone. The petrified wood extends the black horizon line of the agate. Above the horizon is a black tree with the same colors, conveying the idea of heat.

5TH CONCHO: Coral and a Yowah opal that makes up the body of a silver overlay lizard. A scorpion is also in overlay. The Yowah opal is filled with dark matrix that reflects the dryness of the desert.

6TH CONCHO: Plume agate, probably Brazilian. The stone was used because the pattern looks like a sunflower or the surface of the sun radiating heat. A snake in silver overlay has gold dots on its body. Extending to the left is a Hohokam pottery design also in overlay with gold-dot appliqué.

7TH CONCHO: Montana agate, coral, and two lizards in silver overlay. The body of the first lizard is a rectangular Montana agate with a tufa-cast angular tail. The Montana agate has inclusions that look like the field of stars on the back of the buckle.

8TH CONCHO: Two frogs in silver overlay. One has a Bruneau jasper body and the other a disk of tufa-cast gold. They are hopping in different directions. Private Collection, Dallas.

88. "COLLECTOR'S BELT," JUNE 1995

The "Collector's Belt" is one of the few made on commission, and along with Judy Dewey's "Birthday Belt," it is one of the most personal. When the buyer asked for the belt for his wife, he said, "Don't take too long because we're not young anymore." He left the theme to the artists saying that they knew them really well and trusted them to do it. According to Bird, "The belt is filled with inside jokes, shared stories, and experiences. The use of the dinosaurs and petrified dinosaur bone relates to the suggestion of the patrons' daughter that the newly opened Albuquerque Museum of Natural History with its dinosaur displays would be large enough and appropriate for the celebration of a major birthday where her mother could 'celebrate with her peers.' Dinosaurs became the theme for the party; dinosaurs, humor, and enjoyment of life, travel, and Indian art of the Southwest became the theme for the belt."

BUCKLE: Parrel plume agate from Mexico and oxblood coral with a tufa-cast 18k gold waning moon and stylized cloud design in appliqué. The agate has a wonderful natural color that looks like a moon and landscape,

1.5 x 2.5 inches. Buckle reverse: The design is from a Navajo textile; the three stars represent the couple's three children.

1ST CONCHO: Coral and dendritic plume agate with a tufa-cast 18k gold design of a female figure adapted from an early pictorial textile. A friend commented that the golden figure perfectly suited the owner, because she is the golden goddess. The horse, in silver overlay, had a brand, but Johnson changed the brand to include the R and backwards Z to represent the owner.

2ND CONCHO: Dinosaur bone. This concho depicts a Hohokam bracelet, and the corner piece is adapted from a carved stone amulet or pendant from a book on prehistoric jewelry. The circular piece represents the belt owner's travels. The spiral on this concho is similar to the one on the second concho of the prior belt.

3RD CONCHO: Dinosaur bone and a pale blue opal. The line above is a shadow of the silver overlay brontosaurus; the line has dots and refers to an Acoma pottery design of a stem with dots.

4TH CONCHO: Tyrone turquoise and two Australian banded agates. One makes up the body of an exotic cat from Mimbres pottery with a 18k gold tufa-cast tail over its head. At the feet of this stylized cat is a curved tail; the end of the tail connects with the body formed by the other agate. This design reflects the clients' trip to Africa.

5TH CONCHO: Zebra stone from Australia and a plume agate. Bird liked the juxtaposition of these two stones and the Mimbres design in silver overlay that looks like lightning; it represents the energy of the clients.

6TH CONCHO: Yowah opal, lapis lazuli, and coral with a Mimbres-style feline in silver overlay with a curved tufa-cast 18k gold tail. They have used the curve in several belts.

7TH CONCHO: Two agate fossils, probably fossilized bone or shell, and a Montana agate. They used the fossils because of the patterning. The silver overlay stegosaurus has plates on its back. The pattern in the Montana agate reflects the plate-like formation on the back of the dinosaur.

8TH CONCHO: Brazilian agate and a carved agate by Dieter Lorenz. A silver overlay penguin with a tufa-cast 18k gold bar in its center represents the owners' trip to Antarctica.

9TH CONCHO: A Yowah opal forms the body of a silver overlay whale. Another whale, from a whale-watching trip, is appliquéd in tufa-cast 18k gold. The Blue Gem turquoise represents water. Originally, this was the last concho, and it has the characteristic terminal shape.

10TH CONCHO: The last concho was added as a birthday gift from the husband. The "S" represents another shared memory between client and artists. The owner's ambition when she was young was to be a Rockette, so on this particular birthday, her husband took her to New York to see the Rockettes. The two Australian jaspers are placed to look like kicking legs. Private Collection.

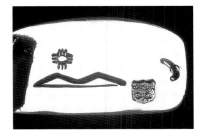

55. "ROUTE 66/TOURISM BELT," AUGUST 1995
The artists based this belt on things they saw growing up in the Southwest. Most of the designs are from Navajo pictorial weaving; others are from billboards, roadside signs, neon lights, and roadside structures. The belt is silver with 18k gold bezels and accents.

BUCKLE: Wild Horse picture jasper. Buckle reverse: Zia sun symbol, which is also the New Mexico state symbol, a horizontally placed bow to symbolize mountains, an arrow from a Navajo pictorial textile, and a US 66 symbol. Designs are appliquéd or accomplished by stamp work or silver overlay.

1ST CONCHO: Montana agate, turquoise, an image that represents the first traveler (the intrepid tourist) and the first pickup truck; lightning bolts, dust, and rainstorms. Johnson thought Bird placed the lightning bolt over the hood of the truck to symbolize overheating engines.

2ND CONCHO: Yellow and white jasper with dendrites, Yowah opal. Patterns in the stones are reminiscent of lightning and storms. The designs include male figures from Navajo textiles; the first figure points at a second figure, who looks surprised, shocked, struck by lightning (the outspread fingers). The figure with his thumbs up may be a hitchhiker.

3RD CONCHO: Owyhee jasper. This concho shows many more cars on the highway; the vehicles come from textile designs.

4TH CONCHO: Lapis lazuli, Owyhee jasper, coral. There used to be a trading post called Twin Arrows on Route 66 that had two giant arrows stuck in the ground. The swirling stone with the large depression symbolizes Meteor Crater Trading Post between Winslow and Flagstaff.

5TH CONCHO: Yellow and white jasper with dendrites, Yowah opal. The Jack Rabbit Trading Post, Joseph City, Arizona, had silhouettes of jackrabbits with numbers on them along the highway; as you got closer the rabbits got larger, the numbers smaller. When you finally arrived at the turnoff, the rabbits were huge with big signs saying, "You are here." The building itself was covered with touristy Indian designs and more cutouts of black jackrabbits. The dendritic agate seems to have faint silhouettes of rabbits.

6TH CONCHO: Blue Mountain jasper, Fox turquoise. Referring to tourist jewelry, with its mass-produced, cheap, "Indian-style" images of horses, dogs, or coyotes, the artists appliquéd and stamped on "Indian" symbols.

7TH CONCHO: Yowah opal, Biggs jasper, and spectrolite (labradorite) to represent the neon on Route 66. The bird is from the Blue Swallow Motel in Tucumcari, New Mexico. For the sign from the Wigwam Motel in Albuquerque, they used spectrolite with lines of blue and opals with yellows and greens to represent bright lights.

8TH CONCHO: Blue Mountain jasper, coral. The designs refer to tourist motels, specifically the Wigwam Motel in Holbrook, Arizona.

9TH CONCHO: Two Trading Post jaspers (probably Owyhee Junction jasper) and two Tyrone turquoise. Here is more tourist jewelry with an eagle, thunderbird, and arrow and small turquoise sets. They used Trading Post jasper because of its name and to repeat the wingspread of an eagle, which also recalls the Mobil service station logo.

10TH CONCHO: Petrified wood and agate, stones meant to symbolize the Petrified Forest. Planes, based on designs from Navajo textiles, fly over Route 66. The stones symbolize the Petrified Forest and the Grand Canyon. This image ends the belt because tourists now more commonly travel by plane. Heard Museum Collection.

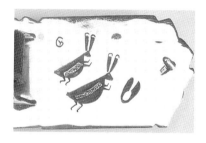

89. "FOUR SEASONS BELT,"
JULY 1996

In 1996, the artists were commissioned to make another belt. They visited the home of the collector, who had a greenhouse with exotic plants that are not indigenous to arid New Mexico. Bird and Johnson found that they shared an interest in gardening and planning the belt coincided with an idea that had grown from the previous "Wildflowers and Butterflies," "Pueblo Gardening," and "Drought and Desert" belts. This belt is about vegetation and growth but not limited to native plants of the Southwest. The artists selected stones that have green in them to reflect verdant areas and forms from throughout the world. The plants reflect the seasons; for autumn they show the chile

harvest and leaves turning color and falling. The winter scene has an agate with white spots that look like snow, and winterberry is represented with coral. The belt is silver with 18k gold bezels and accents.

BUCKLE: Winter—morrisonite and a design of red twig dogwood in silver overlay. 1.5 x 2.75 inches. Buckle reverse: Two Mimbres-style rabbits and Japanese garden shears in silver overlay. The rabbits have tufa-cast 18k gold bars in their centers.

1ST CONCHO: Spring—morrisonite and Manassa turquoise with designs of frogs and leaves in silver overlay and appliquéd tufa-cast 18k gold pieces.

2ND CONCHO: Spring—morrisonite and Tyrone turquoise with designs of budding twigs and flying insects in silver overlay.

3RD CONCHO: Spring—morrisonite and Holley Blue agate and designs of irises in silver overlay and tufa-cast 18k gold.

4TH CONCHO: Summer—three poppy jaspers and a design of a field of flowers in silver overlay with the stems in tufa-cast 18k gold.

5TH CONCHO: Summer—lapis lazuli, Yowah opal, and flower jasper. Designs are of a Japanese peony and a bug from Mimbres pottery in silver overlay and tufa-cast 18k gold. This type of bug, common in New Mexico gardens, has scaly, hard surfaces and looks like a dinosaur bug.

6TH CONCHO: Summer—morrisonite, chrysocolla, and silver overlay designs of buds and patterns from Acoma pottery.

7TH CONCHO: Summer—rainforest jasper and daylilies in tufa-cast 18k gold and silver overlay.

8TH CONCHO: Late summer—green moss agate and two variscites with designs of a Japanese pine tree and topiary in tufa-cast 18k gold and silver overlay.

9TH CONCHO: Autumn—morrisonite, coral, and silver overlay designs of chiles.

10TH CONCHO: Autumn—morrisonite, Yowah opal, and designs of falling leaves in silver overlay and tufa-cast 18k gold.

11TH CONCHO: Winter—Mexican tube agate, coral, and a design of winterberry branches in silver overlay. HMC Collection.

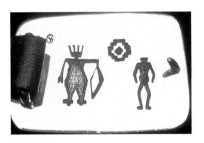

90. "CIRCUS BASKET BELT,"
AUGUST 1997

This belt was inspired by a historic California basket containing circus figures, both human and animal. Johnson and Bird saw it in Dewey Gallery earlier in the year and asked permission to photograph it. As in the 1983 "Basket Belt," surfaces and edges of the figures reflect the coiled weaving technique and also the curved shape of the basket. The belt was made for Indian Market, and while it was displayed in the artists' booth, one could see the basket at Dewey Gallery. The belt is silver with 18k gold bezels and accents.

BUCKLE: Polka dot agate. Buckle reverse: Two basketry figures and a star in silver overlay.

1ST CONCHO: Yowah opal, Australian jasper, and a horse in silver overlay with a small tufa-cast 18k gold stylized bird above in appliqué.

2ND CONCHO: Lace agate, coral, and two camels, one in silver overlay and the other in appliquéd tufa-cast 18k gold.

3RD CONCHO: Lace agate, Yowah opal, and two elephants in silver overlay. Tufa-cast 18k gold pieces are appliquéd to each.

4TH CONCHO: Two poppy jaspers and a camel in silver overlay.

5TH CONCHO: Bisbee turquoise, poppy jasper, and in silver overlay a dog, a bear, and a man holding a bow.

6TH CONCHO: Poppy jasper, lapis lazuli, and in silver overlay the bear and dog designs from the fifth concho. Above in tufa-cast 18k gold is another dog in appliqué.

7TH CONCHO: Montana agate, lace agate, and in silver overlay two men and two women.

8TH CONCHO: Petrified palm and Montana agate with a tiger in silver overlay.

9TH CONCHO: Lace agate, coral, and two elephants. One in silver overlay is shaped and textured like a basketry elephant, and the other is naturalistic and tufa cast of 18k gold.

10TH CONCHO: Coral, Montana agate, a silver overlay tiger, and a tufa-cast 18k gold tiger in appliqué. Jack Reynolds Collection.

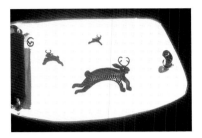

91. "ANTLERS BELT,"
FEBRUARY 1998

The idea for this belt followed a visit to the Petrified Forest in Arizona and the Boyce Thompson Arboretum in Globe, Arizona, where Johnson and Bird photographed trees and cactus with long, extended limbs. Johnson and Bird began thinking of this belt in November 1997 when Christmas cards started arriving, many of which had both realistic and stylized images of deer, elk, and reindeer. According to Bird, "The long, graceful antlers reminded me of the photographs Yazzie and I had taken the previous year. Those images combined with Mimbres designs and petroglyph images are used in this belt. The intent was to be whimsical." They chose stones with patterns that look like antlers. The belt depicts both full antlers and parts of antlers. The belt is silver with 18k gold bezels and accents.

BUCKLE: Dendritic agate with inclusions that look like antlers. Buckle reverse: A series of three rabbits leaping in different directions. One rabbit is from a drawing by Robert Haozous to which Johnson added antlers, transforming it into a jackalope.

1ST CONCHO: Brazilian agate with silver inclusions or saganite and Tyrone turquoise. In overlay is a design of a bighorn sheep and a stylized leaping deer with a tufa-cast decorative appliqué in its body.

2ND CONCHO: Plume agate and coral with a deer and an elk in silver overlay. A single antler in tufa-cast gold with small coral at the end in appliqué separates them.

3RD CONCHO: Tyrone turquoise forms the body of a bighorn sheep with head, legs, and tail in silver overlay. Another in overlay has appliquéd tufa-cast gold in the inner body. Between them is a tufa-cast 18k gold appliquéd bighorn sheep.

4TH CONCHO: Montana agate and a plume agate. The design of two elk is from petroglyphs. One has a partial body with front legs, while the other has just the head and antlers. Inclusions in the plume agate look like antlers.

5TH CONCHO: Dendritic agate. On one side is a deer in overlay with giant antlers and on the other is an elk with four gold dots in appliqué. The agate inclusions look like antlers.

6TH CONCHO: Yowah opal, lapis lazuli, and coral. The Yowah opal is the body of a deer in overlay, and the opal has markings that look like antlers. The second deer is of appliquéd tufa-cast 18k gold with its antlers detailed in pierce work.

7TH CONCHO: Montana agate, coral, and Yowah opal. Designs are of two bighorn sheep. The Yowah opal makes up the body of the smaller sheep in silver overlay, and the feet have drops of gold appliquéd on the hooves. An appliquéd tufa-cast 18k gold bighorn sheep leaps over the Montana agate. The Montana agate has curved lines echoing the shape of the bighorn sheep.

8TH CONCHO: Banded agate and psilomelane and quartz. The agate forms the body of a deer in overlay. Three antlers extend from the other stone, two in overlay and one in appliquéd tufa-cast 18k gold. The designs were inspired by branches that resemble antlers and images from Christmas cards.

9TH CONCHO: Montana agate and coral and three sets of antlers. Two are in silver overlay and one is in 18k gold appliqué. These antlers are soft and full, almost cartoon-like, and the Montana agate has a soft shape, as does the coral. The antler designs may be from an illustration. Private Collection.

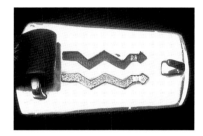

85. "TRANSPORTATION (GOING HOME) BELT," AUGUST 1998
This belt was made for and sold at Indian Market. all bezels and accents are 18K gold.

BUCKLE: Parrell plume agate. Buckle reverse: Directional arrows.

1ST CONCHO: Brazilian agate, coral, and a wagon in silver overlay with 18k gold wheels appliquéd.

2ND CONCHO: Petrified wood and a train in silver overlay. The trail of the smoke from the train continues into the petrified wood.

3RD CONCHO: Montana agate and a tufa-cast 18k gold pickup truck with lapis lazuli. A man on a horse in silver overlay is from a textile design.

4TH CONCHO: Turquoise, Montana agate, and a car with passengers in silver overlay from a Navajo textile design. The front and wheels are tufa-cast 18k gold appliqué. The Montana agate resembles Monument Valley.

5TH CONCHO: Coral and Montana agate and two pickup trucks, one in silver overlay and the other tufa-cast 18k gold appliqué. The Montana agate has inclusions that represent the truck headlights.

6TH CONCHO: Turquoise and Montana agate with a silver overlay airplane with 18k gold wings appliquéd.

7TH CONCHO: Montana agates, two silver overlay pickup trucks at a drive-in movie from a Navajo textile design. An appliquéd 18k gold figure stands between the trucks.

8TH CONCHO: Bisbee turquoise, petrified wood, a tufa-cast 18k gold horse appliquéd, and in silver overlay a boy on a stick horse from a folk art carving.

9TH CONCHO: Montana agate, coral, and two airplanes; one is silver overlay and the other is tufa-cast 18k gold appliqué. Photograph by Kevin L. Suckling. Private Collection.

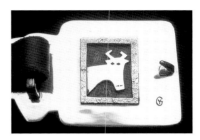

93. "PROTEIN BELT," AUGUST 1999

This belt was based on cow imagery in Navajo textiles and jewelry. In New Mexico, cattle ownership is a sign of wealth; one needs water and good grazing land to own cows. The frequent inclusion of cattle in early to mid-century Navajo art is often detailed and humorous. The belt was made for and sold at Indian Market. The belt is silver with 18k gold bezels and accents.

BUCKLE: Parrel plume agate. The pattern of this stone is unusual because of the mesa outline with the dark sky and the pale blue areas. On the horizon are pale images that resemble cows. To the side are two appliquéd, stamp-work steer heads. Buckle reverse: The overlay design of the cow was taken from a Navajo textile design. An 18k gold tufa-cast appliqué frame surrounds a picture of a cow.

1ST CONCHO: Plume agate and Morenci turquoise and an overlay figure of a cowboy on a horse. The horse has brands in tufa-cast gold. The plume agate has patterns that look like cows, and the turquoise has an image of a cowboy head.

2ND CONCHO: Two poppy jaspers and an overlay and stamped cow design divided in two and connected with a piece of gold. Johnson and Bird had once seen a herd of a particular black-and-white breed of cattle and were struck by their unusual markings.

It seemed natural to include one in this belt, although the artists did not know the name of the breed until the buyer identified it as the Belted Galloway at Indian Market.

3RD CONCHO: Yowah opal, a lace agate, and a textile cow with a J brand and a gold eye. Bird found the "J" in an image of a textile and used it for Johnson.

4TH AND 5TH CONCHOS: This design of cows looking at each other is from a textile. The cows are tufa-cast gold appliqué.

In the 4th concho: Petrified palmwood with a pattern that looks like steer horns.

In the 5th concho: Yowah opal and petrified wood with a graphic design. The artists selected petrified wood because of its use in old Navajo-style tourist jewelry.

6TH CONCHO: Yowah opal, containing a deep brown because of the extensive matrix in the stone. The pattern resembles a canyon with bits of light coming through. In overlay are figures of a cowboy, a steer, and an appliquéd tufa-cast gold dog. The cowboy and dog are looking for the lost cow in the canyon.

7TH CONCHO: Coral and petrified palmwood. The steer has a V-shaped brand; the petrified palmwood is the same shape. The coral goes with the red in the palmwood.

8TH CONCHO: Montana agate and poppy jasper and four steer heads. One is tufa-cast and appliquéd; one is smooth. The third has a head in poppy jasper and horns and ears in overlay. The fourth, in Montana agate, is a stylized pattern.

9TH CONCHO: Lapis lazuli, Yowah opal, and coral. A stamped silver overlay Navajo textile steer has a body of lapis lazuli. The shape of this concho recalls the wedge shape of the last conchos in the early belts. Tunia Hyland Collection.

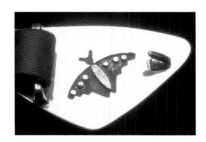

94. "SPOTS AND DOTS BELT," AUGUST 2000

The artists' interest in and purchase of unusual agates and jaspers—Montana agates, petrified palmwood, and poppy jaspers—over the years has included many with spots or dots. There are also many animals and birds that have those markings on their coats and feathers. The artists' dog, Dot, appears on the third concho of the belt, which was made for and sold at Indian Market. The belt is silver with 18k gold bezels and accents.

BUCKLE: Petrified palmwood. Buckle reverse: A moth adapted from a Hopi pottery design with big gold appliquéd dots on the wings and a tufa-cast gold body. Johnson has used variations of this design over the years.

1ST CONCHO: Montana agate, poppy jasper, and coral. The designs are two leaping frogs from Mimbres pottery. A Montana agate makes up the body of one, and the other is in silver overlay with gold appliqué dots.

2ND CONCHO: Yowah opal and petrified palmwood. Silver overlay designs are of a Mimbres-style horned toad and a lizard and

a tufa-cast and pierced snake with a bulge. Johnson and Bird saw a snake with dots on its skin.

3RD CONCHO: Oolite from Australia and Madagascar jasper forming the body of a goat and two barking dogs, one tufa-cast gold and the other stylized in silver overlay with Mimbres gold spots on its body. The two dogs are barking at the goat and a tufa-cast ball is between them.

4TH CONCHO: Ocean jasper and poppy jasper with an overlay goat and petroglyph animal. The images may be from Bird's photographs or from books. The goat has an inset of appliquéd gold with spots, and the other animal has gold spots appliquéd on the tail.

5TH CONCHO: Petrified pinecone, poppy jasper, and oolite. The petrified pinecone makes up the body of a Mimbres-style antelope. The oolite makes up the body of a small deer. Both animals are in overlay.

6TH CONCHO: Two petrified palmwoods and a poppy jasper, which make up the body of cat-like petroglyphs. Their backs are spotted with dots of gold appliqué.

7TH CONCHO: Poppy jasper with designs in overlay of a spotted chicken and a moth with spots across its wings. This is the same moth as on the buckle reverse.

8TH CONCHO: Coral, Yowah opal, and Montana agate. Designs are of two bighorn sheep adapted from petroglyphs. Bird used a Yowah opal for the body of the larger sheep and selected tufa-cast gold for the smaller animal. The body of the small sheep echoes the curve in the opal, and the gold body is filled with stamped dots. The Montana agate they chose is full of spots and stars.

9TH CONCHO: Petrified palmwood and coral. A leaping cheetah has appliquéd 18k gold and an overlay guinea hen has appliquéd dots and a tufa-cast head and body.

10TH CONCHO: Fox turquoise, poppy jasper, and Montana agate. A spotted pony comes from a Navajo textile, and a cow design links this belt to the "Protein Belt." Both are in stamped overlay with gold appliquéd dots. Tunia Hyland Collection.

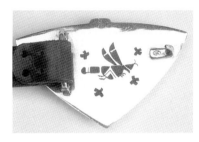

95. "BUTTERFLY BELT,"
AUGUST 2001
Johnson and Bird designed this belt after they served as guest curators for a jewelry exhibit entitled "Be Dazzled! Masterworks from the Heard Museum" and following a seminar with Martha Struever in which they reviewed jewelry collections at the Heard, the Millicent Rogers Museum in Taos, the Museum of Indian Art and Culture, and the School of American Research, both in Santa Fe. Johnson and Bird were impressed by the work of earlier silversmiths and the richness of the materials they used, especially good natural turquoise and high-quality coral. In these early collections they also saw jewelry that incorporated butterfly designs, including work by Zuni jeweler John Gordon Leek, who inlaid turquoise and coral butterfly patterns on a background of jet. The earlier "Wildflowers and Butterfly Belt" (1986) had used pastel colors to reflect the colors of butterfly designs in Hopi pottery. For this

belt, the artists wanted to use rich colors that would reflect the color range and the patterning of butterfly wings. Yowah opals, dendritic agates, and lapis lazuli were used for that purpose. The conchos have unusual shapes to accommodate the designs of the butterflies. This belt incorporates stylized butterfly designs and uses a lot of 18k gold, tufa casting, and gold-dot appliqué. The belt is silver with 18k gold bezels and accents.

BUCKLE: Dendritic agate. The shape is a stylized butterfly and the tufa-cast lines above the stone represent antennae, 2 x 3 inches. Buckle reverse: A grasshopper in silver overlay. Johnson and Bird used a winged creature surrounded by a field of textile stars, which Bird curved to make stylized butterflies.

1ST CONCHO: Two Yowah opals and a Montana agate. Bird selected unmatched opals to capture the sense of a butterfly in motion, with light and dark areas representing the wings in flight. The body and antennae are appliquéd tufa-cast gold. Also, the Montana agate has an inclusion that looks like a butterfly flying and hovering over plants.

2ND CONCHO: A moss agate represents the body of a Mimbres-style butterfly, whose head and antennae are in silver overlay with a gold-drop eye. The other design is a stylized dragonfly with a lapis lazuli body, two Yowah opals, appliquéd tufa-cast gold wings, and antennae in silver overlay.

3RD CONCHO: Dendritic agate and two Yowah opals. The agate has inclusions that resemble a ferny growth with a flower extending to one side. The butterfly has an appliquéd 18k gold tufa-cast body and antennae with round finials.

4TH CONCHO: Three tufa-cast butterflies taken from a photograph of a Hopi painted screen with butterfly and moth images. Because of their thickness, these butterflies look more like moths. The thicker and heavier wings of moths were depicted in tufa-cast gold. The Montana agate has a pattern that looks like a moth.

5TH CONCHO: Dendritic agate, two Yowah opals, and a Montana agate. They depicted a butterfly with simple tufa-cast antennae coming out of the body.

6TH CONCHO: Yowah opal, moss agate (Montana), and two butterflies from Mimbres pottery in silver overlay with tiny 18k gold appliquéd dots.

7TH CONCHO: One butterfly is composed of two lapis lazulis for wings, a coral body, and silver overlay antennae. The other butterfly has a head and wings of tufa-cast gold wings but no antennae. This butterfly and the one on the last concho are from a photograph of a Hopi painted screen and old Hopi pottery designs.

8TH CONCHO: Two Yowah opals and a plume agate. The opals make up the bodies of caterpillars from Mimbres-style pottery designs in silver overlay.

9TH CONCHO: The same figure is reflected three times in silver overlay with different stones. One has a Tyrone turquoise head and small gold drops on the body; another has a dendritic agate body, and the third has a Yowah opal body and small gold appliquéd drops on the head.

10TH CONCHO: Petersite, a nonprecious material, is a stone with high mineral content almost like a spectrolite, and it contains flashes of light. The body of the appliquéd butterfly is thick and next to it is a moss

agate. The shape of the last concho is a stylized version of earlier forms. Private Collection.

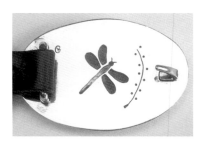

108. "DINOSAUR BELT,"
AUGUST 2002

"Following the butterfly belt, we were blocked on what to do," recalls Bird. "We remembered the dinosaurs in the 1995 "Collector's Belt" and decided to pay homage to that piece. We thought the concepts and shapes should be playful. We used children's books on dinosaurs, watched the movie *Jurassic Park,* and developed the different themes selecting stones that either became a part of the dinosaur's body or looked like vegetation or actual dinosaurs. We later gave the books away to kids." Over the years Johnson and Bird had picked up egg-shaped rocks and jokingly called it their collection of dinosaur eggs. The belt is silver with 18k gold bezels and accents.

BUCKLE: Oval-shaped Montana agate to represent a dinosaur egg. Bird wanted to use petrified dinosaur bone exclusively for this belt, but because those stones are usually small in scale, they chose other larger stones to add size and depth, including Montana and dendritic agates, which they use frequently because the patterns in the stones look like plants or animals, 2 x 3 inches. Buckle reverse: A silver overlay design of a butterfly and a plant references the "Butterfly Belt."

1ST CONCHO: The curves of the coral reflect the curved necks of the dinosaurs, which appear above the foliage represented by moss agate. The tufa-cast and appliquéd 18k gold bars continue the lines of the coral. A petrified dinosaur bone is included also.

2ND CONCHO: Two pieces of coral and a Montana agate with curved designs that reflect the shapes of the stegosaurus in silver overlay.

3RD CONCHO: Yowah opal forms the dinosaur body; the other features are in silver overlay. It stands on a stone of petrified palmwood and looks toward a Montana agate with a pattern that resembles a valley surrounded by a forest of trees.

4TH CONCHO: Yowah opal, dinosaur bone, and coral. The opal forms the body of a stegosaurus-like dinosaur that has spikes on its back in silver overlay.

5TH CONCHO: Dinosaur bone, two Montana agates, and two brontosaurus. One in silver overlay has a spiky tail and the other behind it is tufa-cast and appliquéd 18k gold. They stand one behind the other because scientists believe they lived in groups. The top agate has the head of one dinosaur, and in the agate below are the two heads and necks of the brontosaurus in the distance.

6TH CONCHO: Coral and a stegosaurus with a Montana agate that forms the spikes on its back. The egg is Sleeping Beauty turquoise.

7TH CONCHO: The silver overlay dinosaur has horns on its head and the Montana agate used for the body has curves and the hint of a head, a horn, and a tail. The top Montana agate has a pattern reminiscent of horns, with coral nearby.

8TH CONCHO: Yowah opal, Tyrone turquoise, and dendritic agate with plume-like structures. In silver overlay are a Tyrannosaurus rex and two brontosaurus in tufa-cast 18k gold appliqué with their heads turned to look at him.

9TH CONCHO: Montana agate, dinosaur bone, a dinosaur in silver overlay, and a tufa-cast gold egg.

10TH CONCHO: Lapis lazuli, Yowah opal, and a silver overlay stegosaurus with a Montana agate on its back to reflect the curves and features of the dinosaurs. JoAnn and Robert Balzer Collection.

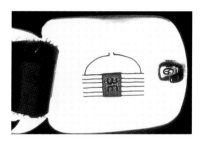

109. "TOURIST SPOONS BELT,"
JUNE 2003
The Wheelwright Museum in Santa Fe commissioned a belt in December 2002. As with their other commissions, Johnson and Bird did not reveal the theme until the belt was completed. They delivered it on June 2003, the same day they began a seminar with Martha Struever. The belt refers to the Wheelwright's collection of Navajo spoons, which was on exhibit at that time, and the belt was included in the exhibit. Johnson made several stamps specifically for this belt. The three-star design on the ninth concho of this belt ties it thematically to the "Butterfly Belt," which uses a three-star pattern for the butterflies on the fourth concho. The belt is silver with 18k gold bezels and accents.

BUCKLE: Fox turquoise and petrified wood with tufa-cast gold antlers. The gold is cast in a sheet and the design cut out and appliquéd to the concho. Buckle reverse: Hogan (Navajo traditional home) and the Wheelwright Museum logo. The design of the original museum was actually based on a hogan.

1ST CONCHO: Petrified wood, coral, and turquoise from the Number 8 mine combined with designs of a lizard and frog in stamp work, awl work, and appliqué.

2ND CONCHO: Petrified wood and coral with designs of three roosters, each with stamp-work designs. Two are in silver overlay and one is in tufa-cast 18k gold appliqué.

3RD CONCHO: Fox turquoise and petrified wood with four deer. Two deer are in silver overlay with stamp work, and one is tufa-cast 18k gold appliqué. One has tufa-cast antlers and another has overlay antlers.

4TH CONCHO: Petrified wood and coral with a sheep and a goat in tufa-cast gold, stamped appliqué, and stamp-work silver appliqué.

5TH CONCHO: Two pieces of petrified wood, one with a silver overlay arrow with an appliquéd gold shaft entering the top of the stone. Between them is a deer in silver overlay with a squash-blossom necklace and the *naja*, or pendant, is an appliqué of silver. Above the deer is a tufa-cast 18k gold appliqué.

6TH CONCHO: Petrified wood, red and salmon coral with a design of three male heads wearing feathers in stamp-work silver appliqué, and one female rabbit with feathers in stamp work.

7TH CONCHO: Petrified wood, Tyrone turquoise, and coral combined with a design of two birds in stamp work and a *naja*, or squash-blossom necklace pendant, in appliquéd stamp work.

8TH CONCHO: Petrified wood and two cats in stamp work and an appliquéd, tufa-cast stamp-work snake.

9TH CONCHO: A Fox turquoise star and three other stars in stamp work, appliqué, and tufa-cast appliqué.

10TH CONCHO: Two pieces of petrified wood and a Blue Gem turquoise are combined with two 18k gold elephants in stamp work and appliqué. Wheelwright Museum of the American Indian Collection.

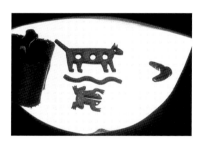

110. "FROGS AND DOGS BELT,"
AUGUST 2003
This belt is linked to the "Spots and Dots Belt" in which the artists' spotted dog Dot appeared. The artists' other dog, Ernie, taught Dot, to catch and release frogs on the couple's daily walks along the river near their home. Both dogs appear in this belt. This belt was made the same year as the "Tourist Spoons Belt." They had to increase work on it to have it ready for Indian Market. The belt is silver with 18k gold bezels and accents.

BUCKLE: Morrisonite. Buckle reverse: Designs of dogs inspired by Ernie and Dot, water, and the frogs the dogs caught and released in the river.

1ST CONCHO: Morrisonite and pale salmon coral and three leaping frogs from Mimbres pottery designs. Two frogs have gold appliqué centers, and the body of the other frog is formed by the coral. Bird and Johnson chose the morrisonite because it has so much color, depth, and light.

2ND CONCHO: Boulder opal, Yowah opal, and dendritic opal. The dendritic opal does not have the flash of the other two stones; the dendrites in the stone look like ferns. The Boulder and Yowah opals make up the bodies of two frogs made in silver overlay in the style of Mimbres pottery designs. There is a gold appliquéd dog and a gold ripple of water.

3RD CONCHO: Two morrisonites and a pale pink coral. The two dogs in silver overlay are adapted from Mimbres pottery designs. They face two directions as if they are on guard duty, and the stones are placed the same way. The body of one dog is coral and the other dog, with its tongue hanging out, is accented by an appliquéd piece of gold.

4TH CONCHO: Pink coral and morrisonite with variscite forming the body of a frog, whose head is an appliquéd piece of gold. The morrisonite has depth as if one were looking into water.

5TH CONCHO: Morrisonite with a Yowah opal representing the body of the frog and coral for the body of the dog, again with its tongue hanging out. The animals are in silver overlay.

6TH CONCHO: Morrisonite and coral. A frog in overlay with spots of gold filling its body is based on a Hopi painting. Coral represents the red-bodied dragonflies that swarm the Chama River. A Mimbres-style dog has appliqué of a diamond-shaped figure in its body formed from sandcast gold.

7TH CONCHO: These stones, chosen for their round or oval shape, include turquoise from Morenci, Fox, and Number 8 mines. At the bottom is a Boulder opal. Three Mimbres-style frogs leap in three different directions.

8TH CONCHO: Three dragonflies with wings of tufa-cast gold and bodies of Yowah opal, Boulder opal, and coral. At the base of the concho is a blue Yowah opal placed to represent water.

9TH CONCHO: Morrisonite and Yowah opal with two appliquéd gold frogs from Hohokam (prehistoric) stone amulets.

10TH CONCHO: Morrisonite with Cerrillos turquoise for the body of the frog and two appliquéd gold pollywogs. Also, a barking dog at the end of the belt has gold dots based on Hopi pottery the artist saw at the Museum of Northern Arizona in Flagstaff. Susan and Howard Goldsmith Collection.

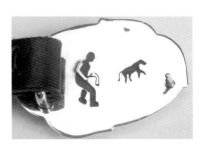

111. "SHEEPHERDING BELT,"
AUGUST 2004
Bird and Johnson participated in an educational seminar to Monument Valley organized by Martha Struever. While driving in Monument Valley, Johnson remembered the landscape and activities of his youth— boys playing near rocks and herding sheep. According to Bird, "The stones were selected for their color and to reflect the desert and Monument Valley. Coral and turquoise are included because they were materials used traditionally by Southwest Indian people. Lapis lazuli is a stone frequently used in contemporary jewelry and the color added dimension." Some of the sheep on the belt recall those in the "Tourist Spoons Belt"; others are from photographs, Navajo textiles, and folk art. This was the first year Johnson and Bird worked with white gold, and it is included in this belt. The belt is silver with 18k gold bezels.

BUCKLE: The complex pattern in this Brazilian agate represents a herd of sheep. Gold is appliquéd to each side to represent the horns of the sheep, 1.75 x 2.5 inches. Buckle reverse: In this design in silver overlay of a boy and his dog, the boy holds a slingshot.

1ST CONCHO: Poppy jasper, coral, Brazilian agate, and snakeskin agate and realistic sheep in silver overlay.

2ND CONCHO: A Montana agate and a herd of sheep. The four sheep are made by different techniques and with different materials. One is formed in silver overlay and three are appliquéd. Of the three, one is cuttlefish bone-cast 18k gold, and the other two are tufa-cast 18k yellow and white gold.

3RD CONCHO: Petersite and Montana agate with a brown background. The goat is cuttlefish bone cast and appliquéd. A Mimbres-style goat with his tongue sticking out was formed in silver overlay and has a tufa-cast 18k gold appliquéd section in his body and a gold drop for an eye. The appliquéd and stamp-work silver goat was inspired by a Navajo silver pin in the shape of a goat that Bird owns.

4TH CONCHO: Sleeping Beauty turquoise and petrified sycamore, the texture of which looks like the coat of a sheep. The turquoise is the body of a silver overlay dog, and the goat is tufa-cast white gold.

5TH CONCHO: Yowah opal, Biggs jasper, petrified pinecone, and a sheep and goat in silver overlay. The petrified pinecone forms the body of one of the sheep.

6TH CONCHO: Wild Horse picture jasper, Tyrone turquoise, and two sheep, one in silver overlay and the other in tufa-cast 18k gold appliqué.

7TH CONCHO: Red and pink coral, an agate, and two rams in silver overlay.

8TH CONCHO: Montana agate with a design that looks like an animal and appliquéd tufa-cast horns above. The appliquéd silver goat again is inspired by Bird's old silver pin. The silver overlay sheep has big horns and a tufa-cast and appliquéd white gold face.

9TH CONCHO: Petrified pinecone, lapis lazuli, and Tyrone turquoise. The turquoise is in the center of an 18k gold cuttlefish bone-cast hogan. Cuttlefish bone casting was used because the texture resembles the horizontal direction logs would be placed in constructing a hogan. The petrified pinecone is also shaped like a hogan. The tufa-cast and appliquéd 18k gold sheep is similar to the one on the fourth concho of the "Tourist Spoons Belt."

10TH CONCHO: Petrified palmwood from Del Rio, Texas, a dog in silver overlay, two white gold tufa-cast goats, and an appliquéd and stamped silver goat.

11TH CONCHO: The image was taken from a photograph. Two Yowah opals are connected by an arch of cuttlefish bone-cast 18k gold above another of tufa-cast white gold. The design forms a rainbow around two sheep, one is stamped silver, the other is in silver overlay and stamp work with gold drops for eyes. JoAnn and Robert Balzer Collection.

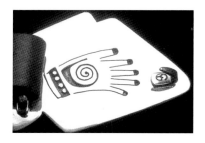

**112. "ALL THINGS HOPI BELT,"
JULY 2005**

This belt was made for Martha Struever, who has represented the jewelry of Johnson and Bird since 1978. A belt had been discussed for over twenty years before Johnson and Bird developed the theme and design based on Struever's interests. A scholar of Hopi art and culture, Struever has published two books pertaining to Hopi artists, *Painted Perfection: Dextra Quotskuyva and Loloma, Beauty Is His Name*. The belt was completed the same year the Loloma exhibit opened at the Wheelwright Museum. The belt is silver with 18k gold bezels and accents.

BUCKLE: Yowah opal, coral. Coral and tufa-cast 18k gold were used to represent the designs of Charles Loloma, who left most of the surface of silver and gold jewelry rough after carving and casting the design in a tufa stone, polishing only select areas of the metal, 1.625 x 2.75 inches. Buckle reverse: A Hopi design of a hand with a bracelet refers to Struever's love of jewelry.

1ST CONCHO: Brecciated jasper and Bisbee turquoise. The images in overlay and 18k gold tufa-cast appliqué are feather designs and traditional Tewa pottery designs from the Nampeyo family.

2ND CONCHO: Petrified pinecone, moss agate, and coral. The petrified pinecone makes up the body and tail feathers of a bird from a Sityatki or Awatovi pottery sherd.

The warm Hopi pottery colors are in the stone.

3RD CONCHO: Brecciated jasper and coral. Silver overlay and appliquéd 18k gold tufa-cast gold designs are derived from pottery sherd bowls Dextra Quotskuyva makes.

4TH CONCHO: The aggregate agate is used because of colors similar to the warm pumpkin and deep orange tones of Hopi pottery. The 18k gold and white gold tufa-cast and appliquéd images are from pottery designs. A ladle-like image contains a pattern of a star.

5TH CONCHO: Morrisonite and coral. The images are winged birds, two in silver overlay and one in 18k gold appliqué. A stylized pattern of the fourth wingspan can be seen in the morrisonite.

6TH CONCHO: Yowah opal and two Montana agates, whose patterns echo the shapes of the two designs in silver overlay, and tufa-cast and appliquéd 18k gold bird designs from pottery.

7TH CONCHO: Two poppy jaspers, coral, and designs in silver overlay and tufa-cast white gold appliqué of stars from pottery designs. Johnson and Bird gave the designs a curved look to resemble the way they sometimes appear in photographs when they follow the shape of the pottery.

8TH CONCHO: Yellow and red Brazilian agate, Mexican agate, and a stone Johnson picked up outside of Loloma's studio at Hopi. He cut and polished it initially for a ring and then decided to use it in the belt.

9TH CONCHO: Two Australian jaspers, a Number 8 turquoise, and geometric designs from Hopi pottery in silver overlay and tufa-cast 18k gold appliqué.

10TH CONCHO: Montana agate and coral. The top figure is a winged bird, possibly a parrot, and the bottom one is a stylized a deer. The pattern in the Montana agate reflects the head and back of a deer. Five gold dots represent Struever's grandsons. Martha H. Struever Collection.

113. "LAGUNA-ACOMA POTTERY BELT," AUGUST 2005

This belt, based on Laguna and Acoma pottery, followed the "All Things Hopi Belt," also based in part on Hopi pottery designs. Bird and Johnson used photographs of pottery from Rick Dillingham's 1992 book *Acoma and Laguna Pottery*, the magazine *American Indian Art*, and other publications as resources. Following the 1982 "Pottery Maker Belt," the 1984 "Mimbres Black and White Belt," and the 1987 "Santo Domingo Pottery Belt," Johnson and Bird had planned to do a series based on historic pottery designs from specific pueblos. The range of colors in the "All Things Hopi Belt" led to the colors and designs for the "Laguna-Acoma Belt." Johnson cut the coral for the second, third, fifth, and tenth conchos. The belt is silver with 18k gold bezels and accents.

BUCKLE: Montana agate with natural curves in the design. Buckle reverse: The design echoes the curves in the stone on the front and is based on a design seen on Acoma and Laguna pottery representing a stem or stalk; generally the design is finely painted. Bird and Johnson have used the design extensively in their belts.

1ST CONCHO: Montana agate, morrisonite, and a tufa-cast 18k gold rainbow and a deer in silver overlay. The designs are based on those seen on an Acoma pot from c. 1900. "You don't often see deer on Acoma pottery," Bird said, "but we saw one example and decided to use this design." The arched pattern in the morrisonite represents a rainbow.

2ND CONCHO: Montana agate and a section of salmon coral cut by Johnson represent the colors in Acoma pottery. A tufa-cast 18k gold design adapted from Acoma pottery of a double rainbow in silver overlay has abstract geometric lines filling the void. Below is an abstract flower design, also in overlay.

3RD CONCHO: Coral, Montana agate, and Bisbee turquoise. The design in silver overlay is of an eagle or bat wings from Hopi pottery. The Montana agate continues the pattern of the radiating lines seen in the overlay design. A tufa-cast 18k gold appliqué is based on a pottery design.

4TH CONCHO: This jasper from Australia has an ochre-colored base with hints of red and a creamy white that are similar to the colors of Acoma pottery. According to Bird, "From the 1880s to 1900 or 1910 there were pots with big swirling designs and rectangular outlines around a big circle. The center represents the circle, and gold appliqué represents the stems and flowers of the jar."

5TH CONCHO: Salmon coral, morrisonite, and a parrot in silver overlay with a gold-drop appliquéd eye and a delicate line in tufa-cast 18k gold.

6TH CONCHO: Brecciated jasper. The plant imagery in silver overlay was inspired by turn-of-the-century pottery, and a deer depicted with gold appliquéd spots was based on a pot dated 1880–1900.

7TH CONCHO: Montana agate, coral, and a floral pattern with leaves, one depicted in silver overlay and the other in 18k gold appliqué.

8TH CONCHO: Montana agate and salmon coral. The agate was chosen and placed to resemble a rainbow. A parrot in silver overlay with tufa-cast gold-drop appliqué looks like it is coming to a screeching halt. The flower is gold appliqué and overlay.

9TH CONCHO: Brazilian agate and Montana agate. The silver overlay design is a stylized angular rainbow. Johnson and Bird refer to it as a mesa outline. This design could be inspired by one of the parrots or a double-banded rainbow.

10TH CONCHO: Pale pink coral, morrisonite, and a parrot in silver overlay with tufa-cast and gold-drop appliqué. The butterfly design was taken from a pre-1900 pot, and the butterfly wings are tufa-cast 18k gold. These images represent movement and the continuation of the rainbow. Tunia Hyland Collection.

Not pictured:
Bruneau Mountain Belt, 1981
Beenhouwer Belt, 1989
Game Refuge Belt, 1996

NOTES

CHAPTER ONE

1. Gene Cavallo, "The 1980 Fellows: Yazzie Johnson and Gail Bird." Official Indian Market Program, August 20, 1981, 67.

2. John Adair, interview with Yazzie Johnson and Gail Bird, December 5, 1981, John Adair Collection in the Wheelwright Museum of the American Indian, 19.

3. Robert and Philip Haozous, whose father is Allan Houser, use a different spelling of the family name.

4. Anne L. Ross, "Gail Bird, Yazzie Johnson Evoking the Land." *Ornament* 16(4), 55.

5. Adair, interview with Johnson and Bird, 9.

6. Ibid., 15.

7. Martha Struever, Address to the Heard Museum Guild, February 17, 2006.

8. Martha Struever, 2006 interview with the author.

9. Judy Dewey, 2005 interview with the author.

10. Ibid.

11. Adair, Interview with Johnson and Bird, 10.

12. Joanne Lyon, interview with the author, 2006.

13. Ibid.

14. Judy and Ray Dewey, 2005 interview with the author.

15. Ibid.

16. Cavallo, "The 1980 Fellows," 67.

17. Mark Lannihan, "Original Style Benefits Artists," *The Indian Trader* (October 1981): 10.

18. Adair, Interview with Johnson and Bird, 16.

CHAPTER TWO

1. Martha Hopkins Struever, *Loloma: Beauty Is His Name* (Santa Fe, NM: Wheelwright Museum of the American Indian, 2005), 99.

2. Jonathan Batkin, personal communication, February 13, 2006. Batkin describes their work as being extraordinary.

3. Dexter Cirillo, phone interview, 2006.

4. Daniel Vallancourt. "Gail Bird Lauds Cohesion of New Work . . ."

CHAPTER THREE

1. John Adair, Interview with Yazzie Johnson and Gail Bird, December 5, 1981 John Adair Collection in the Wheelwright Museum of the American Indian, 9.

2. Wachs, Mary, and Jim Hannah, "The Art of Adornment," Santa Fe *Reporter,* (August 14, 1985), 18.

3. Hammond et al., *Women of Sweetgrass, Cedar and Sage,* 27.

BIBLIOGRAPHY

Adair, John. *Navajo and Pueblo Silversmiths.* 1944. Reprint. Norman: University of Oklahoma Press, 1989.

Adair, John. Interview with Yazzie Johnson and Gail Bird, December 5, 1981. John Adair Collection in the Wheelwright Museum of the American Indian.

Batkin, Jonathan. Interview, February 13, 2006.

Bird, Gail and Yazzie Johnson. Interviews, June 2004–July 2006.

Cavallo, Gene. "The 1980 Fellows: Yazzie Johnson and Gail Bird." Official Indian Market Program, August 20, 1981, pp. 67–68.

Cirillo, Dexter. Phone interview, February 6, 2006.

Cirillo, Dexter. *Southwestern Indian Jewelry.* New York: Abbeville Press, 1992.

Dewey, Ray and Judy. Interview, January 20, 2006.

Hammond, Harmony, and Lucy Lippard, Jaune Quick-To-See Smith, and Erin Younger. *Women of Sweetgrass, Cedar and Sage.* New York: Gallery of the American Indian Community House, 1985.

Lannihan, Mark. "Original Style Benefits Artists." *The Indian Trader* 12(10) (October 1981).

Lyon, Joann. Phone interview, February 2006.

Rannefield, James. "Assimilations." *ArtLines* 5, no. 8. (August 1984): 16.

Ross, Anne L. "Gail Bird, Yazzie Johnson Evoking the Land." *Ornament* 16, no. 4 (1993): 50–55, 75.

Struever, Martha. Address to the Heard Museum Guild, February 17, 2006.

——— Interview, February 17, 2006.

——— *Loloma: Beauty Is His Name.* Santa Fe, NM: Wheelwright Museum of the American Indian, 2005.

Vaillancourt, Daniel. "Gail Bird Lauds Cohesion of New Work, Show: Johnson Puts Designs into Reality." *Pasatiempo, The Santa Fe New Mexican,* August 16–22, 1996.

Wachs, Mary, and Jim Hannah, "The Art of Adornment," Santa Fe *Reporter* (August 14, 1985): 15–18.

Zeitner, June Culp. *Gem and Lapidary Materials for Cutters, Collectors, and Jewelers.* Tucson, AZ: Geoscience Press, 1996.